Whispers of Vivaldi

Books by Beverle Graves Myers

The Tito Amato Mysteries
Interrupted Aria
Painted Veil
Cruel Music
The Iron Tongue of Midnight
Her Deadly Mischief
Whispers of Vivaldi

The New York in Wartime Mysteries (with Joanne Dobson)
Face of the Enemy

Whispers of Vivaldi

A Tito Amato Mystery

Beverle Graves Myers

Poisoned Pen Press

Poisoned Pen Press
6962 E. First Ave., Ste. 103
Scottsdale, AZ 85251
www.poisonedpenpress.com
info@poisonedpenpress.com

Printed in the United States of America

For Nathaniel Riley McKinney

Acknowledgments

Over the years, I've been grateful to everyone who has helped bring the Tito Amato Mysteries to life by sharing information, offering advice, and listening to me spin plots. For *Whispers of Vivaldi*, particular thanks go out to my editor, Barbara Peters, for tempting me to give Tito one last adventure; the entire staff at Poisoned Pen Press for shepherding the book to publication; my trusted "first reader" Joanne Dobson; Adale O'Brien for valuable theater lore; and, as always, my husband and family for unfailing support.

The voyage into Italy is the most interesting of all possible voyages.
 —Abbé Gabriel-François Coyer, 1775

*The mutilation practiced upon his body had made him a monster,
but all the qualities that embellished him made him an angel.*
 —Giacomo Casanova, 1792

All men are villains.
 —Leopold Mozart in a letter to his son, 1778

Chapter One

The one thing I'll never miss about the opera career that brought me fame and fortune is jolting from one engagement to another in crowded mail coaches, watching the roadside vegetation unfold in brain-numbing boredom. One poplar tree is very like another, I've found, and the tenth field of grazing sheep is no more harmoniously pastoral than the first.

So why am I once again rattling along the roads between Venice and Milan? Why had I deserted my dear wife to listen to Augustus Rumbolt snore like a hibernating bear and Benito sigh out of ennui as deep as my own?

I'm a true child of Venice, I suppose. Life is theater, and my whirlwind city offers a stage that entertains and excites like no other. When my old director, Maestro Torani, begged my assistance with a mission of grave import for our opera house, I agreed without hesitation.

As to my companions, I never travel without my manservant, Benito. He brews my morning chocolate to perfection, always sends me out with exquisite lace at collar and cuffs, and has twice saved my life when unbridled curiosity led me into mortal danger. Benito is a castrato—as am I.

The snoring bear in the corner of the carriage invited himself along, but is most welcome nevertheless. Augustus Rumbolt—Gussie—is my English friend and my sister Annetta's husband. He is also an artist between portrait commissions. I'd met Gussie years ago when he'd engineered his escape from a tutor-guided

Grand Tour. Unlike the type of English dandy I often saw loung-
ing in coffee houses with his nose in a guidebook and eyes blind
to the real Venice, Gussie had been keen to learn our language
and our ways. By obstinately remaining in Venice, my friend
had scandalized his family and embraced his lifelong dream of
learning to paint like the Italian masters.

Sighs and snores aside, I'm cheered by my two companions
and confident that each will be—in his own unique way—of
great help once we reach Milan.

At Maestro Torani's behest, we are off to snare an Angel.

◇◇◇

My quest had actually begun several days earlier at the foot of
the Rialto Bridge, where I'd met Maestro Torani to discuss the
looming fall season at the Teatro San Marco. Opera, the reigning
entertainment of the day, especially in our city, had raised gaiety
and pleasure to a high art. For years our Senate-sponsored opera
house had flourished as the crowning jewel of Venice's carnival
festivities, but that year San Marco was in trouble.

We'd been losing subscribers for well over a year, first a trickle,
then a flood. Most of our wandering ticket-holders had taken
boxes at the rival Teatro Grimani, a house known for mount-
ing lightweight operas filled with pretty tunes and even prettier
prima donnas. Something had to be done.

Pleased that Maestro Torani had sought my advice, I'd
scoured Venice—the musical parts of it, anyway—and nosed
out a new opera that would lure our errant audience back. My
delicious spectacle would astonish Venice with something radi-
cally unexpected.

When I'd left home that day—fortified by an extra cup of
early morning chocolate, a kiss from my loving Liya, and a fresh
breeze blowing off the lagoon—I was absolutely certain that
Maestro Torani would embrace my suggestion to replace the
ponderous opera he had already scheduled to open the season.

Later I wasn't so sure.

"A daring step, Tito." Torani tapped his silver-headed walk-
ing stick on the paving stones of the *riva*. He regarded me with

narrowed eyes, clearly hoping I was making an awkward joke. "Is this your best proposal? Mixing comedy into Venice's grand spectacle? Reducing our finest singers to clowns?"

"Humor is merely the seasoning, Maestro. You could liken it to just the right amount of saffron in the hands of a master chef." I avoided Torani's gaze as I touched the brim of my tricorne to a passing acquaintance, then faced him squarely. "I'm not calling for buffoonery."

"I hope not. Venice will have enough of that once Carnival starts. The Commedia players will throw up their outdoor stages, and not a minute will slip by without a stale joke or a boot in the arse."

"You must admit that Harlequin and Pantaleone draw a crowd."

"A crowd of raucous hyenas." He shrugged dismissively. "People don't come to the opera to laugh."

"Perhaps they should."

"What?"

"At least we'd know they were paying attention."

"Look here, Tito, are you suggesting that our productions have grown…I don't know…tiresome?" Torani was sputtering, and the veins of his cheeks stood out fiery red.

"That's not the precise word I had in mind." I'd actually been thinking worn-out, overdone, or hopelessly convoluted. But how to convey this to the touchy old gentleman who'd directed them without sending him into a fatal fit of apoplexy?

I cast a glance at the famous bridge spanning the Grand Canal. Over the water yet untouched by the warm September sun, beneath the bridge's solid arch, mist had collected so thickly that the laden skiffs and gondolas appeared to sail into an otherworldly realm, never to return.

Much like my plans to reinvigorate the Teatro San Marco.

I couldn't let that happen. Not when I'd found a brilliant work that would breathe new life into the company nearly smothered by trite tales of Olympian feuds and tedious exploits of long-dead heroes.

"I ask you, Maestro, how many times can you expect the audience to be astonished at Zeus descending from the clouds to untangle the plot and save the day with a thunderbolt?"

Torani harrumphed, waving his stick wildly. A smock-clad farmer from the mainland jumped out of its way, then shot the old man a *manu fico*. The maestro was oblivious to the vulgar gesture.

"Look here, Tito, people cling to these traditions for a reason. It makes them feel comfortable, like coming home to their favorite chair and a glass of warm brandy. When you've lived as long as I have, my boy, you'll understand."

I exhaled an annoyed sigh. My thirtieth name day had passed several years ago, as Torani well knew. When would he stop calling me "boy?"

As if he'd read my mind, my old mentor clasped my chin and studied my face as he turned it this way and that. For a fleeting moment, I imagined a fatherly possessiveness in his smooth touch.

"No, not a boy," he finally whispered. "Your beardless cheeks make me forget how many years we've been associated."

"Twelve years, Maestro. A full dozen."

"I'm well aware of the passage of time. And of all you've accomplished."

"Then will you consider my plan?"

Torani regarded me silently, lips set in a line. Beneath his cockaded tricorne, he wore a wig fresh from the perruqier, a fashionable, campaign-style wig with gray sausage curls above each ear and a long braid down the back. Along with his distinguished brow, gaunt cheeks, and proud sparrow-hawk nose, Torani's wig gave him the appearance of a weary, weathered general inspecting troops destined to march off to battle without him.

"Tell me, Tito," he said at last. "If humor is the seasoning, what is the meat in the dish you'd like us to serve?"

"This opera tells a story of our own time—not ages past." I raised my voice to be heard over the growing foot traffic on the riva. People carrying all manner of things to sell at the market were flowing across the bridge, popping out of side streets, and alighting from boats tied at the quay's tarred mooring posts. I

continued, "Both the music and the poetry bubble with life and energy of a kind that Venice has never seen."

"What's it called, again?"

"*The False Duke.*"

"The title itself disturbs me. Surely you must see—" The maestro snatched a wheezing breath that ended in a moist cough. Of late, Torani had displayed a surplus of fluid, which his refusal to be bled only made worse. He said, "*False* and *Duke* linked in the same title? It's almost like accusing an aristocrat of a crime. Offensive!"

Glancing around, Torani lowered his voice a fraction. A pair of *sbirri* sauntered by. While the constables who patrolled Venice for pickpockets and other rogues were easy to identify by their red sashes and short swords, the *confidenti*, state spies on the alert for revolutionary sentiments, blended anonymously into the crowd. My companion tapped a finger on the side of his nose and finished on a whisper, "And risky, besides."

I shook my head. "Don't worry. The plot proceeds harmoniously, in a very respectful manner. The true duke realizes his heart's desire—he voluntarily trades places with a forest huntsman."

"Good God! How is this possible?"

"The two men share a remarkable likeness."

Torani touched a handkerchief to his lips. "Twins," he announced cheerily, waving the white square as if he were keeping time with some unheard tune. "Now I see. Twins separated at birth—the huntsman is also of noble blood."

"No, Maestro." I shuffled my feet uneasily. "The twin plot is so old, it should come wearing whiskers. This opera has something new to say, and I believe Venice is ready to hear it."

"And what is this *new* premise that will stop our box office hemorrhage?"

"Simply this: the duke exchanges roles with the huntsman for love's sake, but then he discovers the bliss of a plain life, truly lived, away from the strivings and vanities of court."

Torani lowered his gaze to the pitted paving stones. Thinking, I hoped.

Forcing myself to remain silent, I watched a boy unloading wicker baskets from a skiff bobbing on the canal. His cargo comprised beige and brown mushrooms, perhaps the first of the season, their velvety caps still furred with dirt from the forest floor.

The boy had transferred several baskets to a flat, two-wheeled cart by the time Torani looked up and said, "I suppose the plot might work, Tito. Who hasn't longed to escape the crush of responsibility at one time or another?"

I nodded as he continued, "To live without strife or guilt... to find true contentment." He sighed deeply, then shook himself like a man who has fallen asleep unawares. "Where do matters of the heart come into the story?"

"The duke finds true love with a milkmaid."

The maestro's eyebrows shot up.

"Who does happen to be a noble lady in disguise," I hastened to assure him.

Torani pushed his tricorne back. He dug a finger under his wig and scratched. "I don't know. This gamboling in the countryside, blending the orders of society. It smacks of liberal philosophy. No matter how inoffensive you claim it to be, the Savio—not to mention the entire Senate—might find it hard to swallow."

The Savio alla Cultura was the patrician official charged with collecting a portion of the theater's revenue for the Republic's coffers. Before the summer hiatus, that worthy gentleman had often left Torani's office with a slender purse and a worrisome frown. The Savio was also our official advocate in the Senate—where he could be our most solicitous protector or our harshest critic. I hoped the Savio would be so delighted with *The False Duke*'s potential stream of ducats that the shaky politics of the libretto would pale to nothing. After all, every Venetian aristocrat wore a merchant's tough hide under his silk and velvets.

I said as much to Torani, but the maestro was still concerned. So much was riding on his decision. All of Italy loved its opera. But understand—Venetian opera surpassed any other. Our theaters, open to the public rather than confined to a royal court,

were a reflection of the city itself, the meeting place of society high and low. An aura of nearly sacred proportion surrounded every person and thing that had the slightest connection with the opera. Even the fellow who emptied the singers' chamber pots had something to brag about.

Torani took my arm and leaned on it as we started toward the market on the Campo San Giacomo. "You haven't told me who's responsible for this masterpiece." His voice held an undertone of accusation.

"Signor Rocatti, the young violin maestro at the Pieta. Vivaldi's successor, in fact."

"Niccolo Rocatti?"

"The very same." I stumbled over a loose brick, momentarily distracted by a red-cheeked brunette hawking pastries from a tray hung about her neck. Their yeasty, sugary aroma was delightful, and so were her shapely shoulders. Torani dropped my arm, apparently preferring to trust his stick.

"Tito, I've attended many a concert at the Pieta, and found Signor Rocatti's pieces disappointing. They certainly can't compare with Maestro Vivaldi's genius." He touched his forehead and proceeded to cross himself in memory of Venice's greatest composer.

"But," I quickly countered, "*The False Duke* was composed for seasoned professional singers. The girls of the Pieta are young amateurs. Most of them will end up using their musical skills merely for their own pleasure. This score, on the other hand, is brimming with novel melodies, glorious harmonies. And Rocatti has outdone himself in buoyant arias for the duke—all composed in the style of Maestro Vivaldi."

"When my old friend was still at his best?"

I nodded. "Rocatti patterned his score after Vivaldi's full flowering."

We regarded each other sadly. Several years ago, the fickle winds of musical fashion had blown Maestro Vivaldi away from his beloved Venice. The exemplary and prolific composer they called "The Red Priest" for his carrot-colored hair and his early

induction into the church's minor orders had headed north to stage operas for the Hapsburg court in Vienna. Unable to navigate the politics of that intrigue-ridden court, Vivaldi died there in disgrace. An ignominious end for a great man.

I said, "Maestro, you know I'm difficult to impress, but if you don't believe me, see for yourself. I've left a copy of Rocatti's score at the theater."

He gave a tired sigh. "Let me think on this a moment."

Slowly, not speaking, we turned into the Campo San Giacomo. Though it was early yet, this central marketplace hummed with merchants calling from stalls and women gossiping over garlands of yellow onions and pyramids of purple cabbage. In another hour the uproar would be intolerable, and you'd hardly be able to move a foot without asking someone's pardon. With droning pleas, ragged beggars would extend bowls. Soldiers, all gold braid, brass buttons, and hangers swinging from leather straps, would march past. Young bootblacks would twitch at your sleeve, and perhaps an enterprising whore decked out in paste jewels and tattered lace, hoping for some early business. But just now the *campo* in the shadow of its ancient, red-ochre church was as lovely a place as you'd find in our crumbling city, and the crowd was sparse enough to allow easy passage.

Torani and I came to a halt in a quiet enclave behind *Il Gobbo*, the statue of the crouching, naked hunchback who presided over the marketplace. The director was still frowning. Frustration welled up within me. Why wouldn't Torani give me an answer?

"What is worrying you, Maestro?"

"Balbi—our good Giuseppe." Torani spoke tentatively, almost sorrowfully. "He's already drilling the singers for *Prometheus*. And such attention to detail. Just yesterday he was poring over sketches for the set design and making suggestions."

Torani was speaking of Giuseppe Balbi, the composer whose opera was scheduled to open the fall season. Balbi also happened to be the San Marco's lead violinist—he'd been with the theater even longer than I had. Yes, Balbi was a good man. A talented

accompanist. Kind and patient with the orchestra musicians under his supervision. Loyal to the theater.

Unfortunately, as a composer, Balbi was a hack ruled by outmoded convention. If Torani had forgotten, I needed to remind him.

"Maestro, the San Marco isn't declining because of our fine singers or the excellent direction you've provided. The fault is in the librettos and music the singers are given. *Prometheus* is a prime example—again a mythological hero. And also again, Act One ends with his bravura aria—vehement exit stage right. Act Two begins with a pastorale, another old chestnut. I can already hear the audience yawning—"

Torani interrupted with a slice of his hand. "I can't argue with that. It's just…"

"It's just what, Maestro?"

The tight lines on the director's face seem to signify some mental turbulence beyond the theater's money woes, an underlying despair that had more to do with the inner man than with his very public position. Torani glanced around the campo…. toward the church portico where the money changers were doing a brisk business. Farther up, at the soaring tower with its ornate clock divided into the twenty-four slices of the day. And still farther up, at a sky of pure, undiluted blue.

Gradually, his expression softened, rather like a wallflower opening to the sun. He rubbed the back of his neck and asked, "You realize that *The False Duke* would be a gamble?"

"I do, but it seems like good odds. You know how much Venetians love novelty. Isn't that why you asked me to come up with something new? Aren't you itching to take a risk?"

A quizzical smile pulled his mouth to one side. "I thought you hated gaming, Tito."

Well I should, given that my father had sacrificed our family honor and so much more at the Ridotto's faro tables. But the future of the Teatro San Marco was at stake. Fortune demanded a bold move, and Venice deserved it.

"Maestro, I have faith in Rocatti's opera. Let's go to the theater, review the score. We can discuss the casting I have in mind—"

But Torani was no longer listening. His gaze sizzled on a sedan chair entering the campo from the direction of the fish market. Two bearers rigged out with shoulder straps hauled the gilded, top-heavy box between the stalls. As it passed, a merchant selling bright green melons employed his produce to sketch a comically lewd pose. The thin crowd reluctantly made way.

"Who is it, Maestro?"

A snort. "Don't you recognize the chair, Tito?"

I shook my head. Many wealthy men and women moved about the city by sedan chair, both for show and for cleanliness.

"Observe the livery on its bearers, boy. And commit their colors to memory. It's a wise man who knows his enemy."

I gave an irritated sigh—there was that "boy" again. But I stretched tall to see over the folded headdress of a peasant woman bearing a yoke with jugs of milk packed in straw at each end. Dodging as she swung around, I caught sight of a man in a heavy-bottomed wig behind the glass windows of the chair.

Ah! Lorenzo Caprioli. Even at a mere glimpse, his fat, greasy face was unmistakable.

Caprioli saw us, too. He tapped on the glass and pointed. The chair changed course.

Torani whipped his head right, then left, seeking an escape route. His gondola waited among the produce boats back at the bridge, but the old man moved so slowly, we'd never make it out of the campo and back to the riva before Caprioli's powerful bearers overtook us.

There was no way around it. Maestro Torani would be forced to come face to face with his hated rival, the manager of the Teatro Grimani, the opera house that had stolen most of our lost subscribers.

Chapter Two

The burly bearers—outfitted, I noted, in French blue with yellow trim—set the chair down with the gentlest of bumps. The man in front removed his shoulder straps and turned to open the door. At the same time, the man between the rear poles moved to raise the domed roof. Together they assisted their master in extricating his bulk from the narrow compass of the chair. He approached in mincing steps, as if his shoes or his breeches, or both, were uncomfortably tight.

"Signor Caprioli." Torani spoke first. The title of Maestro was not required. Caprioli possessed no musical skills whatsoever. He was merely an impresario, a showman who'd made his start producing ribald masquerades for naval officers. Nevertheless, this pompous charlatan now ran one of Venice's respected theaters.

Torani removed his tricorne and gave his rival the low bow that politeness required.

I followed suit.

"Maestro, so pleased to chance upon you…and Tito, of course." Caprioli stopped his bow a good six inches above Torani's and favored me with a shallow nod. Duels have been fought over less—among certain classes. Thank Heaven the artists of the opera left the privilege of demanding honor with cocked pistols at twenty paces to our betters.

As Caprioli turned and directed his bearers to take their ease, Torani leaned close and whispered behind his hand, "Not a word about your *False Duke*, Tito, not one word."

I bristled. Did Torani think I was a fool? Caprioli had a reputation for stealing ideas as liberally as subscribers. And performers. The Grimani's best singers had been poached from our company, either wheedled away with promises of salaries fit for a king or compelled by subtler means. It was rumored that Caprioli had a knack for uncovering information—ruinous secrets that people would sacrifice much to protect.

The man made enemies, of course, but protected himself by hiring ex-soldiers of the roughest sort to serve as stage hands and personal servants. Unfortunately, the wars among our northern neighbors produced a steady stream of Austrians and Germans whose farms and towns had been destroyed. With no place to call home, they ended up in Venice in the same fashion that random trash collects in the backwash of a canal.

Caprioli's chairmen were obviously two of his battle-hardened veterans. The front man had a bayonet scar that ran from ear to chin, the other a broken nose sprawled diagonally across his sweat-streaked face.

Now Lorenzo Caprioli offered Torani an unctuous smile that wouldn't have looked out of place on the quack-doctor selling nostrums across the square. "How I wish you could have been a fly on the ceiling at the San Grimani yesterday," he said. "You would have enjoyed quite a treat. Emiliano rose half a note above his best pitch. Not once but five times. My heart melted at the heavenly sound."

I clenched my teeth. Emiliano was the brightest of the San Marco's fugitive stars, one of my longtime rivals, and an expert at the spontaneous musical ornamentation that current taste demanded. I couldn't stand the arrogant peacock, but Emiliano in the lead role had always sold tickets, so Torani had suffered his demands and rued his desertion to the Grimani.

As Caprioli continued to brag about the popular castrato, I thought Torani might erupt right there in the middle of the crowded, sun-drenched campo. He tilted his head back, exhaled audibly, and pressed his lips into a bloodless line. At the theater, such a pose usually preceded a tirade, be it over a poorly tuned

violin or a rebellious prima donna. But to my astonishment, the maestro succeeded in bridling his irritation.

Torani lowered his chin, and his tone held only the barest hint of malice when he asked, "So your company is in rehearsal, Signor Caprioli?"

"Isn't yours?" The impresario's eyes widened in their loose folds.

"My singers are meeting in rehearsal rooms—learning their tunes, sinking into their characters."

"I should hope so. The season is less than six weeks away."

Caprioli was fencing with Torani. With some specific goal in mind, I thought. What was he after?

Torani continued, tapping the tip of his stick into *Il Gobbo*'s worn plinth. "We're in a hired hall because the machinists have commandeered the San Marco's stage. They're planning to outdo themselves with a spectacular finale."

I knew all about the marvelous effect that would free the fire-stealing Prometheus from his prison rock in a blast of flame and smoke, but I still considered *The False Duke* to have more appeal. What was a moment of scenic trumpery compared to four acts of honest drama spiked with laughter and accompanied by beautiful music?

"Hmm." Caprioli brushed the curls of his brown wig away from his lace cravat. A nauseating whiff of hair pomade met my nostrils. "I've been keeping my ears open. The chin-wags in the coffee houses say you're offering home-grown goods this season. Something your fiddler whipped up."

"Hardly whipped up. Signor Balbi is a perfectionist. He's been working on the score for well over a year."

"He's done *Prometheus*, hasn't he?" A smug smile stretched Caprioli's jowly cheeks into a carnival mask. Knowledge was power, in music as much as in war or trade, and the impresario was reveling in his.

"I hear things, too," Torani shot back. "Your company is presenting *Venus and Adonis*."

"I don't deny it. No one can resist a story of young lovers—it's bound to trump your dreary *Prometheus*. How disappointing for you—with the Senate circling your wounded receipt box like a flock of carrion vultures." He sniffed loudly.

And so it went on, a duel of words and wit. Torani extolled the San Marco's singers and scene painters, all the artists right down to our costumer newly imported from Paris. Caprioli parried by proclaiming how the Teatro Grimani topped our theater in every respect. As the two men's voices grew more vehement, beads of sweat rolled down Caprioli's jowls and Torani's face grew pale and taut.

Several passersby stopped to watch. Others clustered close behind them, sensing the prospect of violence, afraid they might miss a fight.

Scarface and his partner had been flirting with a kitchen maid, tweaking the ends of the white kerchief she'd crossed low over her bosom. Now the chair bearers snapped to attention. Their hammy fists clenched and unclenched.

Time to end this. I leapt into the verbal fray.

"Signor Caprioli, you must admit that the Teatro San Marco has one thing you do not—a *primo uomo* who embodies the noble hero. Our Majorano has a profile fashioned for the footlights and shoulders that send women into swoons. On the other hand, your Emiliano is showing his age—and the ravages of an unfettered appetite. I happen to know he keeps his potbelly off his knees by means of a corset." I produced a delicate snort. "Emiliano as Adonis? The very ideal of a handsome youth? Your audience will be choking with laughter."

Because it was all so true, it was precisely the worst thing to say. Caprioli's chin jutted forward. I fancied I could see smoke pouring from his ears. Congratulating myself, I moved to flank Torani and lay a calming hand on his back. I could feel the old man's heart thumping through the thin cloth of his jacket.

"No one asked your opinion, Amato," Caprioli sputtered. "You two think you're riding high in the water. You enjoy the Senate's backing and the Doge's official patronage, but enough

votes in the Senatorial chamber can change that. I ask you, who are the men who deliberate at that table?" He answered his own question with a triumphant cackle, "The very patricians who are deserting your opera house for mine. The Grimani will soon be leading the fleet of Venice's theaters, and you'll be foundering in our wake."

The triumphant satisfaction in the impresario's eyes lasted only a moment. He realized he'd gone too far—given away his hand. Caprioli was mounting a campaign to wrest governmental sponsorship away from the Teatro San Marco!

Torani gaped, goggle-eyed. I didn't like the fire I saw in those eyes. I didn't like the fire that had burst into flame in my own belly.

Perhaps Caprioli also recalled Rinaldo Torani's famous temper. The maestro was manhandling his stick. Its silver head glinted as he passed it from hand to hand.

Caprioli stepped back and signaled his waiting chairmen with two fingers in the air, lace cuff aflutter.

Scarface sprang to open the chair's front panel while his flat-nosed partner raised the domed roof.

The impresario muttered, "You must excuse me, Signori. An important matter—I have an appointment with a man who trains birds." He turned on the heel of an elegant shoe, then threw a last remark over his shoulder: "Our *Venus and Adonis* will have a flock of live songbirds released in the pastoral scene that opens Act Two. Top that, if you can."

As Caprioli's chair receded into the noisy ebullience of the market, I studied Torani's smoldering expression. The manager of the Teatro Grimani had just declared war, and the biggest cannon in his arsenal appeared to be an opera of precisely the type I was urging my mentor to rebel against.

Torani and I were of the same mind—as so often in our years of collaboration—only he phrased it this way: "That scabby, scheming, puffed-up toad has fired a shot across our bow."

"What do you mean to do?"

Torani left me in the dark for a few tantalizing minutes. Hurrying away from the campo, he revealed his strategy in small increments, rather like water dripping from a leaky bucket. First he located his gondola.

"Row us to the Teatro San Marco," he ordered his boatman, Peppino, who uncurled lazily from his perch on the quay's steps. "By the most meandering route you can devise," Torani added, as I steadied him into the swaying boat.

Peppino touched the side of his nose to signify understanding, pushed away from the quay with a booted foot, and leaned into his oar. The high, iron-tipped prow cut through the thinning mist under the Rialto Bridge, and we emerged into the clear sunlight of mid-morning. Around us, the canal stretched out in a jade-green road cobbled with tiny whitecaps right up to the base of the marble palaces that lined Venice's most important waterway. We were moving away from the heart of the city where the theater was situated, toward the outlying Cannaregio, the quiet domestic neighborhood where I lived with my family.

Torani's sharp gaze warned me to keep my mouth shut, so I leaned back and closed my eyes. Behind me, Peppino's oar groaned rhythmically as it strained in the rowlock. The breeze cooled my discord-warmed cheeks as my thoughts ranged to other matters.

Two years ago, a violent accident had reduced my highly trained throat to a dry husk. Overnight my crystal clear soprano had deepened to a gravelly alto—despite doctoring from eminent physicians as far away as Bologna, despite taking the waters at several German spas, despite swallowing pitcherfuls of Liya's herbal concoctions.

Despite all, my celebrated stage voice was irretrievably lost.

It had taken several agonizing months for me to admit that I'd never sing for an audience again, then several more to consider Maestro Torani's urgings that I turn my talents and experience to assisting him at the Teatro San Marco. Instead of shining at center stage, I learned to dwell in the backstage shadows, overseeing rehearsals and drilling the singers I had once joined

in creating beautiful music. Thank the Blessed Virgin for the director's patience. While I was still in my doldrums, I had been a moody, distracted ghost of my former self and couldn't have been much help. Eventually, with the support of Liya and Gussie, and Benito, too, I found my way out of that dark forest of despair.

Since then, I'd been considering my future in a more serious fashion than ever before. Against my will, when I was still an innocent boy, a surgeon's knife had forced my life onto one path. Now I needed to forge another. Mounting the opera I had chosen to save our theater would be the first step on a path of my own choosing—if Maestro Torani had enough faith to let me see it through.

My eyes flew open at the sound of Torani's voice, and I edged forward on the leather cushion. The maestro was finally ready to talk. Excited and impatient, he threw out a string of questions that barely gave me a chance to formulate a reply. Would the highly partisan Venetians swallow an opera by an unknown composer? Would the gondoliers, our staunchest supporters in the cheap seats, think we'd gone mad? Working himself into a lather, Torani whipped off his tricorne, then his wig. When he was truly agitated, the wig always came off.

I came to full attention, shocked. An ugly gash streaked through the wispy curls that ringed his bald pate. A scab knitted the edges together; the skin around it was red and puckered.

"Maestro, you're injured. What happened?"

Torani attempted a weak smile. "Nothing much. I was standing in the wrong place when a roof tile happened to come loose."

"Happened to? Where? When?"

"Day before yesterday." He huffed a sigh. "I was minding my own business—just leaving Peretti's, in fact." He'd named a coffee house near the theater, a favorite place for musicians to gather and exchange news. "I heard something—probably a cat leaping at a bird—and I looked up just as the damnable tile slid off the eave. It's really nothing."

"Hardly nothing," I snapped. "It must have bled like a pump faucet."

He shook his head. "My old wig took most of the blow."

"But, Maestro—"

He made an impatient gesture. His tone was insistent. "Leave it, Tito. A cat on a roof—that's all."

I found myself turning back toward the Rialto with an uneasy glance. Hadn't Torani just been engaged in a heated argument with a man he'd called his enemy?

But the director's focus had returned to the opera. Torani continued, "Which role would Majorano take in *The False Duke*—just for discussion's sake, mind you—the duke or the huntsman?"

I replied after a moment of hesitation. "The duke, of course. He has more arias."

Our boat rocked in the wake of a passing charcoal barge as Torani angled forward and tapped my knee. "Too bad you can't sing the duke, Tito. Sounds like a role tailored expressly for your talents." He must not have noticed my involuntary grimace or my surly silence, because he went right on tossing concerns into the shimmering air.

Tedi Dall'Agata, our prima donna, was nearing the end of her career—could she pull off the young milkmaid? Would Giuseppe Balbi be content with Torani's promise to hold *Prometheus* over until the Easter season? We wouldn't want to lose our reliable lead violinist at this crucial juncture.

At last, as our gondola glided down the narrow ribbon of water that led to the theater's quay, Torani wondered the crucial question aloud, "If I agree to this last-minute switch, would the Savio alla Cultura even allow it?"

The boat swayed. With a gentle bump, Peppino had maneuvered us alongside the landing stones.

"The only way we'd know is to ask him, Maestro."

"Yes." Torani blew out a breath and gave me an appraising look.

"Well? What do you say?" I prodded, unable to endure his indecision for another moment. "Make up your mind for once and all. You owe me an answer!"

He steepled his hands and notched his fingertips under his chin. The ragged gash shone red on his white scalp. Peppino began grumbling under his breath.

Finally my mentor uttered the words that set twin chills of delight and apprehension battling for my backbone: "You win, my boy. Your extraordinary duke and his lady milkmaid will have their chance to capture Venice's heart. I sincerely hope that they—and you—are up to the task."

His jaws split in an uncharacteristically wide grin. "Let me fix things with Balbi—you go and have a talk with the Savio."

Ah, lucky me!

I studied my mentor's expression uneasily. I'd seen that smile before. Despite Torani's lengthy protest, the old fox was pleased. Delighted, actually.

Could it be that my cunning mentor had intended to be talked out of *Prometheus* all along? Perhaps, thanks to his vast supply of eyes and ears throughout Venice's musical world, Torani had already known about *The False Duke* and was curious to see how staunchly I would defend my new opera against his nay-saying. Hmm. Perhaps Torani had also planned for me to be the one to convince the Savio that the change in operas would be a good idea.

Chapter Three

Other cities are built on dry land—terra firma. My ancestors had made their own.

Centuries ago they faced the choice of being overrun by Visigoths or fleeing to the relative safety of offshore mud flats. In this enclosed bay of the Adriatic, they drove pinewood piles into the muck, packed them tight to resist the pull of tides, then topped the piles with beams of larch wood. From Istria they fetched dense, pale gray stone to fashion sea-proof foundations for their expanding islets. Dwellings arose, finer and more magnificent with each passing century—and bridges, stately houses of business and government, churches, all interlaced in a pageant of arches, balconies, colonnades, and emerald canals.

Having wrested a home from the sea, the Venetians set out to further subdue the waters. In oared triremes and tall-masted sailing ships, they gradually secured a monopoly of Mediterranean and Oriental trade and acquired an empire that stretched from the Levant in the east to the Alps in the west. By my time, much of that had been eaten away. The turn of trade to the rich New World across the Atlantic favored other nations, and perhaps, just perhaps, Venetians had become lazy and complacent. They'd allowed themselves to be suffocated by layers of governmental rules and regulations. Protective, yes. Also stultifying.

There were, however, a few men who embodied the vigor and courage of our ancestors. Worthy men who combined a love of

learning, a head for business, and a taste for adventure. Thank God, Signor Arcangelo Passoni, the current Savio alla Cultura, was one of these.

I first sought Passoni on the Broglio, the arcaded walk across from the Doge's Palace where Senators and their minions retired to whisper and plot during recesses of the Great Council. The wind had blown up a bit. In the Basin, a forest of masts rose and fell beneath screaming, circling gulls. Discarded gazettes and other trash skidded along the stones between the great columns dedicated to our patron saints. Under the arcade, I pushed through a crowd of Venice's foremost aristocrats, asking first one and then another about Signor Passoni.

"Not here, Signor Amato," a minor dignitary swathed in his black robe of office advised me. I was still recognized, you see—opera-besotted Venetians never forgot their heroes. The man continued, "They say Signor Passoni has a touch of catarrh. Poor old fellow. He's missing a fascinating debate on the licensing of caulk purveyors for the shipyards."

Caulk, yes. If our Savio found the subject as engrossing as I did, I suspected I'd find him at home, reading in his library with a cup of chocolate within easy reach. The Ca' Passoni lay in the Dorsodura district across the Grand Canal, and the great clock on the piazza had just struck eleven. I hastened to secure a gondola and present myself before the Savio would have roused himself for his afternoon activities.

The footman attending the Ca' Passoni's water entrance must have found my person and recently engraved card acceptable. With barely a trace of the haughtiness that servants of noble houses so often absorb from their masters, the liveried youth led me across the foyer and deep into the great palazzo.

Despite the marble floors displaying an endless pattern of varicolored squares and diamonds, and the elegant silk-damask wall panels framing gilded mirrors, the Ca' Passoni oozed a subtle shabbiness. Many of the plastered acanthus scrolls above the archways had lost a few leaves. And then there was the whiff of rotting damp emanating from a stairwell that led down to the

business floor of the house where boats had once entered the water gate with loads of spices and other fine goods. I supposed the smell signified little.

Like the society around us, Venice's famed stone foundations are crumbling. Every family, rich or poor, fights the damp.

At last the footman ushered me into the Savio's study, which turned out to be a cozy room lit by large leaded-glass windows overlooking a canal. As I'd thought, the illustrious gentleman was taking his ease without a trace of catarrh.

Signor Passoni sat in a patch of sunlight, legs stretched long and crossed at the ankles, reading an octavo volume with the aid of spectacles. He'd not yet suffered the attentions of his valet or hairdresser; silver hair streamed loose over the shoulders of a bright blue paislied robe with folds hanging softly about an untucked linen shirt and breeches that molded muscular thighs. Not a young man, the Savio, but one still full of life and energy.

He received me well, putting his book aside, half-rising from his upholstered armchair and motioning me to sit in its mate. "Tito, to what do I owe the pleasure?"

I made my bow. "Excuse the intrusion, Excellency. Maestro Torani has sent me. We have a…a proposition for you."

Signor Passoni removed his spectacles. His blue eyes crinkled with cheerful curiosity. "A proposition—delightful—just the thing to enliven a dull morning. But first—will you take chocolate? Coffee?"

I declined and took my seat. Best to get right to it. "Excellency, Maestro Torani and I would like to cancel *Prometheus* in favor of a different opera."

Signor Passoni drew himself up, mildly astonished. "At this late date?"

I nodded, summoning courage. I admit I'd come to the Savio with my ears laid back like a donkey expecting the lash. With fellow musicians, my innate confidence was undisturbed. Not so with aristocrats whose family names had been entered in Venice's Golden Book centuries before. Though my singing career—and certain more clandestine activities—had often put me in the

company of those with wealth and breeding, this magnificent palazzo reminded me that I was really only a simple *musico*, the son of an organist who'd barely kept meat on our table.

"Why, Tito?" he asked, expression still affable. "Why this change? Have you run into difficulty with one of the singers? Or have the machines proved too complex?"

"No, nothing like that." I leaned forward. "Excellency, how would you like to double the San Marco's box-office receipts?"

My words came out with too much force, more like a pistol shot than the intriguing question I'd meant to pose. My flustered gaze bounced off the shelves of leather-bound books, the glass-fronted cabinets displaying a number of model ships.

Passoni saw my distress. His slender hand made a flourish, graceful despite its knotted bones. I wondered how he slid his rings, one a heavy gold signet and the other a pyramid-shaped emerald, over those knuckles. "Please continue," he said quietly, "any increase in receipts would be a most welcome eventuality. Explain how this might be achieved."

Describing the great pleasure I took in Rocatti's score put me back in my element. I explained how opera had a strange and beautiful life of its own that must be continuously fed by the new, the novel. I predicted how completely the public would be won over by *The False Duke*—how the line at the box office would stretch around the campo.

Passoni began to nod when I stressed that an opera weighed down by antiquated ideas could never reach the stars. I was encouraged, but sensed an unstated reservation hovering behind Passoni's bland expression.

"Excellency," I asked, "perhaps you find the subject of a peasant taking on the authority of his master too freethinking?"

Passoni chuckled. "The story's political philosophy is pure nonsense—a bumpkin could never fool a duke's courtiers. And how long would a duke live in a hut before he grew sick and tired of dirt and smoke and turnips for dinner? Tell me, is this poetic composer a very young man?"

"In his twenties, I believe." Believe? I was merely guessing. In truth, I knew very little of Rocatti beyond what his music told me.

"It would take a man without much experience of the world to come up with such silliness. If a thing isn't rational, you see, it can't exist. Therefore, it's nonsense." Passoni reached for the book he'd abandoned on my arrival and held it up like a priest displaying Holy Writ. "To keep my wits sharp, I read the learned philosophers and contemplate their tenets. I'm not worried that anyone would take this opera's politics seriously. My concern is whether this particular nonsense will fill the theater's boxes and benches."

He sent me a pointed look. "That's where the rub is, eh Tito? The box office."

"I believe its profits will surpass every opera of the past few seasons." There was that "believe" again. My statement was actually more of a desperate hope.

Passoni leaned forward, elbows on knees, one hand still clutching the leather-bound volume. "I want to help your theater, I truly do. Unlike some, I can't work up any great enthusiasm for the Teatro Grimani becoming Venice's flagship opera house."

Unlike some. I gulped. So Caprioli's machinations had come this far, had they?

Passoni smiled reassuringly. "Don't worry. A few Senators are crying for an end to 'Maestro Rinaldo Torani's money pit,' but I've convinced the majority that Venice needs the Teatro San Marco. Torani can always be trusted to present operas of the highest dignity and taste—amusements we can rely on to impress our perpetual throng of foreign visitors. The Grimani is another netful of fish. It always seems to have a whiff of the risqué about it. Perhaps it's those bold young women they use as attendants...." He trailed off, shook his head and eased back. "More to the point, Torani's account books always tally. I wouldn't trust Lorenzo Caprioli an inch in that regard. He's as slimy as a rotting eel."

I nodded slowly. A lot was riding on Rocatti's opera. On *me*. I sat tall. "Do we have your permission to proceed with *The False Duke*, Excellency?"

"I don't know." Passoni shifted in his chair, toyed with his signet ring. "Won't a change send the company scrambling to be ready?"

"We can manage it."

"Hmm…what special effects does your new opera include?" With a definite sparkle, his gaze darted to the cabinet which held his models. Now I saw not all were ships. There were also intricate models of bridges and windmills. The Savio must be an engineer at heart.

The Duke, as I'd mentally shortened the title, didn't have elaborate scenic illusions written into the libretto. But if a few machines were all that stood between Passoni's yes and no…I thought quickly. "To be sure, Excellency. A fearful windstorm tears through the forest in Act Two."

"Thunder and lightning?"

I nodded enthusiastically.

"Could we have a shipwreck, too? I've always longed to see a galleon capsize down on stage."

I froze in mid-nod. The Savio's suggestion struck me speechless. Had I not just explained that the opera's setting was a mountainous duchy with rolling forests and castles clinging to steep peaks?

"Well…perhaps we could work in a flooded stream."

Passoni pulled a frown. Shook his head.

"But Excellency, the sea is miles away. The libretto has nothing to do with ships."

He pondered a moment, fingering his chin, then said brightly, "I have the perfect thing. The hero and his lady could sail away to the New World and crash on the rocky coast of—what do the English call that place?—Virginia? Yes, Virginia. That would make a magnificent finale, don't you think?"

"I…don't know." I wanted to shriek. A stunt like that could destroy the reality and humor I loved about *The Duke*.

"The wreck is no more ridiculous than the rest of the story." Passoni's gaze narrowed. "And it would mean so much to me." His mellow voice suddenly rasped like a steel point splitting satin. "I would view it as a personal favor."

No longer the dilettante lingering in his library with cups of chocolate and volumes of philosophy, the Savio showed himself as the merchant-aristocrat shrewd and clever enough to be appointed one of Venice's "wise men." Savio alla Cultura—the wise man who oversaw the regulation and licensing of the entire array of Venice's cultural activities. Not only the opera, but printing, bookbinding, play houses, news gazettes, and more.

I inhaled deeply. A hasty compromise was in order. I could only hope that the beauty of the rest of the opera would balance out this absurd plot alteration.

"Excellency," I replied with a respectful nod, "your pleasure is my command. I will see that *The False Duke* is changed to include your shipwreck—not just a run-of-the-mill illusion, mind, but the biggest and best. Our machinist—Signor Ziani—has been begging for a new challenge." And will probably kill me for promising one of this magnitude, I thought.

"Delightful." The Savio grinned. His shoulders shuddered under the silk of his dressing gown. "It will be hard to wait. I'll be on pins and needles."

"Then may I inform Maestro Torani that we have your formal permission to proceed?"

He opened his mouth, but before he could speak a word, the door opened and a young woman entered in a whirl of pink skirts and lace-frothed petticoats. She was the very picture of a Venetian beauty—a plump little sparrow with white shoulders and a barely restrained profusion of red-gold curls. She ran across the study, encircled Passoni's neck in a hug, and planted a kiss on his cheek. "Papa, no. Don't give Tito your promise about the opera just yet."

My heart sank as I rose to make my bow. Two more seconds and the Savio's approval would have been mine. Two seconds.

Passoni laughed and swung the girl around onto his lap. "Little minx. Were you listening at the door again?"

"Papa, how would I ever know anything if I didn't?" They both laughed uproariously while I remained standing, tricorne under my arm, a smile plastered over my disappointment.

The Savio introduced his daughter, Beatrice, but I already knew who she was. I'd seen her in his second-tier box at the theater, sitting at the railing beside her father while the faded Signora Passoni and her devoted *cavaliere servente* watched from the back seats. The signora was known as a woman of impeccable dignity and virtue, unfortunately weakened by intermittent bouts of ill health. The presence of her cavaliere was in perfect keeping with the practices of Venetian society. Every married woman of status had her personal Sir Galahad, a "friend of the house," who kept her company while her husband was engaged in his own amusements. How much, and in what precise manner, these companions profited by the relationship was entirely up to the woman.

But back to Beatrice. My long-distance view from the stage hadn't prepared me for the sheer sparkle of the girl. Beatrice was a fresh breeze on a muggy day. A gulp of chilled *limonata* on a parched throat.

Passoni stroked errant curls from her cheeks. "Now, my pet, tell us why I should not grant Signor Amato's request."

"I've had a letter from Cousin Amalia. She attended an opera—part of some civic celebration in Milan—that absolutely astounded her. She shivered, she wept. She swooned so completely that Uncle Ludovico had to send their footman for a vinaigrette of smelling salts."

"Your cousin is prone to faints, I think."

"Oh, Papa. Amalia wasn't the only one. Many ladies, even several of the gentlemen, fainted from sheer pleasure."

"Who wrote this opera that produced such a shocking result, Carissima?"

"Signor Sanmartini, I think, but that's not the important part."

Beatrice dug into the pocket beneath her skirts and plucked out a folded letter, its blob of red sealing wax still in place. I could make out a delicate flowing hand as she smoothed the missive on her silk covered knee.

"Listen, Papa." She read, "A young castrato imported from Naples sang the lead role. What a ravishing voice! After each aria, cheers spread through the theater like wildfire. No mortal man could sing so divinely. It was as if an angel had assumed the shape of the singer who kept us in his thrall. Thus, the Milanese have dubbed him Angeletto, though his real name is Carlo Vanini. Oh, my dear Bea, you must have your Papa call this angel to Venice so you can hear him, too."

Beatrice looked up, refolded her letter, and regarded her father expectantly.

Passoni gave his head a small shake. "But Venice already possesses excellent singers. Majorano, for one. Nothing would do but that you would have Majorano sing at the musical evening to celebrate your sixteenth name day. As I recall, *you* nearly swooned on that occasion."

A pout. "By now everyone has heard Majorano a hundred times. He's all right, I suppose…but…but it's not fair that Amalia has seen Angeletto and I haven't."

Beatrice turned toward me, beaming a smile that displayed perfectly matched dimples. Of course she would have dimples; this girl lacked for nothing.

She wiggled back around on her father's lap. "Angeletto must come to sing at the Teatro San Marco. He must sing the part of the duke who Tito thinks is so important. Please, Papa."

Passoni set the girl on her feet and regarded me with elbow on knee, chin on fist. He was all business again. "Do you know of this Angeletto, Tito?"

"Not by that name, Excellency. But if he just adopted it, I would know him by his family name. Carlo…?"

"Vanini," Beatrice supplied from behind father's chair. "From Naples."

"Carlo Vanini," I repeated blankly. The name stirred some emotion deep in my gut, but it disappeared before I could even put a name to it. Like most castrati, I'd been trained for the stage at a Naples conservatorio. I remembered no boy by the name of Vanini, but in the dozen years since I'd returned home, over a hundred students would have come and gone. I slowly shook my head. "I don't know him, Excellency. Or even how to reach him."

"Papa…" Beatrice emphasized the last syllable. It hung in the air as a challenge.

"Hush, my precious." Her father reached to squeeze her hand.

To me he said, "You must find him, Tito. With Venice prepared by accounts of Angeletto's conquest of Milan—and my magnificent shipwreck, of course—this new opera might truly double the box office takings." His eyebrows slashed downward. "Do I make myself clear? You and Maestro Torani may have your *False Duke*, but only if Angeletto heads the cast."

So there it was.

I've never enjoyed jousting with the powerful, and it was easy to see who ruled this turf. I assured the tyrant Beatrice that every effort would be made to engage Angeletto, thanked the Savio, and took a hasty leave of the sunny study.

◇◇◇

An uneasy happiness suffused my mood as I retraced my steps to the hall that ran the length of the palazzo. The opera I had chosen would progress from notes and words on paper to a fully acted and sung performance—but with unwelcome compromises. And only if I could locate the newly christened Angeletto in short time. Unfortunately, a journey of several days lay between Venice and Milan.

I was halfway down the corridor when a tall man darted out of a doorway and fell in beside me. "Did you find His Excellency amenable to your proposal, Signor Amato?"

The voice was high and lilting, a castrato's voice. I stopped and turned to face Signora Passoni's cavaliere servente. He sketched a quick bow, making me think he was anxious to conclude whatever business he had and be away. He said, "I am Franco."

"Signor Franco?" I was baffled, I admit it.

"Just Franco." His smile was gentle and wistful. "Will you answer my question? I don't ask for myself."

This "friend of the house" actually served only one person. I asked, "Does Signora Passoni share my concern for the Teatro San Marco?"

"I'll just say that my lady is most anxious to see your new opera come to fruition. She wants nothing to stand in the way of *The False Duke*. Will it come to pass?"

"I've been given leave to open the season with it."

With another smile, Franco reached for my hand and filled my palm with a small weasel-skin purse. My fingers closed around the lumpy bag.

"Wha—" I began, but he silenced me with a finger to his lips.

"For your fine work and…for incidental expenses," he whispered as we reached the main foyer. "We know we can rely on your discretion."

Then, with a flourish of his long arm, and in a louder voice, "Here you are, Signor Amato. It is easy to become lost in our maze of corridors." With that, Franco quickly disappeared through an archway that led to a dim, curtained room. As I slipped the purse in my pocket, I imagined a trail of question marks sweeping behind the castrato like a royal train.

The same young footman who had announced me appeared to see me out of the landward door. After descending a flight of marble stairs, I found myself in a short *calle*. At any other time of day, the alley would have been deeply shadowed. But the sun had climbed over the surrounding buildings, and the alley's inhabitants had come out to greet it. Glossy ivy formed a green backdrop for housewives talking themselves hot and hoarse while they watched children at play. A girl rocked a tattered cloth doll in her apron. A boy kicked a leather ball.

Despite the noon warmth, I was determined to walk back to the theater, both to avoid a paunch like the Teatro Grimani's lead castrato, and to have a good think. My brain was in a whirl. It seemed that poor Balbi and his *Prometheus* had been doomed

from the moment Rocatti had placed his aria from *The False Duke* in my hands. Three people at the Ca'Passoni were surprisingly excited about this new opera, all for different reasons. The Savio craved his shipwreck, Beatrice her Angeletto, and the signora her...*what?* Sweating profusely, I loosened my cravat as I headed for the nearest *traghetto* stop to board a ferry.

The air was cooler on the other side of the canal. Or perhaps putting some distance between myself and the polite stratagems of the Ca'Passoni only made it seem so. I was passing under the scraggly trees of the Campo San Samuele, pumping my legs and breathing fresh air, when my head cleared. Unbidden scraps of loose talk and backstage gossip popped into my mind.

I realized that I had heard of Carlo Vanini before Beatrice mentioned his name.

Secrets whispered in dressing rooms, then denied. A man's knowing, ribald laughter. Gales of giggles from a pair of female sopranos. But what had the talk been about?

The small campo darkened for a moment as an errant cloud obscured the sun. I stopped so suddenly, a bearded Turk with white linen wound around his head crashed into me. I was oblivious to his Arab curses and the flapping of rising pigeons.

I had it now. I'd remembered. How could I have forgotten?

Carlo Vanini, so the rumor went anyway, was no eunuch. Carlo was not an emasculated he, but a daring, cunning, masquerading *she*.

Chapter Four

And so, thanks to Signorina Beatrice's passion to hear the latest castrato sensation, my companions and I were bouncing along the road to Milan in search of an angel of undetermined gender.

It was impossible, of course, that Carlo Vanini was a girl. I knew that. At the Conservatorio San Remo, I'd lived in an austere dorm with ten or twelve other boys. Rather like orphaned children—destined never to produce any of our own—we lived under strict supervision for the sake of our artistic and moral development.

A lay brother would awaken us before dawn by beating on a copper pan. Under his gimlet gaze, we would sing a Laudate—a prayer—while we washed, dressed, and made our beds. Then it was Mass, a hunk of bread, and voice or composition lessons until we went, starving, to a silent dinner at the stroke of noon. If the weather was fine, as, thank the Virgin, it usually was, we went for a walk two-by-two in our black and yellow uniforms. The rest of the afternoon and evening was filled with more lessons, practice sessions, and rehearsals until our second meal at seven in the evening. After some rough-housing and a few games, we were sent to bed, a dozen boys in two facing rows of narrow cots. There was simply no way a female child could have progressed through this system without being found out.

But what if Carlo Vanini had received private instruction? The grandmother of one of my early colleagues at the Teatro San Marco had donated her vineyard's profits toward his surgery and

subsequent training. While I'd been tricked into undergoing the knife, this boy had been so enamored with music that he'd actually begged to be made a eunuch. He hadn't been subjected to the extended scrutiny of the conservatorio. Still any competent teacher with eyes in his head…

"What is your opinion, Tito?" Gussie's words snapped me back to our private carriage speeding toward Lombardy. The look in my brother-in-law's inquiring blue eyes turned to mock accusation. "You're off on another jaunt in your head. You haven't even been listening."

"Not a bit," I admitted, resolving to be more companionable with my fellow travelers. "But I'll bet you're debating Angeletto's sex—that's the question of the hour."

Gussie chuckled and Benito asked, in his high, fluting tones, "Did Angeletto ever sing in Rome?"

"I don't know." I guessed where my manservant's question was leading but, after another glance at the passing vegetation framed by the carriage window, I decided it would be more amusing to play dumb. We had hours to fill before our next stop. "Why do you ask?"

Benito was a small man, as delicate as a sparrow, unlike most of my fellow castrati who grow decidedly tall. Across the small space that separated the carriage seats, he hunched his narrow shoulders and caved his chest like a man who'd just taken a blow.

He said, "I was describing the dreaded examination to Signor Rumbolt."

"Is this true, Tito?" Beside me, Gussie had been lounging into the carriage's rounded corner with one foot on the opposite seat and tricorne on his bent knee. Now he stiffened, and his usual frank, good-humored expression turned to an incredulous frown. "Do the castrati who sing in Rome really have to undergo a priest's intimate probing and prodding?"

"Benito is correct. A papal ban on women appearing on the stage anywhere within the Pope's political realm has been in effect, off and on, for decades. The churchmen take the matter quite seriously."

"Men play all the roles?" Gussie scratched the yellow haystack barely tamed by a black ribbon at the nape of his neck. "I can scarcely credit it."

I wasn't surprised at his disbelief. My English brother-in-law had ditched his Grand Tour before it had reached Rome, and it was odd, if you stopped to think about it. I explained, "In plays, natural male actors make tolerable stand-ins for leading ladies—if they've mastered the feminine walk and gestures. But where opera is concerned, only a castrato can match the true sweetness of a female soprano voice. Many of them carry on with the disguise outside the theater. On Roman streets, in cafés and taverns, I've seen singers who could fool their own mothers, so round in the hips and bosom, so tender and girlish their looks."

"I still don't understand why the Pope insists on such a topsy-turvy masquerade."

"Oh, well…" I waved a hand in a rolling circle. "The church fathers consider a woman exhibiting herself in public as altogether too dangerous and decadent to be allowed, you see."

"They have a proverb in Rome," Benito chirped up. "A beautiful woman who sings on stage and keeps her chastity is like a man who leaps into the Tiber and keeps his feet dry. Wasn't there some similar practice in your country?"

"Well," Gussie harrumphed awkwardly, "back in Shakespeare's time, I suppose there was. But that was a long time ago. England has moved into a more enlightened age—it's 1745, after all."

Benito snorted. "Rome is always a century behind. Perhaps several."

"Did you sing in Rome?" Gussie asked of my manservant.

Benito tossed his head proudly. "I sang *secunda* donna at the Teatro Argentina for two years."

Gussie gulped audibly. "You submitted to the…examination?"

"It was a requirement of my employment. Before the director would sign my contract, I had to drop my breeches and let an old priest satisfy his eyes. And hands." Benito grinned at Gussie's obvious distaste, then added. "It wasn't so bad, really. It's just

that his sight was poor and he insisted on holding a candle so very close."

"By Jove!" Gussie slapped his knee and jerked his head toward me like a mullet on a line, "Tito, you never...?"

I shook my head. I was deeply grateful that my Italian performances had been restricted to Naples and Venice, two cities that reveled in their theatrical women and were as likely to give them up as they were to forego their daily bread. Thoroughly schooled in playing the hero, I wouldn't have known how to begin to depict the heroine.

"Well, then," Gussie settled back against the worn leather upholstery, "if we can determine that Angeletto sang in a Roman opera house, that should settle the question of his manhood."

"No." I sighed. "Not with absolute certainty."

"What? Why?"

I removed my tricorne and fanned my face. The day had turned warm and humid. A haze hung over the distant green hills. "Gussie, in our world of illusion, you can never be sure of anything. I've played characters with outsized ears, and with noses as large as a cormorant's bill. Remember the time I was supposed to be an Egyptian ibis-headed god. Quite realistic, didn't you think?"

"Yes. But I was watching from the second tier and you were down on the stage."

"It's all a matter of scale." That was Benito again. On creating illusion, he could speak with authority. Besides dressing me for the day, Benito had also transformed me into my opera roles.

"You must exaggerate for the stage," Benito continued, "in whatever attribute is called for. But if I were intent on fooling the Pope's examiner, I'd strive to create a lifelike effect. Wax is a wonderfully adaptable medium for any appendage. Some people use bayberry, but I prefer beeswax mixed with powdered pigment to create a flesh tone." He nodded wisely, raising a forefinger. "First I'd pour the melted wax into a mold of the proper size. Finding a model for the size I wanted, now that would be the fun—"

"You needn't spell it out." Gussie held up a large hand. "I understand. Sometimes I'm glad I'm a simple painter with only my own daubs to worry about."

Hardly a simple painter, this transplant from English soil. Gussie's keen eyes were adept at capturing his subject's inner essence on canvas. Surely my artist brother-in-law would be able to discern Angeletto's gender, even if the singer possessed a servant as skilled in theatrical artifice as my Benito. Thus, I expected both of my companions' talents to prove valuable in Milan.

Maestro Torani had dismissed the rumors questioning Angeletto's God-given identity as pure nonsense. When I'd returned from the Ca'Passoni, the maestro had been more concerned about the Savio's insistence on creating a spectacular storm and shipwreck than about my hiring Angeletto. Time was short, with only a few weeks to go until the barely controlled hysteria of *provo* rehearsals and opening night. With official approval in hand, Torani had immediately canceled rehearsals for *Prometheus*, sent *The Duke's* score to the copyist, and put our machinist and scenic artists to work on the new illusions.

To me, he gave a generous allowance of gold *zecchini* and several letters of introduction to his musical acquaintances in Milan. I was heartened by his obvious confidence, but even so, I had no desire to engage a singer whose artistry was based on a lie.

My mission was to revitalize the Teatro San Marco, not bury it in disgrace.

◇◇◇

Our party reached Milan on the first Friday in September and entered the walled city by the Porta Renza. A customs officer halted the carriage for the usual inquiries, but a zecchino persuaded him to pass us and our baggage through the ancient gate without needless delay. It was afternoon, the sun still peeking from behind a mantle of clouds which held the promise of a cooling rainstorm, and yet the city seemed dark and close within its walls. The smell of ripe fields and rich country dirt gave way to the pervasive stench of the city. As we navigated Milan's narrow streets and cramped squares, strangers met our

gazes through the carriage windows, tight-lipped and unsmiling. The city's new Austrian overlords seemed to have brought suspicion and hostility with them. I wasn't sorry when we came to the cul-de-sac near the old Castello that contained the house of Signor Leone, Maestro Torani's longtime friend.

Leone answered the bell surrounded by five children, as alike as eggs, with huge brown eyes and wrists poking out of their shirtsleeves. After scanning Torani's letter of introduction, he welcomed the three of us into his home. His wife, a sloop-shouldered, sad-eyed woman with messy hair, made a place for Benito in the kitchen boy's cubby hole. Leone himself installed Gussie and me in a small room on the second floor. Not without apologies.

Though we were delighted to be spared another night at an inn where the sheets were suspect and the food worse, Signor Leone wrung his hands over the thin mattress, the frayed coverlet, the cheap candles. "You deserve wax, my friends, but alas, my household must make do with tallow." For dinner, Signora Leone served a thin cabbage soup, bread, and dried cod. Proudly, no apologies from her. Before we returned to Venice, I resolved to leave a liberal sum in her apron pocket.

Hours later, as Gussie and I made the best of the thin mattress, trying to ignore the rain dripping from a broken gutter and the neighboring church bells tolling the interminable hours, my thoughts turned homeward to Liya.

My wife had also been delighted with Gussie's offer to accompany me to Milan. That beautiful pagan never let me set out on a journey without consulting her scrying crystal or the well-worn cards she kept in a sandalwood box. While most people played a pleasant game of *tarocchi* with the pasteboard rectangles that featured fools, demons, stars, and skeletons, Liya used the cards for a more serious purpose—divination. The night before I set off, she spread her cards on our bed's blood-red counterpane. With her raven hair rippling down her back, she arranged them again and again, faster and faster, in ever more complicated patterns.

Liya had seen something in the cards that worried her—something she was either unwilling or unable to explain. All she could offer was a general caution to take special care and avoid risk.

Though I took Liya's oracles with a grain of salt, I liked to set her mind at rest when I could. I'd promised that Gussie and I would both be on the alert. With a youth spent tromping over his father's Northamptonshire estate and galloping horses over field and stream, Gussie was noticeably hardier than either Benito or myself. I admit I also felt more confident with Gussie's strong right arm at the ready, whether the misfortune Liya divined turned out to be pistol-toting brigands or a slipped carriage axle.

Gussie and I woke to a fair morning. The rain had washed the skies to a clear, unbounded blue and ushered in the first hint of autumn coolness. Signor Leone, now acquainted with our mission, conducted Gussie and me around the meeting places of Milan's musical society. Leone was a horn player with no opera-house connections, but he was certain that we would eventually run across news of Angeletto if the singer had remained in town after the performance that Beatrice's cousin had described.

We had our first spot of luck at a café spilling out of its dim interior onto a pavement shaded by red-striped awnings. As we sampled saffron-laden risotto served with unfamiliar sausages, I caught snatches of conversation from other tables. Apparently, a public concert was to be held that evening at the residence of Count Firmian, the Austrian governor of Lombardy.

"—our best chance to hear the musico who's been causing such a sensation."

"Angeletto, you mean?"

"Yes, naturally. Who else has captured the public's attention so thoroughly?"

"Angeletto does sing well. But still," the original speaker heaved a deep chuckle, "you always feel there's something missing!" Laughter rumbled from table to table.

"Missing his chestnuts or not, the women love him."

"My wife will insist on going."

"My daughter, also. Are any tickets to be had?"

Though the three of us dawdled long over the good local wine, wagging chins with Leone's acquaintances, I heard nothing against Angeletto besides more of the inevitable *evirato* jokes that are always heard in male company. No other innuendo. No real disapproval beyond the fact that the singer was a southerner— Milanese pride was nearly as rampant as Venetian.

Later that evening, when Gussie, Benito, and I arrived at the Count's theater at the appointed hour, the only available tickets merely gained admission to stand at the rear of the small auditorium bounded by two tiers of scarlet-draped boxes. More gold coins changed hands before three chairs were added at the end of the first row on the floor—no rough benches for Count Firmian's patrons. My purse was rapidly growing lighter, but the expense was justified. I needed a good view, and the theater was soon so packed that a king's ransom couldn't have bought admittance of any sort.

I waited restlessly, between Gussie and Benito, as a dozen or so orchestra musicians took their places on the stage framed by a gilded proscenium arch. The string musicians began tuning their instruments along with the harpsichord, and presently, a person who could only be Angeletto appeared at the edge of the tightly folded velvet curtain.

At last, the object of my quest stood before me, in full view, like a butterfly under a naturalist's magnifying glass. I narrowed my focus into one gimlet beam, barely breathing.

The singer had come by his stage name honestly. He was the perfect picture of the sort of angel often portrayed in religious paintings, an anomalous being too delicately beautiful to be masculine, too sleekly powerful to be feminine. Anyone who knows the painting of Tobias and the Angel that hangs in the Church of the Madonna dell'Orto will take my meaning precisely. But, I reminded myself with a sigh, Angeletto wasn't a heavenly creature. He was entirely human, either a male eunuch or a young woman in disguise, and I must decide which.

Angeletto moved to take his place beside the harpsichord. His carriage was stately and proud, as if he owned the stage, or

perhaps the entire theater. He was dressed in full formal regalia, face whitened and rouged, starch-white wig curled in front and tied with a black satin bow behind. A patch decorated his right cheekbone—a sign of passion for those who indulge in the language of fashion. Lovely, yes, those bowed lips, delicately arched nose, and rounded chin that nestled in his lace-trimmed cravat. But were they female? Not necessarily.

Besides preserving our soprano voices, the cutting often bestowed other characteristics: tall height, lustrous hair that never went bald, peach-like skin, and a certain refinement in bone structure. It was all rather unpredictable—just as a few unfortunates ended up sounding like croaking frogs at the time when their voices would have naturally broken.

I lowered my gaze from Angeletto's face to the figure covered by a suit of plum-colored taffeta trimmed in gold lace. I detected an unmistakable fullness of bosom—also not unusual in a castrato. The hours of daily vocalizing during boyhood, when the bones were still flexible, expanded our chest cavities to a noticeable degree.

Surprisingly bewildered, I decided to reserve judgment and concentrate on Angeletto's singing.

His first selection was a popular aria by Jomelli that I'd also performed in years gone by. It demanded a voice as light and agile as a dancer's physique, and Angeletto didn't disappoint. He wove a spell of magic around the first deceptively simple melody, the slower second section, and on through the embellished repeat. Magic, I say, because Angeletto's flashes of brilliance deafened the audience to his mistakes and imperfections. Not many, too be sure, but naturally I was able to detect them. I found myself planning strategies to help him correct them.

More operatic arias and concert songs followed. After each, the finely dressed Milanese supplied a terrific noise and clapping of hands, then fell eerily silent as their hero opened his mouth to begin again. The sheer stamina of Angeletto's voice continued to astonish me. He could hold a heartrending, swelling note for what seemed like minutes, without any sign of strain or exhaustion.

If only I could tempt Angeletto into singing *The False Duke*, Caprioli's schemes for the Teatro Grimani would come to nothing. Venice would be wild for him, and the San Marco's seats would be full again. Maestro Torani's worries would melt like an early spring snowfall—how I longed to see the fine old man relieved of his burdens.

With quickening hope, I tore my gaze from the stage to measure my companions' response.

Gussie was impressed. His blue eyes were as round as saucers. His cheeks were flushed, his lips parted in apparent admiration.

I whipped my head around.

Benito's face was a total blank, and he refused to meet my eye.

At the end of the concert, as the rapid thunder of applause accosted my ears and flowers rained down on the stage, I sealed my conviction that Angeletto was a valid castrato. A woman could never deliver a song with the power Angeletto possessed. After all, that was why the peculiar practice of castrating boy sopranos had gone on for so many years—the preservation of the delicate larynx combined with the astounding size and power of a man's lungs created a voice that defied earthly laws.

Angels, indeed.

With Gussie and Benito in tow, taking my time to let Angeletto's well-wishers offer their tributes and clear out, I pushed through the chattering, excited crowd. I shushed Gussie so I could listen to the talk, but I heard no whispers of anything as it shouldn't be. At last I located the pass door and again plumbed the depths of my purse for more coins to gain entrance to the dressing-room corridor.

A well-dressed woman was just slinking out of a door; she hid her face with her lace shawl as we passed. Now the corridor was deserted.

So certain was my conviction of Angeletto's masculinity that Gussie's first words sent me reeling. He said, "A shame about your *Duke*, Tito. It would have been a deuce more entertaining than the usual fare."

I felt my breath catch. "What do you mean, 'would have been'?"

"Well, you said you wouldn't hire Angeletto if the rumors are true, and if Signorina Beatrice doesn't have her Angeletto, the Savio won't allow *The False Duke* to proceed." Gussie regarded me sympathetically. "Isn't that right?"

I'd raised my hand to pound on Angeletto's door, actually placed my palm on the paneled wood. Now I let my arm fall, unable to believe what I was hearing. "But I need Angeletto. I must hire him to come to Venice and save the opera house."

"Oh, Tito, you're joking. Anyone could see that Angeletto is a woman, even dressed and coiffed as a man. An irresistible beauty, in fact."

"Gussie, no." I took a hard gulp. "It's an illusion. Castrati who sing female roles are drilled in this art. I thought you of all people would see through to the man beneath."

"What I saw was a woman revealing herself in a hundred little ways. Didn't you catch those melting glances, the perfection of face and figure?"

I stood quietly stunned. Then I recognized the dreamy look in Gussie's eyes for what it was. "You fancy him," I said accusingly.

"Her, Tito. *Her.*" Gussie jutted a belligerent chin. "Angeletto has to be a woman."

"Has to be? Why?"

"Because…" Gussie shot me a disgusted look. A blush crept up his neck. "Well, hang it all…because I've never in my life been attracted to a man."

Benito had been listening attentively, his birdlike gaze shifting between my face and Gussie's. Grasping his shoulder, I asked fiercely, "What do you think?"

For once my manservant refused to state an opinion. His eyes clouded, and he answered as if behind an invisible veil, "I think the matter requires further study."

How absurd. How frustrating. Apparently, Gussie and I each imagined Angeletto to be of the sex we wanted him to be. And Benito's famed candor had deserted him.

Thoroughly annoyed, my mind in a tumult, I knocked on Angeletto's dressing room door.

Chapter Five

"*Avanti,*" a woman's voice shrieked.

We entered to find an antechamber occupied by a hard-eyed woman tending the wig Angeletto had worn for the concert. I put her age at fifty or more. Small hands, as mottled as a quail's egg, gathered a curl here, snipped an errant lock there. Her flat bosom was encased in a black bodice that had faded to a dusty gray; her white apron was frayed at the hem and none too clean. With one last decisive snip of her scissors, she raised her gaze from the wig stand and pursed her lips.

"Signora Vanini?" I inquired, making my bow. Somewhat pompously, I admit, for I was brimming over with the gravity of my mission.

She nodded and flicked her scissors' sharp tips at a credenza heaped with flowers and other small tributes. "If you have a present for my son, put it over there. Thank San Gennaro you didn't come packing flowers." She slipped a felt bag over the wig and continued in an irritated tone, "What am I supposed to do with flowers, I ask you? Can't sell them, can't eat them."

In the woman's chopped syllables, I recognized the rude dialect of backstreet Naples. I also recognized something else: her carbuncle eyes glinted with the look of a peasant calculating what use she might make of the three fools Fortune had delivered to her door.

I bristled. Taken for a fawning dolt when I'd traveled all the way to Milan to make a generous offer!

Gussie spoke up hurriedly, "This is Signor Tito Amato—from the Teatro San Marco in Venice."

"Eh? An opera house?" She rubbed her hands, then hastily crossed them over her apron. Her wrinkled lips smoothed into an ingratiating smile.

"Venice's foremost opera house," I answered solemnly.

"You liked my Carlo's singing, Signore? You think you could use him?"

Signora Vanini certainly wasted no time on going to the heart of the matter. Perhaps negotiations would prove easier than I'd first expected.

"Carlo!" she shrieked.

A rear door opened. Six young women of varying ages spilled though it, all dressed similar to Signora Vanini in shades of brown and gray, all pretty in a modest way. Angeletto followed, wrapped in a trailing banyan of brilliant blue. A soft, turban-like cap of the same hue had replaced the periwig. Now I saw that his own hair fell to his shoulders in chestnut brown ringlets, here and there tinged with gold. I was eager to get a look at his neck—the prominence of his larynx could be revealing—but a length of tightly wrapped toweling prevented me.

Waving her apron and squawking commands, Signora Vanini set the girls to gathering discarded ribbons and buckles, folding garments, and clearing away flowers. They fluttered around the edges of the room like a flock of sparrows. Carlo—Angeletto—was the peacock in their midst.

As I made our introductions, the singer smiled languidly. One hand rested on the toweling at his neck.

"It is a pleasure to know you, Signori," he whispered. His luminous gaze swept over the three of us, then settled on me. "You are the man who was staring at me before the concert."

"For good reason. I was very anxious to hear you sing. Your voice came highly recommended."

"I hope you weren't disappointed."

"You were magnificent," I said simply.

He acknowledged my compliment with a silent bow. From the sidelines, his mother's ears were practically flapping under her frilled cap. The girls nodded in unison.

I asked, "Where did you study, Signore?"

Angeletto hesitated and his crone of a mother jumped in. "With Belcredi." Not a shriek this time. More of a cackle. "The famous singing teacher, Belcredi, was my son's first and last master."

I gave her a nod. "I met Belcredi when I studied at the Conservatorio San Remo. He had a reputation as a hard taskmaster."

"That's as may be." She squeezed one beady eye shut. "But I'll tell you this—Belcredi was our miracle—our instrument of God."

Angeletto finally got his word in: "I could not have been better treated if I were his own son. Maestro Belcredi found me in a church choir where the priest had given me the rudiments of a musical education. He took me away that very day. I was ten years old, and he stood me up on the back of a cart and made me sing all the hymns and songs I'd ever learned. Maestro said I had a perfect ear and perfect larynx. If I would submit to the operation and to his training, I could someday sing on stages and in courts throughout Europe."

"Your father—he allowed this?"

"Our father was dead, Signore. I'd become the man of the family, and I decided. I submitted to the knife and studied hard. I never shirked my exercises. Meanwhile, Maestro Belcredi gave my mother work as his housekeeper and provided lodging for all of us. He promised to use his influence to secure a place for me at one of the great courts— Vienna or Dresden— but before that could happen…" Angeletto trailed off with a wistful shrug.

"Belcredi died in a cholera epidemic," I supplied, having had the news from one of my Neapolitan friends nearly a year ago.

The singer nodded.

Gussie stirred, and we exchanged a telling look. If the Vanini family was concealing a secret, how convenient that Angeletto's teacher was beyond the reach of questions.

"Our continuing tears pay him homage," Angeletto said quietly, fingering the sash of his banyan. Several of the girls nodded sadly. One sniffed loudly until shushed by Signora Vanini.

Then Benito cleared his throat. Loudly. I took the cue.

"Have you sung in Rome?" I asked Angeletto.

"One season. At the Teatro Argentina."

"In a female role?"

He nodded. "Maestro Belcredi came to believe that singing the prima donna would make my career."

For an instant I felt vindicated—Angeletto had passed the dreaded examination!—then I remembered Benito's account of how to fashion a wax phallus. Nothing was certain. And yet, I just couldn't convince myself that Angeletto was a woman in the clothing of a man. I truly believed that this singer could be our savior—if he wanted to be.

The room felt hot, close, and crowded, and I was suddenly aware that everyone in it was staring at me, waiting for me to state the purpose of our visit. Gussie's eyes were soft and wide with concern; Benito's narrowed. In warning? Was my manservant sending me a silent message?

And Angeletto—though the beautifully molded planes of his face were as placid as a distant mountain slope, I sensed that he was brimming with anticipation.

It was time to throw the dice and see where they landed. On a deep breath, I made one last search of my heart and found no wavering there.

"Signor Vanini," I said, "I would like to engage you as primo uomo for the autumn season at the Teatro San Marco."

Angeletto's glorious smile told me all I needed to know, but he evaded discussing financial matters or making a commitment—in the most gracious manner possible. Whoever had taught him his diction and manners clearly wasn't his unsophisticated mother. Presently, he put a hand to his forehead and murmured, "Forgive me, Signor Amato. I am very tired. You must take the details of business up with my manager."

I bowed.

He bowed.

Signora Vanini yelled for reinforcements.

◇◇◇

Maria Luisa Vanini was clearly not a young woman born to tending hearth and home. I'd seen that the moment she'd passed through the inner door. It wasn't the luxuriant brown hair tortured into a severe knot. Or the upper lip troubled by the dark down often observed in women of southern climes. Not even the pair of old man's steel spectacles that sat on the bridge of her gracelessly arched nose. No, it was a particular amalgam of carriage and expression that I knew so well from my years with Liya.

Hardheaded, practical, resourceful.

Those words defined my wife and the qualities that had carried her through a painful break with her Hebrew family after a forbidden romance and an out-of-wedlock child with a long-departed Christian scoundrel. Hardheadedness, particularly, sustained Liya through the self-imposed exile in Monteborgo, the mountain village that clung to the old ways and the ancient gods. I supposed all of those qualities sustained her still. It couldn't be easy for Liya, living in an unsanctioned marriage with me. The once celebrated Tito Amato. Now a voiceless castrato whose fame and fortune were dwindling away—and whose amorous fervor would never match that of normal men no matter what virilizing potions his skillful wife concocted.

"Your terms—what are they?" Maria Luisa's matter-of-fact tones stopped my musings in their tracks.

We were alone. The younger girls and their mother had followed Angeletto through the inner door like muddy water swirling down a street drain in the wake of a bright wisp of carnival refuse. Maria Luisa had ordered Gussie and Benito into the corridor.

"Signorina Vanini," I tightened my back muscles, straightened my shoulders, "the Teatro San Marco offers three thousand silver ducats for the three months of the autumn season and necessary rehearsals."

"It's not enough, Signore. My brother supports a large family."

"Is it necessary that the full complement of sisters accompany him to Venice? How many of you are there, anyway?"

"We are eight. Four sisters and a pair of orphaned cousins—then our mother and myself. Carlo requires our presence."

"Requires? For what purpose?"

"To ensure his tranquility. If my brother is to sing at his best, he must have adequate rest and well-ordered surroundings. As his family, we are bound to protect him from disquiet and any ignoble sentiment that might disturb his artistic nature."

Blessed Virgin! A pang of resentment coursed through my gut as I recalled the appalling conditions I'd performed under when my career was just beginning. Drafty dressing rooms, macaroni for dinner day after day, unwashed costumes that stank of sweat and crawled with lice. But Angeletto—*he* required tranquility. Who did this hothouse blossom think he was? The great Farinelli?

Much as I would've loved to march straight out of the door, loyalty to the Teatro San Marco kept me rooted to the spot. You must strike a bargain with this sensitive angel's sister-manager to win the war with Lorenzo Caprioli, I admonished myself.

"In addition to your brother's fee,' I said. "I'm also authorized to offer lodging appropriate for a gentleman and his entourage for the run of the contract." Before I'd set off for Milan, Signor Passoni had expressly ordered me to invite Angeletto—undoubtedly at the tyrant Beatrice's behest—to stay at the Ca'Passoni. The Savio wouldn't be expecting such an invasion of Vanini sisters and cousins, but he would be gracious. That was the sort of man he was, and, after all, the Ca'Passoni was a roomy mansion.

I ladled on the honey: "You will be the guests of a high-ranking Venetian aristocrat."

Maria Luisa dipped her chin and sent me a cool look over her spectacles. "That is only as it should be. You will have to do better on the cash settlement, with at least ten percent due on signing. We have…immediate expenses."

"Travel?"

"Among other things."

All right. I was willing to give a little, but I made my tone firm and resolute. There would be no further offers. "Three thousand and five hundred, Signorina."

"Four thousand. You said yourself that Carlo's voice is magnificent."

Ah, Maria Luisa had overheard my conversation with her brother. Did all young woman make a habit of listening at doors these days? At least it told me that this one was sly in addition to calculating and clever.

I shook my head. "While I acknowledge that your brother is an exceptional performer, the Teatro San Marco has many demands on its accounts. You have our final offer. If we cannot engage Angeletto, there are other singers who will fit the role."

"How many of them are riding a tide of public acclaim as high as Carlo's? Four thousand is not too much to ask for a voice that will astound Venice as completely as it has Milan." She smiled, along with a modest flutter of eyelashes. Another woman could have made the gesture flattering, even seductive. Not Maria Luisa Vanini. Coquetry didn't suit her one whit.

When I failed to respond, she said, grumpily. "Very well. I'll agree to your terms—if Carlo is allowed to give private concerts in his leisure time and to retain his full compensation for doing so."

"I have no objection as long as he remains in good voice for performances."

"Understand this, Signor Amato—" She stabbed the air with a forefinger. "Carlo will sing no more than six full-length performances per week—I won't have his throat worn down from overuse."

Ah, Carlo, the delicate flower. Raising an eyebrow, I replied smoothly, "I wouldn't dream of overtaxing him."

She adjusted her spectacles, then nodded slowly. "When do you propose to begin preparation for the opera?"

Yesterday, I thought, given that the Teatro Grimani had been rehearsing *Venus and Adonis* for well over a week. But I said, "As

soon as possible. Perhaps you would allow me to make travel arrangements?"

"I'll see to it," Maria Luisa snapped.

Ouch! I inclined my head. "As you wish, Signorina."

Maria Luisa fetched pen, ink, and paper. Like a man of business, this unusual girl kept a traveling desk at the ready. This she set up on the credenza which the younger girls had cleared of flowers, and within a quarter hour, she'd written out two copies of a contract in a rapid but precise clerical hand.

She handed me the quill. A flush had come to her cheeks, a candid, sweet smile to her lips. At that moment, Maria Luisa looked almost pretty. Unfortunately, not as pretty as her brother.

I returned the smile and signed the documents, silently congratulating myself that my grand scheme for the opera house was coming together at last.

◇◇◇

Whenever I traveled, it was always the small elements of home that I craved. The next afternoon, as the carriage's rhythmic rocking and an inn's roast pork dinner conspired to lull Gussie and Benito to sleep, various scenes popped into my mind. Our dining table set with my mother's blue and white plates, the ones that seemed to hide a cryptic tale in their Oriental scenes. My adopted son Titolino's toy soldiers arrayed in mock battle in a sunny corner of the sitting room floor. The potted palm my sailor brother Alessandro had carried back from the Levant as a tender green shoot. Most of all, I looked forward to the scent of Liya's orange-blossom eau de cologne in the parts of the house she frequented. And the special way she had of hugging me as I came and went. She liked to pass her arms under my jacket, press herself against me, and brush her fingertips along the small of my back.

Another day passed, and at long last, our carriage reached Mestre, the mainland port across the lagoon from Venice. Though the sun had dipped behind the low hills and the dockmen were straggling towards tavern or home, we managed to locate a boat with two oars and two sails whose owner agreed to

ferry us across. After an hour fighting the uncooperative tide, we landed at the San Girolamo quay at the tip of the Cannaregio.

Night had fallen with a vengeance—moonless, heavily misted, without form or shape except for the globes of light surrounding the landing lamps. Benito roused a porter to unload our luggage, and soon Gussie had set off down the fog-blanketed canal in a gondola with a lanterns hung at prow and stern.

My house was closer. I walked along the pavement by the canal, careful to keep within arm's length of the hushed houses that sheltered Venice's more modest citizens: artisans, shopkeepers, clerks, and fishermen. Most houses were dark—their inhabitants rose early—but a few still showed ladders of lamplight filtering through their shutters. Benito and the porter with his cart followed behind me, the noise of its trundling wheels muffled by the fog.

Blind to my usual landmarks, I came upon the familiar door before I expected it.

Chilly fingers of mist brushed my cheeks as I stepped back to survey my home's fuzzed outlines. I'd bought the three-story stucco house with the iron balconies and enclosed garden when my boyhood home on the Campo di Polli had become too small for my growing family—back when I was paid twice what I'd offered Angeletto. Though we were comfortable here, I knew that many needed repairs were hiding under the blanket of fog, waiting for better times. These days my property was considerably grander than my purse.

But I was home! Putting money worries aside, I hastened to unlock the door. Warmth enveloped me the moment I crossed the threshold into the tiled foyer. I took a moment to breath it in. Behind me, Benito shifted our bags, paid the porter, then softly closed and latched the door. I tossed him my hat and stepped into the archway that led to the sitting room.

Liya sat at the table in a canopy of light from a branching candelabrum. The rest of the room was as dark as pitch. The olive skin of her smooth cheeks and forehead shone in the candles' golden glow, as did the unbound black tresses covering

her shoulders like a shawl. My wife had spread her cards out before her in the pattern of a Greek cross, but they lay forgotten.

Liya had fallen asleep. Her generous lips were parted, and one cheek rested on a propped up hand. It didn't surprise me that I'd caught her drowsing. Before I'd left for Milan, I'd noticed a certain listlessness in Liya's manner and smudges of sleeplessness beneath her eyes. Was it the continuing tensions with her Ghetto family that bothered her? Or perhaps something she'd seen in the cards that she was keeping to herself?

I cleared my throat. Liya's eyelids flew open, and she ran to me with her hair streaming behind. For a moment we bubbled with laughter, questions, and overlapping replies. Then we fell silent, entwined in each other's arms. Now I was really home, my nose filled with the scent of orange blossoms from her skin and hair.

Benito hovered in the foyer. He knew my moods well enough to realize that someone else would be undressing me that night, but his years in service had accustomed him to ask, "Will you require me, Master?"

There was only one thing I required.

I dismissed Benito to his bed, and Liya and I went happily to ours.

Chapter Six

The next morning, after a hasty breakfast of bread and fruit, I set off for the Teatro San Marco on my own. The sky above was an even gray, as opalescent as the inside of an oyster shell, and the air was as moist as could be without actually raining.

Once at the theater, I shook my damp cloak in the deserted lobby and pushed through the swinging double door padded with crimson velvet. Within the cavernous, horseshoe-shaped auditorium, five tiers of boxes rose into gloom. On the sloping floor, the empty gondoliers' benches sketched a murky herringbone pattern. Down front, on the distant stage, the glow from footlights and wing lights illuminated two figures against a familiar backdrop: a landscape of wooded, rocky hills that seemed to disappear into a cerulean sky streaming with clouds so fluffy they'd put Heaven to shame.

Despite the pastoral scene, I sensed a roiling unease in my theatrical home, as if those snow-white clouds concealed a rumble of distant thunder. Once I'd reached the stage, I understood why. Giuseppe Balbi, our violinist turned composer, was knee-deep in argument with the singer Majorano. Balbi was actually shaking his instrument as if he meant to use it as a club.

The violinist was a smallish man, with a doughy, rounded face that usually displayed an affable expression, and slender, delicately boned hands that could mark the orchestra's time signatures with inspiring flourishes. I was surprised to find him in such a rage.

Balbi yelled at Majorano, "What in the seventh circle of Hell is wrong with you? When did you become such a prize ass?"

The singer was staring daggers at Balbi, lips clamped together, arms stiff at his sides. Then Majorano caught sight of me and burst out, "Tito, Signor Balbi insists that I act like a bumpkin. A clod!"

"No, no...like this." Balbi whipped his fiddle under his chin and played a few bars of the huntsman's showpiece aria from *The Duke*. "There, that is how it's done. You are not a clod," Balbi retorted, "but you must attack the tune with a jaunty flair. You must give a sense of the absurd idea that a huntsman is going to live in a palace." Balbi appeared calmer, but his tone was as starchy as his wide white collar. He sent me a pleading look from protuberant gray eyes. "Am I not right, Tito?"

Before I could reply, Majorano crossed his arms and assumed an expression of wounded vanity. Ah, our noble young star was resisting the role of a peasant. I'd feared this. But why was Balbi conducting rehearsal? Where was Maestro Torani?

I jumped when someone tapped my shoulder. Aldo, the stage manager, had crept up behind me on the felt-soled boots he wore so as not to make noise during performances. "The old man's been waiting for you—wants to see you right away. He's on the boil about something."

I advised Balbi and Majorano to take a break—as far away from each other as possible. As the violinist repaired to the orchestra pit and the singer to his dressing room, I turned my attention to Aldo. Bullet-headed, stocky, and overbearing by nature, the stage manager had the Herculean task of keeping everything backstage running smoothly. Aldo and I had fought a few spectacular battles over the years but had lately settled into an indifferent truce.

"What's the latest crisis?" I asked, not overly concerned. Preparing an opera always amounted to one calamity after another. It was the cursed way of the theater.

"Maestro Torani didn't bother to tell me." Aldo shrugged, then jerked his shirtsleeves up over muscular forearms. "But I'm sure you'll soon know all about it."

Did I detect a note of resentment? Aldo made no secret of his belief that retired singers should buy a villa in the country and leave theater business to men with cooler heads.

Like a pair of stags about to lock horns, the stage manager and I exchanged a pointed glare before I went in search of Torani.

◇◇◇

The maestro opened his office door with a moody, heavy-lidded look. Venice's damp gloom seemed to have penetrated every nook and cranny, throwing the glass-fronted cabinets and shelves that lined the walls into shadow. Tedi Dall'Agata, the company's prima donna, stood at the diamond-paned windows, gazing out at the light rain stippling the stuccoed walls of the building across the narrow canal. As always, Tedi wore a gown the color of a delphinium blossom. She'd lived long enough to be confident about what suited her, no matter what the reigning fashion dictated. Today the poor light dulled her favorite blue to a color more appropriate for mourning, and her expression followed suit.

Tedi—Teodora on the playbill, but Tedi backstage—was a handsome woman who hid her forty-odd years well. I knew that the maestro and his prima donna had formed an unlikely liaison—so did Aldo, no hiding anything from that busybody—but I wasn't sure how many of our other notoriously self-involved singers were party to that knowledge. Though Tedi and Torani took obvious pleasure in each other's company, they'd been cautious about keeping to their defined roles of dignified maestro and formidable prima donna within the theater.

In response to my cheerful greeting, the soprano turned away from the window. It was early, so I wasn't surprised to see Tedi's golden, silver-threaded hair simply dressed, her earlobes naked of their signature sapphires, and her cheeks only lightly powdered and rouged. But something untoward was going on. I could feel it. I slid my fingers into my jacket pocket and patted the portfolio that housed Angeletto's contract. That should cheer both Tedi and Torani.

"Hello, Tito." Tedi's *buongiorno* had never been briefer.

"Chocolate, Tito?" Torani indicated the fat-bodied pewter pot and mismatched cups and saucers. "I believe it's still warm. If not, I'll have Aldo fetch another."

"Yes, thank you." I never refused chocolate. My brother Alessandro teased that I was as besotted with the frothy brew as Turkish natives were with their black poppy juice.

"My dear?" The maestro sent Tedi a bracing smile.

She shook her head.

"At least come sit." He removed Isis, the gray theater cat, from a wooden chair which he slid across the terrazzo floor.

Uncharacteristically obedient, Tedi sank down with a rustle of blue silk. I took my usual chair in front of the maestro's cluttered desk, which was presided over by a large plaster bust of Minerva. St. Cecelia, the patron saint of music, would have been more appropriate for an opera director, but Minerva, the ancient goddess of wisdom, she was.

Torani poured me a cup of fragrant chocolate, still tolerably warm, then topped off his own and settled into his high-backed leather chair across the desk. Its surface was piled high with loose sheets of music. A spherical paperweight of multi-colored millefiori glass usually held the scores in place. I'd always loved that piece, a rare and precious bibelot bestowed on Torani by an appreciative Doge, but today I didn't see it among the dirty crockery fighting for space with bottles of dried ink and the feathery detritus of spent quills.

"Have you been down to the piazza?" the maestro asked after a deep swallow. "Or stopped in at Peretti's?"

"No, I stayed abed past my usual time, then walked straight here. Why?" I barely touched my lips to the bittersweet drink, wondering what was wrong. Torani should be hectoring me with questions about my journey to Milan.

Instead he said, "Castrato fever is sweeping through Venice, Tito. At every café and coffee house, men who haven't the ears to distinguish one tune from another are disputing the merits of Angeletto, Emiliano, and Majorano. Women can't wait to experience the latest thrill."

"Did you say Angeletto?"

He gave a short nod.

My mouth dropped open. "Since when?"

Torani slid his wig from his head and slapped it on his desk. He massaged the scab where the roof tile had grazed him—a jagged, wine-dark streak. "Since yesterday morning—since the *Gazzetta Veneta* announced Angeletto would sing at the San Marco. The journal praised him to the skies, made the young man sound like the second coming of Farinelli."

"But that's impossible! I did engage Angeletto, but I returned home only late last night and I've spoken to no one outside my own household." I probed my pocket for the leather portfolio, flipped it open, and handed over Angeletto's signed contract.

"My spectacles. Damnable things...never where I left them." Torani continued to grumble, patting papers, grabbing his wig's long plait and flinging the offending headpiece toward the wide window sill. Tedi caught the wig on the fly, then rose to retrieve his spectacles from where they perched on Minerva's crested helmet.

"The light is better by the window," she suggested.

Torani shambled over and began to read.

I said, "I still don't understand. I'm certain Gussie wouldn't say a word about Angeletto. Besides, he returned to the city with me only last night." I chewed on a knuckle, thinking furiously. "I suppose a man on horseback could have beaten us back to Venice, but—"

"Don't torture the facts for an explanation, Tito." Tedi's face darkened. She wrung Torani's discarded wig like a vindictive laundress. "Beatrice Passoni is the one to blame. She just couldn't wait until your return—until announcements could be made in formal and correct fashion. No, the little wench had to waggle her tongue far and wide, bragging how she'd persuaded— no—commanded the Teatro San Marco to hire her precious Angeletto. She's the very soul of indiscretion. Blasted wench!"

"Take care, my dear." Torani clucked his tongue, busily scrutinizing the document I'd envisioned handing over amidst general

gaiety and shared congratulations. "The Savio would have your head if he knew you'd called his daughter such."

Tedi muttered an oath as she plopped down in her seat.

I asked, "How could Beatrice be so certain that I'd be able to engage—ouch!"

Isis was digging her unsheathed claws into the brass buckles that cinched my breeches' cuff. She meowed complainingly when I nudged her away. The poor thing was heavily pregnant. We'd have kittens any day now. Again. She stalked away with belly dragging the floor and tail held aloft like a shepherd's crook.

Tedi continued, cheeks flushed. "Have any of young Beatrice's desires ever been thwarted? She wants Angeletto carried into Venice trussed up like a suckling pig on a silver platter, thus she believes it must come to pass—a gift from Papa."

Tedi's theory did make a certain sense, and it struck me why the soprano was so upset. Like Angeletto, Tedi sprang from common stock, but there'd been no mentor like Angeletto's Maestro Belcredi in Tedi's life. She'd elbowed her way into the opera house and up to prima donna on her own, depending on no one and nothing besides her own vocal talent and natural musicianship.

At the window, Torani uttered a deep sigh. He removed his spectacles and spun them by a wire earpiece. "This contract appears ironclad, Tito. Did an advocate draw it up?"

"No, Angeletto's manager…er…his sister."

"Well, which was it?" Torani snapped. "His manager or his sister?"

"His manager and his sister are one in the same: Maria Luisa Vanini." I was beginning to feel as bewildered as I'd been in last night's fog. I set my cup down with a rattle. Chocolate slopped over the rim. "Are you considering breaking the contract, Maestro? Haven't I done exactly as you wanted? I procured Angeletto, and I tell you, his voice is a wonder. All Venice will fall in love with him."

I smiled, my spirits buoyed up by my own words. "Don't you see? With Angeletto heading our cast, Lorenzo Caprioli will find

the shoe on the other foot. Why, it may be a blessing that the news leaked out. As excitement builds, our subscribers will come flocking back. There'll be a run on the box office. The Teatro Grimani's boxes will be dark. Its pit deserted. The gondoliers will fill our benches."

I trailed off as a sidelong glance passed between Torani and Tedi.

The maestro pursed his lips, then said, "Tell him, my dear."

Tedi shifted uneasily, stretching her torso and swan-like neck. Even this gesture of discomfort was beguiling, marked by a seasoned performer's grace. It was easy to see how Teodora Dall'Agata had managed to enjoy the stay at the pinnacle for more years than most prima donnas.

"Tito," she began, "Are you acquainted with Girolamo Grillo?"

"Only by reputation." Tedi had named one of Venice's more notorious rakes. Springing from uncertain origins, perhaps as low as the son of a whore and a gondolier, Grillo had managed to inveigle his way into society by presenting himself as a master of some highly secretive cabbalistic oracle. Gifted with a darkly handsome face, a fine set of shoulders, a knack for witty discourse, and a nature both forthright and daring, Grillo was a welcome guest at several aristocratic dining tables. He was rumored to be as adept in female seduction as he was in collecting gullible patrician benefactors.

Tedi cleared her throat delicately. "Last night, I was invited to sing at a reception at the Palazzo Renier—a welcome for all the families returning from their summer villas on the mainland. It was quite lovely, a brilliant assembly. After I'd done my turn, Senator Renier encouraged me to mingle with his guests and have my fill of food and wine. The true nobility are admirable in that regard—it's the newly made aristocrats, the ones who've bought their way into the Golden Book, that shuttle you off with small thanks and a few coins pressed into your palm."

I nodded, recalling the many times I'd been hustled out the side door like the tinsmith or the knife grinder. Tedi stared into

space, stroking Torani's wig as if it were a small lap dog. I prod-
ded, "You were speaking of Grillo, Tedi."

"Yes." Her focus snapped back to me. "I came upon him
regaling a few friends in a secluded alcove. One of the younger
Renier brothers—Dionisio, I believe—took my elbow and drew
me into the circle. 'You'll want to hear this,' he said.

"Well, I knew it had something to do with a woman. The
leers and the coarse laughter told me that much. Grillo lounged
on the velvet-cushioned window seat, the arrogant brute, and
described the seduction of a reluctant young woman. Teasing
her with stolen, playful kisses. Tempting her to meet him in a
secluded *casino*. Then, once she was in his power, nuzzling the
maiden breasts that made such a delicious mouthful. Stroking
the silken skin of her thighs above her ribbon garters. I won't
go on. You can fill in the rest. The important thing is that this
assignation occurred just last month. In Milan."

Tedi hesitated again.

"Go on," I muttered through gritted teeth.

"Of course, you've guessed. She was a woman from the opera.
'A trifle,' said Grillo, 'who should've been flattered.' Flattered
that he'd even bothered with her. Her name was Carla Vanini,
and she was hiding a terrible secret—she supported her entire
family by pretending to be a castrato singer." Tedi pressed her
lips into a thin line. "I'm sorry, Tito."

I took a deep breath. I shifted my gaze from Tedi to Torani.

The maestro didn't appear nearly as outraged as I expected.
In truth, he seemed more exhausted than anything. He studied
me solemnly, leaning back against the window sill with arms
crossed. "If that story is true," he said after a moment, "our bacon
is well and truly cooked."

"It's not true." The words tore out of me without conscious
thought.

"Are you certain?"

"I wouldn't have engaged Angeletto if I weren't." I meant
those words. During the journey from Milan, I'd thoroughly

dismissed Gussie's assertions and stuffed them into a cobwebbed niche in a remote corner of my mind.

"All right. I trust your judgment." Torani nodded deeply, crinkling his eyes. "If you are certain, Girolamo Grillo must be lying. The question is—what are we going to do about it?"

Tedi spoke up in an ominous tone. "The Savio will soon hear of this. He wasn't at the reception, but word spreads quickly among the foremost families."

"Let's see," I rose and began to pace the small office. "We have a known charlatan and adventurer claiming that he has personally enjoyed Angeletto's...er...womanly charms. We also have at least one person who would love to see *The Duke* fall flat on its face." I whirled around to question Tedi. "Did Grillo make a point of his conquest being the one and the same Angeletto who will soon head our cast?"

"Yes, several times," said the soprano. "He painted the Teatro San Marco as the butt of a huge jest, and called our new opera an outright farce. His friends were drinking it in."

"Someone put him up to it, I'll be bound. Grillo is merely a tool being used to discredit us. We can't blame Beatrice Passoni. She may have overstepped her bounds where the news of Angeletto's hiring is concerned, but she certainly didn't invent this story for Grillo to spread." I tapped my chin. "We know our enemy, don't we, Maestro?"

"Lorenzo Caprioli." Torani made no attempt to cover his contempt in his tone. "Making a puppet of Grillo, using his scandalous escapades as a weapon against us, that would be precisely Caprioli's style."

"Exactly." I nodded slowly.

Tedi regarded me plaintively. "But what do we do, Tito? How can we fight him?" She shot a quick glance at Torani.

Framed by the dark wood of the window embrasure, the maestro seemed to have aged ten years. His expression was perplexed. His head bobbed like a boat on the waves, and the loose folds of his neck trembled as he repeated Tedi's question, "Yes, Tito, what do we do?"

My gaze slid from one to the other. And back again. Maestro Torani had always provided wise and worldly advice, not only about music, but about the prudent conduct of a castrato who was by his nature detached from conventional society. Angels to some and monsters to others, castrato singers could never slip through a crowd unnoticed. For years the maestro had been at my back, guiding me past the traps of fame and the despair of isolation. Now Torani was begging advice from me. It was an unsettling feeling.

I took a few more fitful paces, then said, "First, we must shut Grillo's mouth. And quickly."

"How do you propose to that?" Torani asked.

"I'll find a way," I answered quietly.

A knock on the door saved me from further discussion.

"Avanti," Torani called.

The door creaked open, and Aldo's head poked through the gap. "Signor Balbi has assembled the orchestra, Maestro. He's awaiting instructions."

Torani straightened. "Tell him Tito will be there in a few minutes."

Ah, yes. We had an opera to rehearse. No matter what other trials lay before us, *The Duke* had to be ready to open, note perfect, in just over three weeks.

Chapter Seven

As Aldo withdrew, a sudden glimmer of sunlight shot through the churning clouds. Every surface—walls, ceiling, and floors—shimmered in watery light reflected off the canal through the diamond window panes.

The resulting dispersal of gloom seemed to lighten all our moods. Torani reclaimed his wig and kissed Tedi on the cheek. Then the maestro went over to his desk. He pulled out the long middle drawer, but instead of placing Angeletto's contract inside, he closed it again. He winked, and after folding the papers longwise, tucked them under the blue blotter that was just visible beneath the mess on the desktop.

"We'll keep the business details to ourselves, Tito. If Majorano finds out how much we're paying Angeletto, he'll demand the same."

Tedi ran her fingers through her loose chignon. She murmured something about having her maid redress her hair before rehearsal, and slipped through the door.

"Walk me out, Tito," Torani said as he grabbed his cockaded tricorne off a wooden peg.

"You're not coming to rehearsal?"

He shook his head. "You can handle it; I have business elsewhere. We ran through Scene One yesterday. Except for the duke's arias, of course—they'll have to wait for Angeletto's arrival. When will that be?"

"A day or two, I expect."

"That will do. I told everyone we'd do Scenes Two and Three today. The copyist is hard at work delivering the scores as we go—faster that way. Now Tito," he touched my arm, "it's early days yet, but don't allow Majorano to go overboard with posture and stance. He still wants to act the prince, even though he's playing a lowly huntsman."

I merely rolled my eyes.

As we navigated the maze of corridors that wound from backstage toward the water entrance, I was pleased to see that the maestro seemed to have shaken off his worries. He was the Torani I was accustomed to: aged, yes, but also brisk, confident, anticipating every detail.

"How did you get along with Signor Leone?" Torani trotted along. Tapping his stick no more than every third step, he outpaced me in the narrow passage.

"Leone was very helpful, but I regretted taking his hospitality. His household is so poor."

"Poor?" Torani guffawed. "My friend Leone keeps a locked chest full of ducats in his storeroom. He insists on saving them for the rainy day that never comes."

"While his wife and children live little better than paupers?"

"You've heard the old proverb about the ant and the grass-hopper." The old man shrugged. "Leone is the industrious one who lays up stores for the lean days of winter."

"Then who's the squandering grasshopper?"

"Me, of course." Torani sighed. "I've always been a fool where money is concerned." His steps slowed and his stick's taps grew farther apart. "There's something else I've been meaning to ask you, Tito." Tap…tap. "How did you come by Rocatti's score in the first place?"

The passage widened into the lobby, and I lengthened my strides so that we were walking shoulder to shoulder. "That was a curious thing, Maestro. Rocatti seemed very hesitant when he asked my opinion of the work."

"Where did he approach you? Peretti's?"

"No, that was another odd thing. I'd gone to the Ghetto with Liya. While she visited with her mother, I planned to bend Pincas' ear at his shop."

A sidelong glance told me Torani understood. As a witness to my family's tangled history, he knew that Signora Del'Vecchio and I were sworn enemies. I couldn't stand to breathe the same air as that viper of a woman, and she never tired of telling me— capon, she called me, never Tito—what a poor, damaged scrap of a man I was. Liya's father, Pincas, was another story. The used clothing dealer and I got along very well.

"Pincas happened to be out," I continued. "So I strolled up the calle to the Spanish Synagogue where a concert was taking place."

Torani stopped. He wrinkled his brow. "I know that Christians often attend afternoon lectures and concerts in the Ghetto. But I've never heard you mention that particular activity."

"No. It's the kind of thing I always mean to do but rarely find the time for."

"What happened?"

"Not much, really. The Hebrew orchestra was good, but nothing special. During the intermission, a good-looking young gentleman approached me and introduced himself as Niccolo Rocatti. He recognized me from the opera and prevailed on me to take a look at a score."

Torani leaned on his stick and harrumphed loudly. "I get scores shoved at me every time I sit down at a café. If I reviewed all of them, I'd never get any work done."

"Yes…" I thought back to the thin-faced man, about my own age. At first I'd taken Rocatti for a fop, but his intelligent, deep-set brown eyes belied the superficiality of his exquisitely curled wig and festoons of Alençon lace.

I went on, "I suppose I accepted the score because the composer wasn't paying court like the usual lickspittles. Rocatti was shy, almost diffident about what he'd written. He carried only the first scene, pocketed in a tight scroll. Of course, I fell in love with the music. I soon called in at the Pieta, and he gave me the entire score."

Torani sent me an odd look. "You had no qualms about the way you stumbled on *The False Duke?*"

"Well…" I chuckled uneasily, then blurted out a question that had been on my mind. "I actually thought you might have known of the opera beforehand and put Rocatti up to following me with it."

His jaw dropped. "What put that absurd idea into your head, boy?"

"I don't know, Maestro. Forgive me. These days, I find myself wondering about everything—look how I misjudged Leone's situation. I've been feeling as unsettled as…" I threw up my hands and glanced toward the glassed entry doors, "as unsettled as the skies that can't decide whether to rain or shine."

The clouds had opened again. It was pouring.

"Yes." He consulted his watch, clicked it shut, and shoved it deep in his waistcoat. "I must hurry on." His tone implied that my suspicion had not only puzzled him, but also wounded his trust.

I accompanied Torani out onto the portico, alarmed that he was taking off in such weather. He waved my concern aside impatiently and snapped his fingers at Peppino. Torani's off-and-on gondolier had been lounging in a relatively dry corner, swathed in an oilskin cape. Off-and-on, I say, because Peppino was an inveterate loafer. He'd perfected the intertwined arts of doing absolutely nothing and disappearing when any burdensome task loomed before him. I was thoroughly surprised that Peppino had waited instead of seeking the warmth of a nearby tavern. Why the old man put up with him, I never knew.

Perhaps Torani's loyalty had something to do with the uncanny gondolier's instinct that had led Peppino to affix the boat's cabin before the rain settled in. Inside that cabin, the old man would be as safe and dry as a tortoise inside its shell.

Taking Torani's arm, Peppino hustled his master down the steps, through the downpour, and into the waiting gondola. Then the boatman donned his wide-brimmed beaver hat, unlocked his oar, and kicked away from the stones.

There was no reason to stand under the portico with damp seeping into my bones and drips from the eaves staining my jacket. I shivered. The wind had picked up and it was growing colder. I should have gone in, but as Peppino steered down the canal toward more highly traveled waterways, something kept my feet rooted to the spot. Deep in my gut, disquiet uncurled like a snake waking in the warmth of a summer morning.

I tried to shake the feeling off. The company was waiting. Balbi would be quieting his musicians' complaints. The singers would be drifting around the stage, gossiping or threatening to retire to their dressing rooms. Majorano would be devising heroic poses that I'd only have to make him unlearn. *Get to work, Tito.*

I'd turned to re-enter the theater when a flash of movement caught my eye. A second gondola darted out from under an arched bridge fifty yards or so up the canal—a two-oared gondola with boatmen fore and aft pushing their oars like mad. I ran down the steps, ignoring the needles of cold rain.

The boat shot past the landing. Its sleek blackness, unrelieved by a coat-of-arms or identifying shield, was swiftly gaining on Torani's gondola. It carried no passenger, only the pair of stout-shouldered boatmen. Their eyes were shaded by tilted hat brims, the lower half of their faces covered by kerchiefs.

Their malicious intent was clear. I ran along the pavement overhanging the canal, yelling at Peppino's receding back. Despite the weather, he was oaring in his usual lazy strokes, but my warning fell on deaf ears, lost in the pounding of rain on stone, tile, and water.

I looked around frantically. The shops and homes along the pavement were shuttered—the rain had driven everyone indoors. Neither was help to be found across the canal where the houses came right down to the water. A flat-bottomed punt was moored at one house's door, but I saw no sign of life within.

I ran on.

Through the slanting sheets, I saw Torani's gondola draw near the intersection of a wider canal. The faster boat had nearly caught them. As Peppino angled to make the turn, the chasing

gondola's bladed, serrated prow bore down on Torani's boat like a snapping dog leaps at a cornered boar.

It rammed the smaller gondola direct center. Wood splintered and cracked. The cabin toppled.

Peppino flew off his deck, mouth open in a scream. Where was the old man?

I sped the last few yards tearing off my jacket and waistcoat. Half-leaping, half-slipping from the edge of the slick pavement, I dove into the chill, salty water. It covered my head, but I quickly bobbed to the surface. Like every Venetian boy, I'd learned to swim soon after I could walk. In a city crisscrossed by waterways, it was a necessity.

Peppino was splashing in the water amidst the wreckage. "Where's Torani?" I yelled. He shook his head before disappearing behind the floating cabin hood.

A blow to the back of my head caught me by surprise, an invisible hammer swinging out of the mist above the roiling canal. A burning swallow of saltwater stung my throat. Had the bravos in the chase boat come about to launch another attack?

I whirled around. It was Torani! Thrashing and flailing in a desperate attempt to keep his nose above water, the old man had clonked me. I clutched at his white collar, a visible target in the dark water, but it slipped through my fingers. We struggled. The old man was in a panic, resisting the very efforts that would save him. Finally his head went under and didn't come back up.

With a huge breath, I ducked under the surface. It was too dark to see, but after several terrible seconds I made contact with a limp arm. I pulled mightily, fighting to find solid footing amid the refuse on the canal bottom. Impossible! Weighed down by his drenched clothing, the maestro was as heavy as a baleen whale.

My lungs were near bursting when Torani's body suddenly lightened. Peppino had found us. He sent me a triumphant grin as we broke the surface with Torani between us. I tipped the old man's chin back; Peppino pointed toward the pavement. A few men had gathered there. We floundered toward them, and

strong hands pulled us from the water that lapped and sucked at the mossy stones.

Trembling, heart pounding, and as weak as the proverbial kitten, I could only sit with my arms around my knees as a sturdy, white-aproned barber applied his knee to the middle of Maestro Torani's back. When the maestro's head rose from the pavement, coughing and sputtering, I knew he would survive.

Crisis averted, I began to feel the cold through my sodden shirt and breeches. I was suddenly very tired. The hubbub caused by the gondola crash seemed to recede into the distance, as if a giant's hand had scooped me up and set me down on the next campo. Shivering, I found myself hunching forward, hugging my neck with my right arm. Though my throat was no longer golden, the instinct to protect it remained. I was barely aware of someone—Peppino?— throwing a cloak around my shoulders.

More than anything in the world, I wanted to close my scratchy eyes and forget this flagrant attack—along with the bewildering events of the past few days. Instead, I twisted around to survey the intersecting canals.

The wreck of Torani's gondola had come to rest at a landing across the wider canal. The oaken ribs showing through its lacquered, crumpled hull put me in mind of our Christmas goose once most of the meat had been stripped from the carcass. Several sbirri were inspecting the stricken boat, poking the black frame with long rods. The constables turned to each other with puzzled frowns and impatient gestures, then started questioning the small crowd that had gathered. The men and women immediately backed away, shook their heads, and spread their hands. Even beyond earshot, their message was clear: "We saw nothing."

The rain continued to fall, lighter now, but miserable just the same. All was drizzle, haze, and fog. The marauding gondola had vanished into the mist.

◇◇◇

The Savio alla Cultura was quickly informed of Torani's accident—the gazette's eventual and totally misguided term for the

brazen attack—and named me interim director of the Teatro San Marco on the spot. I wanted to wait to see how Maestro Torani fared, but Signor Passoni insisted. While I was still in my dripping clothing, he graced my palm with a pouch containing twenty gold ducats and told me he expected great things for our coming season.

Receiving unexpected purses from the Passoni family was becoming a habit.

Torani set about his recovery without serious consequences, but the ordeal left him rheumy and weak. Doctor Gozzi confined the old man to bed and called in every day to see that his orders were followed. Each time I visited, I recalled an old porter who'd swept my boyhood campo and run errands for its inhabitants since time immemorial. My elderly Aunt Carlotta would point to his stooped frame and declare, "That *facchino* is nothing but gristle, bone, and leather, but he'll be pushing his broom long after I'm gone."

Torani was much the same. Tough. I expected to be interim director for a short time only.

There was no official inquiry into the incident, even though I reported what I'd seen to the sbirri. Once Torani was settled at his lodgings under Tedi's watchful eye, I'd gone to the guardhouse on the San Polo side of the Rialto Bridge, a turreted pile of brown stone that housed Venice's peacekeepers. The uniformed sergeant at the reception counter gave me scant consideration.

Why the callous dismissal?

Very simple. Carnival was coming. Foreigners were already taking up residence in preparation for the famous fete that began on the first Sunday of October, a good four months earlier than in any other city. Cafés were setting out extra tables, shop windows displayed tempting goods, and a gaudy riot of pennants, flags, and posters decorated the piazza. Frivolity and excess filled the air. The sbirri had a host of pickpockets, sandbaggers, fraudsters, and sneak thieves to worry about; they had no time for an operatic feud.

Even when I demanded to be shown into the presence of Messer Grande, the aptly titled chief of the peacekeeping force, I found uninterested ears. Messer Grande had once been my ally in the investigation that led to the loss of my voice. I called him by his Christian name, Andrea, and considered him a friend. But as our work proceeded in different worlds, we had seen less and less of each other, and on this day my old friend seemed preoccupied. Andrea gave me ten minutes to lay out my suspicions.

I wasted no time in blaming Lorenzo Caprioli for Torani's terrible state. Andrea agreed that there'd been a long-term rivalry between the two theaters, and he could well believe that Caprioli's latest ambition was to wrest the Senate's sponsorship away from the Teatro San Marco. But when I pointed out that Caprioli's brutish sedan bearers could probably row as effectively as they shouldered his chair, Venice's principal lawman began to shake his head.

"You must listen," I said, putting passion behind my words. "The announcement about Angeletto's upcoming arrival has taken the city by storm. The minute he heard the news, Caprioli would have immediately recognized the advantage it gave us—Maestro Torani's acquisition of such a prize would be sure to raise the Teatro San Marco's stock with the Senate. In his crude fashion, Caprioli took steps to right the balance. Such a thorough villain would see the attack as merely another move in the game."

Andrea kept shaking his head. "Tito, Tito," he murmured as he leaned back in his chair and clicked open a malachite snuff box. I observed my friend while he took his tobacco. The current Messer Grande was a tall, broad-shouldered man, with ruddy cheeks, deep-set brown eyes, and bushy eyebrows that seemed to speak a language of their own. The fleshy platform between thumb and forefinger where he placed his dab of snuff was thick and meaty, leading me to think he had more than a few peasants in his ancestry. But Andrea also came down from a more illustrious line. He'd always worn a heavy crested ring on his left hand, and, after all, a man was not appointed Messer Grande without prominent family ties.

Before he carried the snuff to his nostril, he gave a dry laugh. "Based on your flimsy tale, I would never be able to take Signor Caprioli before the Quarantia Criminale. What have you given me? A swift black gondola. A pair of anonymous bravos. Not many of those in Venice, eh?"

Andrea pinched one nostril closed and inhaled his snuff though the other. After the resulting sneeze, he fixed me with a somber stare. "I often see Maestro Torani prowling the city in the wee hours—completely on his own. Your best course of action, my friend, is to see that he keeps to his fireside where a man of age belongs."

I shrugged. The maestro was always keyed up after a performance. He liked to call in at the Ridotto for a little faro or relax in a tavern, sometimes with Tedi, sometimes without her. I'd sooner chase a bear out of his lair than order Torani away from his favorite haunts.

Andrea showed me out with a trace of his old friendliness. "At least this gives you a chance to shine, Tito. Yes, I heard about your new appointment. About time isn't it?" He placed a hand on my back, with just the slightest pressure to ease me through his office door. "When he is well, tell Rinaldo Torani I order him to go straight home after the opera. A man in his bed behind a couple of doors with stout locks isn't going to be much of a target, is he?

"And, Tito…" Messer Grande peered at me for the space of a long breath. "You'd best be careful, too."

"To be sure." I made my bow and left the guardhouse with a new worry burrowing into my soul. It hadn't occurred to me that I would become a target, but it made perfect sense.

I was in charge of the Teatro San Marco now.

Chapter Eight

I had scarcely three weeks for preparation. Not optimal for a four-act opera, but time enough if I went about it the right way. Unfortunately, by the time Angeletto arrived in Venice, insulated by layers of Vanetti females, battle lines had been drawn. Imaginary lines, but there were so many of them, the San Marco seemed more like an armed camp than an opera house.

The family's journey from Milan, as arranged by Maria Luisa, took closer to a week than the several days she'd promised. I used the time to accustom the company to *The Duke's* idiosyncrasies. Ziani, our machinist, voiced loud complaints over having to produce a shipwreck in short time, but once he finished grumbling, he had his men push Prometheus' rock into a corner of the workroom and started sketching.

The next loudest complaints came from the solo singers, who I now required to sing in chorus, blending their voices and actually cooperating instead of striving to outshine each other. At first, the tenors and basses barely concealed their sneers, and the sopranos complained in whispers behind angrily fluttering fans. Eventually, little by little, my troupe warmed to Rocatti's new technique.

Majorano presented the worst sticking point. As I'd predicted, the celebrated castrato felt supplanted and dug his heels in at every turn. He actually became something of a troublemaker, whispering against me in the ranks. Then word circulated that Majorano intended to hire a claque—audience members paid

to cheer and applaud him and, in turn, to boo and hiss his rival. Rocatti's opera called for a warm bond of brotherhood to develop between Angeletto as the duke and Majorano as the huntsman. Totally unbelievable if the pair of them were throwing vocal daggers across the stage.

"I think you should arrange something to introduce Majorano and Angeletto," Torani said when I visited him at his lodgings on the Calle Castangna. "You know, present them as equals."

"Something?" I repeated wonderingly. Did the maestro think these two huge personalities would become instant comrades over a dish of coffee at Peretti's?

"A reception. Their first meeting should occur on neutral territory—not the theater." Torani squirmed on a wide bed hung with green damask draperies, propped up on three fat pillows. His forehead sported a gash on the opposite side from his scabbed wound. Tedi was intent on bathing both with a cloth that smelled of pine spirits. The maestro pushed her hand away with an impatient gesture.

"I don't suppose your Liya could rise to the occasion?" he asked with raised eyebrows, plucking at the counterpane.

I tried to imagine the opera stars facing each other across my homey sitting room, the Savio and other political luminaries supping on Liya's plain fare, and Benito in a full-blown lather serving Champagne from a quivering silver tray. An alternative scenario formed in my mind's eye.

"Perhaps the Savio would agree to host a reception," I suggested.

Torani and Tedi both nodded enthusiastically.

But then the soprano said, "It's true that Majorano and Angeletto would both be on their best behavior at the Ca'Passoni, but it would give young Beatrice a golden opportunity to make trouble."

"What do you think she might do?" I asked.

Shaking her head, Tedi rose with her basin and cloth. "Oh, I don't know—some nonsense calculated to embarrass all of us."

"I shouldn't worry, my dear. Castrati expect young women to make fools of themselves over them—older women, too."

Torani attempted a jocular chuckle. "Am I right, Tito? I'm sure both Angeletto and Majorano know how to handle Beatrice."

I had to agree. After a few more minutes' discussion about the guest list, I noticed that the old man was growing weary and took my leave. Tedi saw me out. I missed her at the theater. I'd been counting on her experience to balance Angeletto's stirring but less practiced gifts, and had been disappointed when she'd withdrawn from the prima donna role. Torani had laid down the law on that one point. He needed Tedi at his bedside. Oriana Foscari, our secunda donna, was reveling in the unexpected opportunity for advancement.

Tedi had made light of it, saying, "It's for the best. I'd make a poor milkmaid, wondering if everything was all right here. Besides," she'd laughed, "Isis decided to have her kittens in the box that held my only peasant wig. It's ruined."

At the entrance, poised on the red-and-black tiled doorsteps lapped by the canal, I spoke of something else—delicately—as I had no wish to frighten Torani's good lady. "Nothing…untoward has happened, has it?"

"Untoward? How cryptic you are, Tito. Are you speaking of bravos lurking in the shadows with drawn stilettos? Masked ruffians climbing the vine up to the balcony?" Her forced smile belied the shadows under her blue eyes, the stained bodice, the frowzy bun at the back of her neck. Had Tedi dismissed her maid? "There's no need to fret," she continued. "The old fool is going to be just fine."

Tedi was a brave woman, perhaps a bit too brave. Did I need to remind her of recent events?

She went on, leaning against the door jamb, slender white hand pressed to her cheek. "When I call Rinaldo an old fool, I mean it. He's managed to cause us a great deal of trouble, but it's over now. I've seen to that." She finished with a firm nod.

A surprised "Eh?" escaped my lips. Did Tedi have some hold on Lorenzo Caprioli that had escaped my notice? I asked as much.

Tedi let my question float in the air a moment, then said quietly, "You must let a lady have her secrets, Tito." She blinked anxiously. "If you want to worry about something, worry about Girolamo Grillo. He's spewing his filth again, even more publicly. I thought you were going to put a stop to it."

"I've been a little busy, Tedi." I sighed and gave my buckled shoes a long look—scuffed—they needed Benito's hand. Raising my chin, I asked, "Where? Where has Grillo been holding court?"

"The Café Sultana on the piazza." Her reply formed a clear call to duty.

I made my bow, boarded my waiting gondola, and directed the boatman toward the heart of Venice.

◇◇◇

Grillo wasn't hard to find. The great campanile was just tolling the *nona*, the noon bell, when I entered the colonnade running alongside the Procuratie Nuove. The Café Sultana was halfway along the vaulted walkway. A few patrons were braving the cool, overcast day at outdoor tables nudging into the vast square. I didn't linger to watch them sip at small cups of black coffee or nibble at pastries. Knowing that my quarry enjoyed his creature comforts, I pushed through glass doors fogged with the warmth of cooking and the breaths of shouting waiters and chattering patrons.

I spotted Grillo immediately. He occupied a corner table by the window. A woman known for circulating about the piazza, ostensibly selling balms and scents but really selling herself, sat close beside him. Her satin-clad arm stretched upon his shoulder; her lacey cuff tickled his neck. A quartet of richly dressed fops filled out the table, English by the look of their excessively high wigs topped by oddly undersized tricornes. I'd have to remember to ask Gussie why his young countrymen had suddenly surrendered their taste and good sense to the most ridiculous of fashions. They were all staring down at the white tablecloth as if it held a map to buried treasure.

What was Grillo up to? I stepped closer to the table and saw that the cups and plates had been pushed aside to accommodate

twenty to thirty brightly colored tiles. He shifted the tiles with quick, swinging arm movements, like a trickster running a shell game and daring a punter to follow where the walnut landed. Then, with two fingers pressed to each temple, Grillo appeared to study the numbers and symbols painted on the tiles. He murmured something, and his onlookers leaned forward so as not to miss a word. His tomfoolery reminded me uncomfortably of my wife's study of her cards. Though Liya wasn't out to cheat anyone, I'd wager my last zecchino that Grillo was.

I announced my presence with a small cough.

The charlatan looked up with a smile that quickly faded. Displaying near miraculous dexterity, Grillo swept up his tiles and extricated himself from his companion's embrace. He swiped a green cloak off a peg and made for the exit. If a waiter bearing a tray piled with dirty crockery hadn't chosen that moment to block my path, I would have been right on Grillo's heels. Delayed, I reached the open piazza only to find it thronged with promenaders of every complexion, class, age, and sex. At least it was not yet Carnival—very few wore mask and costume. Black *tabarros*, shawls, and cloaks were the order of the day.

Grillo's cloak was a bright jade, the color of the lagoon on a perfect, sun-kissed summer day, and lined with equally bright yellow. With the superior height of a eunuch, I should be able to spot it easily. I craned my neck and caught a flash of green fabric snapping in the breeze. Grillo was moving quickly, heading for the passage under the clock tower that led to the Merceria. If he reached that busy shopping thoroughfare, I stood a good chance of losing him.

I pushed through the crowd, crossing the long shadow cast by the free-standing campanile. The bell tower's massive presence soared above the piazza, dwarfing the domes of the Basilica and making the humans on the paving stones seem like ants. I was losing Grillo. I broke into an outright run, drawing a squawk from a lady's maid toting her mistress' lapdog and nearly toppling a peasant boy in wooden clogs.

My lungs were burning when I finally made it to the other side of the square. I caught up to Grillo just as he ducked into the shadowy tunnel under the clock. He was making a play of sauntering casually along, as if he had nothing better to do than find another café in which to take coffee and conduct business. I put on a final burst of speed and clutched the collar of his green cloak.

"You may unhand me, Signor Amato," he said, once he'd recovered from his surprise. "I have no intention of running."

"Five minutes ago you were determined to avoid me."

The villain shrugged. "I suppose I must face you at some point—it may as well be now."

As best I could in the dim passage, I looked the man up and down. His loosely arranged hair was dark, cheeks olive, and eyes a lustrous black. His green cloak and claret-colored jacket suited his complexion perfectly. The man was of Spanish ancestry, I'd be bound. As I sensed no muscles tensing to flee, I released his collar.

"Let's find a more private place," I said, aware of the steady stream of humanity headed toward the Rialto via the cramped confines of the Merceria.

He nodded and we walked shoulder to shoulder in tense silence until we found a quiet alley beside the modest church of San Zulian.

"What do you mean by spreading rumors about Angeletto?" I began without preamble or politeness.

"Everyone loves a bit of gossip," Grillo shot back smoothly.

"Your kind of gossip sets in people's ears like plaster—impossible to remove. Plus, it's all lies."

He burst out laughing. "Lies is it? Are you so sure? The singer called Angeletto has many talents beyond music, Signor Amato. Think about it—how much do you really know about Angeletto?"

"I know your deliberate gossip is wronging more than a fine young singer. It's threatening the San Marco opera house and everyone in it. If the theater is ruined, hundreds will be without jobs—not just the musicians, but scene shifters, seamstresses,

candle tenders, ticket takers, grappa sellers. Everybody right down to the old prompter who has whispered singers' forgotten lines for the past forty years."

"And your job, too. Right?" He smirked. "Just when you've managed to put old Torani out to pasture. That's what really has you steaming, isn't it?"

I felt my face grow hot with anger. "You don't know what you're talking about. Maestro Torani is getting better by the day. He'll be back at the helm in a matter of weeks."

"Perhaps. You would know better than I." Grillo propped a shoulder against the church's polished stone wall. "But I don't enjoy being called a liar. I have a certain reputation to uphold, especially as a devoted admirer of the fair sex. If Angeletto *is* merely a boy who's lost his chestnuts, I end up looking like a fool."

I grabbed his collar again and pulled his smooth cheeks close to mine. "I don't care what you look like. I want you to shut your mouth. Better than that, I want you out of Venice for the run of *The False Duke*."

"Exile, eh?" His breath was hot on my face.

"Temporarily."

He splayed his hand on my chest and pushed me away. Silent for a moment, Grillo seemed to be sizing me up. Then, with an oily smile: "Are you about to make me an offer?"

Well, what else could I do? I had no bravos at my disposal to intimidate Grillo. If my brother Alessandro were in Venice, he would have known how to put the fear of the Devil in him, but Alessandro was far away in Constantinople. "All right," I grumbled. "Just tell me—what will it take to end this farce? How much has Lorenzo Caprioli paid you?"

Grillo raised his eyebrows. His mouth twitched. I thought he was going to laugh again, but he merely answered. "Fifteen ducats."

The purse the Savio had given me was still weighing my pocket down. I poured most of the coins into my palm, counted them, and sealed the bargain with Grillo.

"Tonight, you'll be resting your head on the mainland," I observed, experiencing a hollow, sinking feeling. The roof tiles over my front door were hanging by a thread, and I'd just bartered away my best hope for a repair.

"As you wish, Signor Amato." The schemer had the gall to make me a fine bow before sauntering down the alley and turning out of sight.

I'd nearly made it back across the piazza before it occurred to me that my transaction with Grillo had proceeded much too smoothly. While I had no bravos, Caprioli certainly did. If ordering them to ram an old man's gondola didn't prick the impresario's conscience, what would stop him from making Grillo pay dearly and painfully for his disobedience? And Caprioli wouldn't forget during the few short weeks that Grillo stayed out of Venice. That self-anointed great lover and cabalist would return to the city as soon as *The False Duke* had completed its run, perhaps sooner if he thought he could get away with it.

Grillo didn't strike me as a man of courage, yet he'd quickly agreed to my demands. Had I again misconstrued what lay before my eyes? I pondered that question until I reached the Teatro San Marco and was swept into another contentious rehearsal.

◇◇◇

The tower where I'd caught up with Grillo houses an ornate, blue-and-gold clock that displays a uniquely Venetian motto: "I number only happy hours." Those happy hours had been in short supply of late, but that evening I enjoyed a few of them in the company of my family. Tucked away on the north side of the island, far from the tensions of the theater and the growing uproar on the piazza, my home in the Cannaregio was a beacon of serenity.

Over a late dinner of roast chicken, boiled musetto salami, and creamy polenta, Liya and Annetta demanded to know everything about our new castrato star. My sister, Gussie, and their three youngsters were joining us at table. Gussie had told Annetta just enough about Angeletto to whet her appetite for more.

"What do you want to know?" I asked, glad to see a sparkle in my sister's eyes. Annetta had suffered a bout of melancholia after five-year-old Isabella's birth and had never fully returned to her old self. My fearless playmate and fierce protector during our motherless childhood had grown quiet and distant. Her buoyant prettiness had also faded, rather like a once bright banner that had waved in the sun and sea breeze until the colors were barely visible among its tatters.

Annetta swallowed a bite of salami. "Does he sing better than Majorano?"

"Not better, but differently." I thought back to the concert in Milan. "Where Majorano strives to stir his listeners with extravagant technique and chivalrous deportment, Angeletto seems more intent on pleasing himself. I've never met an artist who seems to enjoy his own singing so intensely. Of course, an audience responds in kind."

"But his voice? What does it sound like?" Annetta pressed.

"Light and flexible, but also capable of great emotion. Angeletto can produce a sob of fury or a tremolo of ecstasy with equal ease."

Gussie held up his glass, and Benito hurried to fill it from the carafe on the sideboard. "That should please Signor Rocatti," Gussie said after a sip of Montepulciano. "Has he been around to the theater to hear the celebrated Angeletto sing his *False Duke?*"

"Angeletto hasn't started rehearsal yet." I abandoned my fork and sat back with a huff. "It seems that he requires rest from his journey."

Yesterday, I'd stopped in at the Ca'Passoni to pay my compliments. While Angeletto reclined on a chaise, eyes closed, his lovely face as still as a death mask, Maria Luisa had laid down the law. Her brother would attend the reception tomorrow night, but under no circumstances was I to expect him to entertain. He would begin rehearsals the following day. Time was of the essence, but this hard-driving woman knew she held the whip hand. What was I going to do? Send Angeletto packing? Not with all Venice in eager anticipation of hearing the latest rage.

Not with the tyrant Beatrice enthralled with having the sensation of the hour in residence at the Ca'Passoni.

"Besides," I continued on a sigh, "Rocatti has dropped by the theater only twice, and only for a few minutes. He claims that his duties at the Pieta allow him little free time."

Gussie raised his eyebrows. One of them was smudged with blue paint, a sure sign he'd come straight from his studio. He asked, "Won't Rocatti be leading the orchestra on opening night? I thought that was the drill at the opera house. The composer conducts the first three performances at least."

I shook my head. "For some reason, Rocatti seems content to leave that to me." I shrugged. "Perhaps the sheer size of the San Marco intimidates him. The Pieta's theater is not nearly so grand—little bigger than a stage for marionettes really."

Matteo and Titolino had been having their own whispered conversation at the other end of the table. Now my adopted son spoke up. "Are Majorano and Angeletto enemies, Papa? Like Hector and Achilles?" The boys had been studying Homer's account of the Trojan War at school.

An image sprang to mind: my two stars taking up broadswords, dueling to the death, and the victor dragging the body of his slain rival around the theater from the back of his chariot. To my surprise, I heard myself giggle like an overexcited schoolboy. I shook my head and wiped my palm across my forehead. I was the one who needed a good rest, not Angeletto.

Fortunately, Liya answered for me. "I wouldn't call them enemies, Titolino, but they do compete for the audience's affection. Both singers want to be the best."

"Why can't they both be the best?" That was Matteo.

I smiled without mirth. "It just doesn't work that way. The people watching the opera decide who rules the stage, and there can only be one ruler. It's rather like being anointed as a king or prince. Here in Venice, we never have more than one Doge, do we?"

The boy cocked his head. "I guess not. But they *could* fight, couldn't—"

"That's enough for now." Gussie cut Matteo off. My brother-in-law had correctly sensed that I was growing weary of opera talk and knew the boys' questions could go on forever. "I've been meaning to ask, Tito. Did the theater's mouser ever have those kittens?"

Isabella bounced up and down in the seat next to her father, clapping her hands. "Zio Tito—a kitten. You promised me a kitten."

I spooned some polenta onto my plate. A wisp of steam curled from the serving bowl. "So I did. I'd almost forgotten with all that's been going on."

"Are they borned yet?" Isabella asked under the indulgent gazes of both parents.

"Yes, and fine kittens they are. Three turned out gray like Isis, and one is black with white paws and whiskers. You may have your choice."

"Tomorrow?" she asked with a squeal.

"Oh, no," Liya put in. "They're much too young—just babies."

I nodded at Isabella. "Aldo is looking after them until they're old enough to leave their mother."

"When, Zio Tito? When can I come get my kitten?" The girl regarded me with huge, solemn eyes.

I thought for a moment. "Can you count to four?"

That exact number of fat fingers immediately waved in the air across the table.

"Good. Exactly four weeks from now, have your father bring you to the theater and I'll let you choose your kitten."

Her brother Matteo pulled a face. "That's a whole month," he taunted with a mouthful of polenta.

"It is not," Isabella yelled.

"Oh, yes it is. Four weeks is the same as a month."

Childish arguments and parental admonitions reigned until I rose and tapped on my glass with a knife.

"I have another surprise. For the adults, at least." I turned to my sister. "Do you still have the special gown you used to

wear to the San Marco when I was singing—the crimson with the gold embroidery?"

"Yes." Annetta's expression was puzzled. "Why?"

Liya sent me a knowing wink. I'd already let her in on the news that the Savio had agreed to a reception at the Ca'Passoni.

I grinned broadly. "Because, dear sister, tomorrow evening we're all going to a party, and you'll be one of the first women in Venice to meet Angeletto."

While my family erupted into happy, anticipatory chatter, I stretched my arms over my head and gave a mighty yawn.

Chapter Nine

We were early. Night had barely unfolded her star-silvered mantle when our gondola drew up to the water entrance of the Ca'Passoni. A calm silence reigned, broken only by the dip of our oars in the dark water streaked by the flaming reflections from the portico lamps. The Savio's palace rose lofty and majestic—waiting, it seemed, for the arrival of a much grander party than ours.

As the gondolier fastened his mooring rope, a pair of liveried servants broke away from their posts flanking the bronze entry doors and skittered down the marble steps to assist the ladies to disembark.

Annetta had indeed worn her crimson gown, now swathed in a black lace *zendale* against the nocturnal coolness. Liya, who usually dressed for utmost practicality, had also fussed. When I'd first met her, she had been employed in making headdresses and helmets for the theater. For tonight, she had put her sewing skills back to work. Her chignon of thick dark hair was embellished by a tiny, pearl-studded cap sporting an ostrich plume, and her fine neck and shoulders were set off by snow-white ruffles atop a silver-embroidered, cobalt-blue bodice. We passed through the foyer and into the salon unannounced. Frescos vaulted above us, punctuated by hanging chandeliers fashioned of yellow and pink Murano glass. The wide, empty expanse of mosaic floor shone in the glow of wax tapers and their hundred mirrored reflections.

My wife clutched my arm and leaned close. The scent of orange-blossoms brought an involuntary smile to my lips.

"Everything will go perfectly," Liya warmly advised. "No one would dare make trouble on such a dignified occasion."

"Did you consult your cards?" I whispered back, not certain whether I was teasing or not.

A rare expression flickered in her face. So rare it took me a moment recognize it: bewilderment. "They told me nothing," Liya replied in a flat voice. "I'm speaking from my heart, and it is telling you not to worry."

I marveled at that organ's optimism. My own heart subscribed to a cardinal rule of the theater: If something can go wrong, it absolutely will. And at the worst possible moment.

A harpsichord sounded above, and on its heels, the A string of a violin. I looked up. A gallery overhung the far end of the salon. A small orchestra consisting of the theater's best musicians had assembled there. Giuseppe Balbi was tuning his instrument, broad face and fluffy wig appearing top-heavy on his slender form. He saw me, too, and greeted my party with a flourish of his bow. I saluted him with a wave. Good old Balbi. I knew I could count on him to do the Teatro San Marco proud.

An open stairway dropped from the gallery level, railed with gilt, and guarded by a matched pair of torch-bearing caryatids. Across the salon, at a square angle, an archway led to the banqueting hall. That room was alive with maids and footmen ferrying trays and covered serving dishes to a linen-draped table that must have been yards long. The smells wafting into the salon made my mouth water. Prawns in butter and venison tarts, if I didn't miss my guess.

Gussie and Annetta had been admiring a second harpsichord, a pretty thing enameled in red with ebony keys, with Flemish paper decorating the keywell and lid. This beauty stood in the corner beside the descending stairway. I would play the instrument later in the evening to accompany the planned entertainment. As Gussie and Annetta strolled back over, my brother-in-law posed a question: "I say, Tito, are we going to hear Angeletto tonight?"

"No, Maestro Torani suggested that I have Oriana Foscari sing several of the milkmaid's arias."

"Deuced shame, if you ask me." Gussie traded a sour look with Annetta.

"It's only good business," a new voice spoke up.

I turned to see Maria Luisa Vanini at my elbow, wearing a gown the color of smoke. A plain linen fichu was wound round her neck and pinned high on her bosom. Her spectacles were in place, and her hair arranged in the same knot she'd worn in Milan.

"Would you buy the cow once you've had the milk for free?" she continued in response to Gussie's puzzled look. "Tickets! Box office! When my brother sings in Venice for the first time, people will have paid for the privilege of hearing him."

"She does make a point," I observed airily, and then made introductions among the ladies.

Liya nodded approvingly. "You look after your brother's monetary interests."

"I look after all my brother's interests," Maria Luisa replied smoothly. Her eyes narrowed to slits behind her glasses and took in the entire group, perhaps all of Venice. "And a pox on those who attempt to cross us."

Though there'd been no humor behind her words, Gussie chuckled faintly. I bit my lip to keep from shooting back a reply. It could be worse. Maria Luisa could be dragging her crone of a mother and all the young sisters and cousins in her wake.

She nodded from me to the harpsichord in the corner. "Maestro, have you tested the instrument?"

Maestro? Torani was the maestro, not me.

I shrugged. "It's fine, I'm sure. Signor Passoni hosts many musical evenings. In a house like this, no instrument would be allowed to go out of tune."

"A house like this—you mean a house built on a veritable cistern? With damp seeping into its foundation stones and mist burrowing through its window frames?" She went on in a thin, precise voice, "Nothing plays havoc with a keyboard more

quickly than damp. You are now the opera director, are you not? It's your responsibility to see that all is well."

She was correct—damned troublesome woman.

I followed her across the salon. Maria Luisa's back was ramrod straight, and her uncommonly long arms dangled at her side— like a spider's legs, I thought unkindly. I also wondered why the woman was so concerned about the tuning of an instrument that would not be accompanying her brother.

I'd brushed aside the skirts of my brocade jacket and half-lowered myself to the harpsichord's bench when an idea struck me. I straightened and gestured to the keyboard as if I were offering this testy woman a lavish gift. "Please, Signorina. You do the honors."

Maria Luisa's expression registered surprise, but she did as I asked. After sounding a few tentative chords, she launched into a Bach prelude. It was a perfect piece to test the entire keyboard, filled with arpeggios and complex harmonies, all within range of her long reach. Interesting…brother Angeletto wasn't the only accomplished musician in the Vanini family.

Though the harpsichord was in perfect tune, Maria Luisa kept playing as she made room for me on the bench and said, "I want to speak to you before the guests start arriving."

"Yes?" I sank down. We were shoulder to shoulder. A presentiment of trouble fluttered in my belly.

She started on a deep breath. "When we came to Venice, I expected my brother to be courteously received."

"And has he not?"

"Scathing accusations have reached our ears. Evil gossip." Her fingers hit the keys like little hammers. "People are saying that Carlo is a cheat—a woman wearing breeches—only pretending to be a castrato soprano."

"I've heard the same," I admitted.

Her hands fell away from the keys and she turned to regard me with a vengeful gaze. "You have no idea of the pain these gossiping tongues have caused my brother."

Without naming Girolamo Grillo, I assured Maria Luisa that I'd induced the source of the unfortunate rumors to leave Venice. She countered by pointing out the obvious: once a titillating story is loosed, there's no containing it.

"How could you let this happen?" she asked angrily. In vain I sketched the rivalry between the two opera houses, the lengths that Lorenzo Caprioli would go to in order to insure that his Teatro Grimani came out on top. Maria Luisa wasn't mollified.

"What else can you possibly expect me to do?" My store of patience and tact was rapidly dwindling.

"You must raise Carlo's salary to compensate for his embarrassment and suffering."

I could scarcely believe the woman. "Is that your answer to every stone in your brother's path—money?"

"He is due—"

I rose, dismissing further discussion. "Carlo is due nothing more than his contract stipulates—and you can tell him this for me—now that he has become *Angeletto*, he will learn to deal with fame and all of its trappings or end up one very unhappy man."

I made my bow to the simmering Maria Luisa. Heart hammering under my ribs, I took long steps toward the foyer where activity was picking up. It must have been getting close to eight o'clock. Up in the gallery, Balbi and his musicians were lowering their talents to play a tinkling minuet, the sort of innocuous, background drivel they could play in their sleep. Outside, gondolas would be lining up at the mooring posts. The reception would soon begin in earnest.

Gussie intercepted me. "Something wrong, Tito?"

"Merely the small coin of theater life." I shook my head. "How is Annetta faring?"

"She's getting her bearings. Look." He pointed. "She and Liya are talking to the star of the hour."

I followed Gussie's pointing finger. In the foyer, a beautifully turned out Angeletto was being put through his paces like a trained bear at Carnival. He was giving my sister and my wife a low, graceful bow. Ah, he was kissing Annetta's hand.

Gussie harrumphed. "Damn counterfeit peacock," he muttered. "What makes these women think that this creature walks on water?"

"Hush," I cautioned under my breath. Whatever Angeletto might be, and however indulged by family and admirers, he knew how to flatter a woman. I could make out Annetta's blush and radiant smile from where we stood ten yards away. It was good to see her excited over something. Liya appeared similarly charmed, though she wasn't blushing.

If Angeletto was the star of this menagerie, his keeper was the Savio. Signor Passoni drifted from group to group, passing a word here, nodding there. The foyer was becoming quite crowded with people who tarried determinedly hoping to be presented to the divine creature. Searching for evidence of Grillo's gossip, I did see a few skewed glances and several curled lips, but no one turned down the opportunity to meet the singer. By some criteria which was lost on me, the Savio selected which guest would have that privilege. With great ceremony, Passoni conducted his chosen one to Angeletto, who invariably greeted the newcomer with another bow and a slight, patient smile.

But where was Majorano? The occasion that was meant to present these two singers on an equal footing was in danger of becoming a solo tour de force for Angeletto. I tried to imagine what our princely young star had in mind, then chuckled. I'd wager Majorano was waiting until the guests had all arrived so that he could make a grand entrance.

While Gussie succumbed to the temptations of the dining table and our ladies found acquaintances to converse with, I strolled through the knots of guests filtering into the salon. Each was announced by Signor Passoni's major domo, an old fellow whose livery was resplendent with golden epaulettes and yards of braid. The guests were an odd mixture of elegantly outfitted aristocrats; smug, black-clad clerks who ranked high enough in the complicated routine of government to grace a reception hosted by one of the ruling families; a few bishops and monseigneurs; and a sprinkling of well-known theatrical

performers. The latter were immediately recognizable, even if I hadn't known most of them; by virtue of their glittering finery and dramatic gestures, the performers stood out so much more vividly than anyone else.

The Savio had even invited a few shabby-looking literary men: poets, playwrights, and journalists. Nothing spreads news of a triumph like a cleverly wielded pen. And since the Savio all Cultura had oversight of Venice's news-gazettes as well as its theaters, we could count on a favorable report.

Pushing the carnival season, a few guests were wearing masks or dominos: no fancy costumes as would soon be seen, merely molded half-masks that covered the eyes and nose; or on the women, the disguising velvet ovals peculiar to Venice. One of the maskers particularly caught my eye. The fellow was flitting around the salon's perimeter, pausing in shadowed corners, and often turning to admire a painting or ornamental mirror, as if he desired to escape notice. His mask of smooth white leather rose to meet the forehead seam of his powdered wig, and because one hand continuously played about his chin, I was unable to see more than a square inch of his face. *But there was something about his tight, turquoise breeches and that narrow gait....*

The sight of young Beatrice interrupted my train of thought. I'd wondered when she would make her appearance. The girl wore a billowing yellow gown too sallow for her complexion and too low-cut for her tender years. Its skirt rose and fell as she floated about like a tropical bird moving from branch to branch, and she was constantly smoothing it down with her hands. When she drew near, I overheard her describing the Vanini family's arrival at the palazzo, then giving a recitation of the foods Angeletto seemed to favor. Both gentlemen and ladies deserted disgruntled partners to attend to her. I shook my head—not at Beatrice's girlish antics, but at the fact that anyone actually cared to learn what the singer preferred for breakfast.

When I turned my attention back to the skulking masked man, he was gone.

It was time to pay my respects to our hostess, now my confidential patroness thanks to the weasel-skin purse of coins delivered by Franco before I'd left for Milan. Signora Passoni and her cavaliere stood well away from Angeletto and his growing circle of admirers. Neither altogether in the foyer nor in the salon, they seemed more observers than part and parcel of the reception. I'd always felt rather sorry for this woman who stood so completely in the shadows thrown by her brightly shining husband and daughter. I'd spent her coins to enhance *The False Duke*, and I hoped she would be happy with the results.

The signora—I don't think I'd ever heard her Christian name—had passed her fortieth name day, but she'd maintained a trim waist. Unfortunately however, the contours of her bosom resembled a pair of squashed panini. Her pleasant face was neither overly painted nor decorated with patches. Above, the soft curls of her formal wig put me in mind of a mound of whipped cream destined for a bowl of strawberries. As I straightened from my bow, she tilted her pointed chin and a smile descended from her crinkled eyes to her rouged lips.

"Always a pleasure, Signor Amato," she said, as the singularly named Franco nodded benignly in the background.

"You are very kind to play host to Angeletto and his family," I said.

"There did turn out to be a few more of them than we'd expected." She gave me a droll smile. Franco cocked an eyebrow.

"I hope they're not causing any trouble."

"Not at all—after our major domo put the old mother in her place. Except for the sister who seems to act as emissary for the lot, they mostly stay in their quarters. When I do see our angel duke, he makes a pretty bow, but has little to say. In fact, he acts as if he couldn't count to five without his mother or sister encouraging him."

Our three gazes slid inexorably toward the Savio and Angeletto.

"Tell me," Signora Passoni continued in a curiously brittle tone, "will *The False Duke* be true to his promise?"

She was asking if the opera would be ready for opening night. Everyone else just assumed the production was proceeding according to plan. I was by no means certain—I had yet to conduct Angeletto's delayed rehearsals—but I put on a show of bravado. "Of course. *The Duke* would never let us down, and his premiere will be spectacular."

My wife often asserted that words have power in and of themselves. Perhaps saying it would make it so.

"And my husband's shipwreck? He talks of nothing else. How does it progress?" The signora removed her fan from the reticule bag hanging from her wrist like a fat sausage in a velvet casing. Wasn't that Franco's job to keep up with such sundries as hankies and fans?

I replied with an enthusiastic nod, "Ziani has outdone himself. The wreck on the rocky coast will be talked about for years to come." On this point, I could answer quite honestly. Our machinist had started with double the usual amount of thunder and lightning, and then crafted rolling cylinders swathed in billows of silk to represent the waves. Angeletto and Oriana would sing their concluding duet lashed to the mast of a marvelous ship's deck that would split in two with the release of a hidden lever.

As pleasant as Signora Passoni's smile was while conversing with me, it brightened to lighthouse-beam intensity when Signor Rocatti joined us.

"Niccolo," she greeted the composer warmly, "what kept you?"

"Giovanna, I came as soon as the Pieta's master would give me leave." He took both of her hands in his and kissed them.

I glanced at Franco. I thought bestowing kisses was also his job, but the tall eunuch seemed unperturbed.

Signora Passoni—Giovanna!—tapped her folded fan in her palm. "They work you too hard at the Pieta—it's criminal. I wish you would let me speak—"

The handsome young man stopped her with a caress to her bare forearm. "I may be a teacher there, but I'm still learning. I must comply with the discipline of the head maestro."

Signora Passoni merely set her lips in a hard line, so I rushed in to fill the silence. "You studied under Maestro Vivaldi, didn't you? You were one of his few male pupils."

Rocatti nodded, smiling. "It was a piece of extraordinary luck that I was born in a time and place to be given that opportunity."

"Well, now that you are here"—Signora Passoni put her fan into play again, this time aflutter—"would you at least consent to accompany Oriana Foscari tonight."

The composer's thin face flushed right up to the powdered waves that furrowed back from his smooth brow. His expression sobered. "It will give me great pleasure to hear my music interpreted by Signor Amato."

"Oh!" The signora's fan flew to cover her face for an instant. "You must think me very rude, Signor Amato. Of course you must play the harpsichord for Oriana. It's been planned." Lowering the fan to flutter at her flat bosom, she drilled me with the gaze of a patrician accustomed to having her whims carried out. "Unless...you might prefer to take your ease."

Rocatti and I traded glances. His was hopeful, buoyant even. Had he become less shy in the aura cast by his patroness?

I capitulated. Rocatti went to confer with Oriana, and the signora and her cavaliere drifted off into the salon that swirled with a medley of bright silks and satins and froths of lace at necks and elbows. From the gallery above, innocuous but sprightly music rained down on the brilliant assembly. It was a pretty piece, one I was unacquainted with. Perhaps it was one of Balbi's own compositions.

I was searching for Liya when a surprise guest was announced.

"Maestro Rinaldo Torani," the major domo declaimed above the babble. Then softer: "And Signora Teodora Dall'Agata."

I whirled to see the old man advancing, silver-headed stick supporting him on the right, Tedi's crooked arm on the left. I swallowed over the lump in my throat. Torani looked ancient. His translucent skin was stretched so tight that the bones of his cheeks and scarred forehead stood out in sharp relief. His moss-green taffeta coat hung so loosely from his thin shoulders that

he could have been a carnival dummy fashioned of old clothing draped over a pair of crossed sticks.

I shook my head. The maestro should be home in bed, not hobnobbing with this crowd. What had Tedi been thinking to bring him to the Ca'Passoni?

A second glance at the soprano showed me that she wore her second-best gown and that her hair had been clumsily arranged with a blue aigrette as its only adornment. The delicate skin under her eyes was bagging, and her cheeks were pale under dots of rouge. Tedi was watching me, too. She launched a pained look. I understood; it hadn't been Tedi's idea to attend the reception.

"My boy," Torani burst out when I reached them. "I couldn't stay away. No, don't fuss." He resisted my efforts to take his stick and transfer his arm to mine. "With the San Marco on the verge of such a great success, how could you expect me to stay abed like a lazy Calabrian?"

"But, Maestro, you're not well."

"I'm fine, fine. Ah, our host…"

Signor Passoni strode up, overflowing with dignity and concern. He beckoned his major domo, and together they supported Torani to a seat on the front row of gilt chairs that footmen were assembling in a half-circle around the harpsichord.

Before I could say a word, Tedi spread her hands. "I tried to keep him down, Tito—I really did. While I'd gone to the bodega to fetch some supper, the old fool made his valet send for Peppino and his gondola, then dress him in his best suit. Rinaldo was waiting on the doorstep when I returned—he actually threatened to lock me out of the house if I didn't go along with him."

I sighed. "Maestro does insist on being in the middle of things."

"Not just that. Rinaldo intends to buttonhole all of the influential Senators he can find—"

"And extol the San Marco's virtues against the Teatro Grimani's?" I finished.

"Exactly."

"That seems like a tactic of desperation," I said dubiously. "I was intending to let the music speak for itself."

Tedi didn't answer but raised her eyebrows at someone behind me. It was Balbi, doughy cheeks bunched in a frown. "Is Maestro Torani all right?" the violinist asked with obvious concern.

"He's weak. I'm going to keep an eye on him."

Tedi chimed in, "And I'm going to get him home as soon as I can."

"Where are you off to?" I asked.

Balbi rolled his eyes with an air of patient suffering. "Supper," he said. "We've been offered a meal in the kitchen while the *principal* entertainment proceeds."

I sent him on his way with the advice to eat a bellyful and make sure he and his men drank their share of the Ca'Passoni's good wine. Then, the Savio's major domo sounded a small gong beside the gallery stairs, summoning the guests to be seated. This pompous household official appeared vexed by Torani's unexpected presence. I could almost see the wheels turning in his head as he was forced to formulate a new seating arrangement.

Certainly Torani, as the longtime director of the opera house, must be seated on the first row, but how near the center, and did that courtesy extend to his mistress? And should the maestro push Angeletto, the honored guest of the house, one seat over from the center? That would put his poorly dressed sister one row back.

And what on earth to do with Tito Amato, the present director, since he wouldn't be playing the harpsichord after all?

Oh, dear. Beads of sweat trickled down the major domo's forehead. He wrung his hands.

I finally ended up on the second row, directly behind Signora Passoni, who sat with Franco on her right and Maestro Torani on her left. My family was relegated to the pigeon loft, the twelfth and last row. They would see very little over the wigs and stiff ostrich plumes in front of them, but at least they could hear. Tedi had been consigned I knew not where.

Now, I thought, as I squirmed on the padded-silk chair. Now we will see what Venice thinks of *The False Duke.*

Chapter Ten

Rocatti and Oriana crossed the expanse from the foyer. The lovely Oriana fairly floated, smiling with every muscle of her face, keenly aware of making the correct impression. At her elbow, one step behind, the young composer kept his eyes glued to the harpsichord, either unwilling or unable to meet the gaze of the audience.

They took their places. Garbed in an elaborate gown of violet silk, with her fair hair immaculately coiffed, the tiny Oriana resembled the French fashion doll on perpetual display in the window of the exclusive dressmaker's establishment on the Merceria. She clasped a sheaf of music in her small hands, not because she required it, but because she'd decided she looked quite fetching holding the music at a gracefully curved arm's length.

Rocatti struck the keys and they were off. The little soprano sang with a voice to rival Angeletto's, and the composer accompanied her with fire and force. The first aria was so sweet, so full of the milkmaid's longing, that many listeners were moved to tears. The second was lilting and jocular, ending with a glorious note that seemed to stretch to infinity. Though I'd repeatedly schooled Oriana in the technique for this very aria, I felt the hairs on the back of my neck rise.

And then there were the inevitable encores. Before Oriana's last note died away, I knew we had a triumph.

"Astonishing. Marvelous. A miracle," I'd been hearing people exclaim behind me. "This new opera will be something to see,"

they murmured from every quarter. "Do we still have our box at the San Marco?"

Along with almost everyone else, I sprang to my feet, applauding and nodding appreciatively.

Torani didn't rise, but sat erect, pounding the tiled floor with the stick planted between his feet. His benevolent gaze beamed on one and all.

Once a mass of white blooms had been pushed into Oriana's arms, once Rocatti had risen to take his bows, once the general tumult had died down and the audience had again seated themselves, Torani pushed himself up on his stick. Polite clapping followed the old man as he limped to the harpsichord and turned to face the assembly. He raised his hand for silence and then proclaimed in a stage voice that belied his fragile appearance, "My good people, tonight you have witnessed a taste of Heaven. When *The False Duke* opens, you may banquet on its many beauties—banquet to your fill. Anyone who misses it will be most unfortunate indeed, as I predict our new opera will eclipse anything else presented this season."

The maestro bobbed his head so deeply, he was almost taking a bow himself. "Though I can't claim to have composed this treasure, I *can* take credit for discovering the opera and its young composer. Thank the Blessed Virgin, I found it in time to replace the gruel we were going to make do with."

What? My jaw dropped and hung open. Torani taking credit for discovering *The False Duke*? When I had taken so many pains to persuade him to even consider mounting the opera? And then brought it to near fruition through hours of rehearsal and staging? I almost cried aloud—No!

Torani rambled on as he returned to his seat: "It is my considered opinion that nothing this fine has been heard since Maestro Vivaldi's days. Rocatti may even be the better composer: in addition to capturing your heart, he can make you laugh."

Like two puppets controlled by one wire, Signora Passoni and Franco swiveled to face each other. They exchanged an enigmatic look.

After Torani had eased himself down, he leaned close to Signora Passoni and spoke more quietly: "Did you hear the whispers of Vivaldi, my dear signora?" The old maestro's jaws stretched in his wolf grin. "If anyone were to notice, I expect it would be you."

Signora Passoni's cheeks flamed as if she'd been slapped. She jumped up, one hand to her flat bosom. She took a few steps, and her reticule bag fell to the floor with a clunk. Franco trailed behind her, inquiring in a stage whisper that seemed to be directed to anyone and everyone except his lady, "Cara, are you ill? Do you have a faint coming on? May I get your smelling box?"

I rose, pushed the signora's empty chair away, and retrieved the bag. It wasn't the velvet trifle I expected; it weighed my palm down as if it were filled with pebbles. Signora Passoni obviously carried more than a female's usual mirror, comb, scent bottle, and snuffbox. I caught up to Franco and handed him the bag. He stowed it his pocket with a quick nod of thanks.

A violin flourish sounded from the gallery and a cheerful gavotte reeled through the smoke-hazed air; Balbi and his men had ascended the narrow staircase during the applause. As the salon took up its chatter once again, I felt compelled to make my own escape. Perhaps I could face Maestro Torani later, but for now, I didn't want to even look on him.

"Tito," I thought I heard Torani call, but I ignored it. I was hot under my clothes and couldn't catch my breath, as if this crowded space were suffocating me. From a distance, Gussie waved to catch my attention. Beside him, Liya regarded me with an anxious hand to her lips. I shook my head at both of them. I needed to be alone.

Footmen appeared to whisk the chairs away, and the guests were on the move again, processing toward the banqueting hall. To conclude the evening, ices were being served. I pushed the opposite way. A few well-wishers intent on complimenting the performance tugged at my sleeve or planted themselves in front of me. I'm afraid I did little more than murmur excuses and

advance toward the foyer. I emerged into its emptiness with a sigh of relief and kept right on walking.

For one wild moment I considered flinging myself into the night, but then the staircase which led down to the Ca'Passoni's business level beckoned, almost affectionately. It was dark, cool, deserted. I descended a few steps and felt myself slip into blessed invisibility. Ignoring the musty draft, I shrank against the wall, oddly comforted by its cold smoothness.

Why had Torani taken credit for discovering *The False Duke*? How dare he rip that laurel from my grasp? What else was I to do now that my voice was gone? It was my pumping heart that whispered these questions. Not singing had once been inconceivable. Venice had basked in my voice, as I'd basked in Venetian cheers and applause. And now? I was striving to take on the mantle of my mentor, but how could I become the maestro when Torani failed to acknowledge my worth? Tears stung beneath my eyelids.

I refused to let them flow. Sadness was weakening. If I gave it free rein, it would rush headlong into the hollow dug out by Maestro Torani's humiliation. I closed my eyes. Breathing deeply, I endeavored to calm my senses and strengthen my will so that I could end the reception and walk out of the Ca'Passoni with head held high.

Eventually a chilled, impassive Tito that I barely knew was ready to return to the salon. I ascended several steps, but paused when I noticed a young maid creeping along the corridor. Her furtive demeanor aroused my curiosity. She wasn't a serving girl from the kitchen. The black, high-necked bodice and tailed muslin cap atop a coronet of sleek braids marked her as a ladies' maid, probably from the private family apartments. Keeping against the wall, I mounted several more steps.

From that oblique vantage point, I watched the maid dodge around the guests engaged in conversation in the foyer. In just a few moments, she'd cut Beatrice out of the herd as skillfully as a Bergamese sheep dog.

A folded missive changed hands so quickly I wouldn't have seen it except for the glaring contrast of white paper against the maid's black bodice. Beatrice secreted the note in her palm and read it with a slanting, nonchalant gaze before crumpling it in her fist. After a glance around, the little minx hurried toward the back of the palazzo with the maid at her heels. Neither of them saw me in the stairwell as they passed.

Was this the mischief Tedi had feared? Beatrice's sly mission might well be none of my business, but then again, if it involved Angeletto, it was very much my business.

I followed the girls down the wide corridor, hanging back when they turned and disappeared from sight. After a few seconds, the maid reappeared and looked as if she meant to station herself as a lookout.

I approached, clearing my throat. "Ah, there you are," I said in a severe tone. "The signora requires you upstairs." Which signora? Well, it didn't really matter, did it?

Big brown eyes widened in surprise. Looking back down the empty passage, the maid stammered a few words.

"She's spilled something on her gown," I pressed. "She'll have your head if you don't hurry."

The poor girl gathered her skirts and ran for the main stairs.

I dove into the narrower, less resplendent passageway. Moving as quickly and silently as I could, I soon heard muffled voices. A paneled door stood slightly ajar. Through the crack came a young woman's voice, at once beseeching and fearful, then a man's deeper rumble. I have an ear for voices—a consequence of my training, I suppose. Beatrice's was unmistakable. The other I could only guess at, but even so, it dripped into my ears like corrosive acid.

Slowly, barely breathing, I pushed the door open another couple of inches and applied my eye to the slit. The room was laid out similar to the Savio's study. The large leaded-glass window, set in a deep embrasure, was open to the night air. If I had the geography of the house correct, the window would overlook a narrow strip of well-tended garden. In front of the window, a

tripod card table held a squat candle whose wax drips snaked down its heavy bronze stand. Someone had laid out a tableau of playing cards for the solitary game of Patience on the felt tabletop, but the game had been abandoned in mid-play. A green cloak with bright yellow lining was draped over the back of the table's one chair.

A moan sounded from a shadowy corner well away from the candle's glow. I craned my neck and saw a couple entangled on a low sofa. The folds of Beatrice's gown shown golden in the errant rays. It had been pulled up over her white thighs. Her garters were a startling red. What sixteen-year-old girl wears red garters? I thought, apropos of nothing.

"I'm afraid," the girl was saying. "What if someone comes?"

The man laughed. "I promised your maid a zecchino if she kept the corridor clear—and the back of my hand if she didn't. You're safe, my pigeon. Now…"

His arm eeled under the golden skirts. Beatrice responded with a catch of her breath, then arched her back. But her round mouth whispered, "No, no."

It was the sight of his breeches slipping over his naked buttocks that got my feet moving. I threw the door open so hard it slammed against the wall. The couple sprang from the sofa, clutching clothing, jerking at fastenings.

I drew enough breath to shout, but restrained myself to a raspy whisper. "Signor Grillo, I expected you'd be over on the mainland by now."

Beatrice crossed her arms over her bosom, as if she'd just realized how low her neckline was. Then, with a strangled cry, she ducked her chin and ran. As she pushed past me in the doorway, she spat out, "I hate you, Tito Amato." I felt the spray of her spittle on my chin.

She continued running down the passageway and around the corner. I made no attempt to stop her. Beatrice had only been doing what comes naturally to a girl awakening to womanhood. Grillo was another story entirely.

Signor Passoni met the boy on the fly, caught him in mid bound, and gave his shoulders a rough shake. For a moment, thought the Savio was going to slap him. "What do you mean by this display?" he cried.

The remaining guests pressed in, alarmed and curious. I wa dimly aware of Maria Luisa rushing to her brother's side. Where had she been all evening? I'd barely seen her.

Carlito's cheeks had been drained as pale as ivory; his freck- les stood out like spots of mud. "The old maestro. In the card room. He is dead."

I stepped into the room, not sure what I intended. Did I mean to send him on his way for good this time? Or to drag him before the Savio by the scuff of his neck?

The attack came so quickly, I was afterwards never wholly able to piece it together. Grillo rushed me, teeth bared icy white against his dark cheeks. He looked so wild, he could have escaped from the madhouse. I jumped sideways, off balance, and upset the tripod table.

The candle stand clattered to the terrazzo floor, and the flame extinguished itself. It was suddenly as dark as the inside of a caulking barrel.

Blinded, I felt the cold blade of a stiletto against my throat.

I had a stiletto, too. At home. I'd failed to change it to the pocket of my dress waistcoat.

Grillo's blade pricked my skin, and one thought exploded in my brain—I couldn't die with so much yet undone. I thrust my assailant's arm upwards, wildly, and snapped my bent knee straight into his crotch. Or so I aimed—Alessandro is the fighter, not me—my blow missed its mark.

Grillo danced away. As I whirled back and forth in the dark, I heard his laugh and then a snort like a boar's.

My eyes adjusted to the low light filtering through the open door just in time to see him come at me again. He was slicing the stiletto blade in wide arcs, bounding forward, ever forward.

Retreating in undiluted terror, I tumbled backwards over the upturned table. The hard floor jarred my bones, but also deliv- ered the heavy square candle stand into my fortunate grasp. I sprang up and swung my new weapon. This time I didn't miss. A sharp corner caught my assailant's right temple. Grillo bellowed in pain and clamped a hand to his face.

Feeling triumphant, I tarried in one spot too long. Grillo lunged, and I felt his blade rip across my shirt and graze my chest. The moment it took for me to look down and assure myself I wasn't mortally wounded gave him the opportunity to escape.

Grillo knocked aside the chair that was still standing. In one smooth motion, he pressed his hands to the broad window sill and leapt through the aperture.

He turned and stuck his head back through, just for an instant. Blood dribbled from a gash beside his right eye. Even so, he wore the wide grin of scoundrel who was delighted with his escapade. Then he disappeared.

Hands clasped to my chest, I stumbled to the window and leaned out. The Savio's garden appeared deserted. At first I heard nothing, then a muffled splash. I saw only a narrow gravel path, an overturned rose tree in a broken pot, and a balustraded stone railing stretching into the darkness.

◇◇◇

My wound amounted to little. Being hoodwinked by Grillo stung a hundred times worse.

I withdrew from the card room, found the water closet, and prevailed upon the footman who usually answered the door to bring me clean cloths to wash and bind my chest. In a few minutes, he returned with a soothing balm, as well.

"What's your name?" I asked.

"Carlito, Signore." His fresh, freckled face registered avid curiosity, but he was too well-trained to put any questions to me.

My shirt showed some bloody stains. Dabbing with water only caused them to spread, making it appear as though I'd been run through with a rapier. I shook my head. Benito would insist on consigning the shirt to the trash the minute he saw it. With Carlito's help, I rearranged my lace cravat so that it covered the worst of the stains. I also buttoned my jacket over my waistcoat. Swiveling back and forth before a cloudy mirror, I decided I could take hasty leave of the palazzo without calling attention to myself.

I found Liya in the foyer searching for me with a worried frown. By the bronze entry doors, guests were making their bows and curtsies to the Savio, who stood with a weary-looking Angeletto. No one paid me the slightest attention. Except Liya. My wife made a quick inspection of my person and her dark

eyes peered intently into mine. "Where have you been?" she whispered. "What happened?"

I brushed a stray hair from her neck and bent to her ear. "It's best told at home."

My wife grabbed the lace at my wrist. "Tito, this is blood!" she exclaimed, still in a whisper. "And your shirt!" To her credit, she didn't immediately attempt to unbutton my jacket. She merely stated, "I'll find Annetta and Gussie—then we go."

I nodded, feeling like a weight had been lifted from my shoulders. But I had one more duty to perform. "I must say goodnight to Maestro Torani."

As Liya hurried off, I stepped into the salon and scanned the diminishing crowd for Torani's hawk-nosed profile. I didn't see him, but I did spy Tedi's delphinium blue. She and another singer were in deep conversation by the harpsichord. Tedi seemed to sense my stare. She turned and our gazes met across the space grown smoke-hazy from hundreds of burning tapers.

Torani? I silently mouthed, injecting a question into expression.

Tedi shrugged her shoulders and made a vague ge towards the tables. I hurried into the banqueting hall b only a few stragglers clinking their spoons to scrape the their ices from crystal bowls. Along the wall, a quartet men waited to clear the table with silver trays. Thinki I realized that I hadn't seen the maestro since I'd hu directly after Oriana had sung her pieces. That was at minutes ago.

I rubbed my chest, which was aching under the dage. Torani wasn't in the salon or banqueting hall man gone in search of the water closet? He coul unseen while I was talking with Liya.

I'd just stepped out of the salon when chaos

Carlito ran into the crowded foyer, yelling in his rounded features distorted by fright. In or an empty silver salver. With every bound, the wig bounced on his shoulders.

Chapter Eleven

Torani—more than merely dead.

He'd been murdered. Murdered!

The word drummed in my head as I stared down at the maestro's lifeless body on the floor of the card room where I had so recently faced my own end. A wave of grief inundated me. A sharp grief of the kind I hadn't known since my sister Grisella had met her terrible death.

Torani lay on his stomach, neck twisted to show the profile of his razor-sharp jaw jutting up at an acute angle, curving nose, and one rheumy eye staring at…nothing. Shafts of light from several branching candelabra shone on his bare, shiny skull and made a melting glow of the dark red blood seeping onto the terrazzo floor. I gulped back tears at the sight.

Tedi was kneeling beside the body on an island of blue skirts. She rocked back and forth, emitting desolate whimpers of distress. Tears also welled unshed in her eyes. I wanted those tears to flow, for me and for her. I sank down, reached for her hand. It lay limp in mine.

"Tedi, Tedi," I soothed. And then, squeezing her fingers. "When did he leave you? Did he go to meet someone?"

The grieving soprano appeared deaf to my questions. She was dazedly asking and answering her own: "How is this possible? It's not—it's totally impossible—it makes no sense." She removed her hand from mine and wiped the tears that finally

began to flow. "Why did I let the fool wander off alone? Because our troubles were over, that's why—we had nothing to fear."

Nothing to fear? This was the third time an anonymous villain had caused harm to Maestro Torani. This time, the ultimate harm. What did Liya always say—the third time seals the charm? I felt a mad laugh rising up my windpipe.

Swallowing hard, I looked up at Signor Passoni. He stood a few feet away, still clutching Carlito's collar in his bony fist. The footman stared at me with aching eyes, and then dipped his chin to the floor.

Candlelight glinted off the Savio's emerald ring as he released Carlito, underscoring the authority and power concentrated in that aristocratic hand. The Savio's usually pleasant, cultured expression had turned as craggy as the Dolomite cliffs. Venice's most revered opera director had been cruelly struck down within the confines of his ancestral palazzo, and he was taking it hard.

Passoni announced, to no one in particular, "I've summoned Messer Grande."

I was dimly aware of people edging into the room from the narrow passageway. There were murmurs, gasps, and the rustle of silk skirts. Oriana hastened to coax Tedi away from Torani's body. The soprano's tears became a flood as her friend embraced her. Balbi patted Tedi's shoulder awkwardly. He and a few other musicians murmured words of disbelief, then comfort. Rocatti stood by himself, one hand squeezing the curved back of the sofa, staring down at Maestro Torani's body with opaque slate grey eyes. My family was suddenly there, hovering over me without speaking. Then people I barely knew crept in, people I hadn't even spoken to during the evening.

The only noticeable absences were Angeletto and Maria Luisa. Were they displaying a marked degree of tact? Or had Maria Luisa dragged her brother away so that he would not be exposed to any taint of unpleasantness?

The room had grown quite crowded when Signora Passoni finally pushed through. For once it was Beatrice glued to her side

instead of Franco—the flitting yellow bird was now sheltering under mama's wing.

"Arcangelo, what has happened here?" the signora asked her husband. He ignored her. Instead of repeating her question, she turned to beam compassion upon our miserable tableau. I was too dismayed to take any comfort from it.

The Savio addressed me with grim determination. "Signor Amato, I must ask you to remove your jacket."

I rose slowly. My grief surrendered to a mounting sense of horror. I was a suspect! Of course, Carlito had been forced to tell his master about my injury. I unbuttoned my jacket, shrugged out of it, and removed my waistcoat for good measure. What else could I do?

An ascending arpeggio of sharp, indrawn breaths ran around the room when I revealed the torn linen shirt flecked with blood and stained rosy pink where I'd tried to cleanse it.

Liya pressed herself to my side with a little moan. Annetta was suddenly on the other, and both women wrapped me a protective embrace. Gussie's blue eyes were aflame. He took a step forward and addressed the Savio hoarsely: "Excellency, with respect, you can't mean to accuse Tito."

Passoni gestured toward Torani's body with a scoop of his long hand. "I see before me one man bloodied and one man covered in blood. What else can I make of it?"

"Hardly covered." Liya fumbled with my shirt ties. Frustrated in her efforts, she tore the fabric farther. "Look, Tito has been wounded. He's bled through this bandage and onto his shirt. He just needs to tell us what's happened."

Passoni glanced at her sharply. "I'm giving Tito the opportunity to explain himself. If he can well and good, if not I'll be forced to think the worst."

With a nod, Gussie echoed Liya. "Just tell us what happened, Tito."

Everyone peered at me with expectant gazes. Many leaned forward encouragingly; a few held back, smirking suspiciously.

"I was attacked," I said evenly, raising my voice. "This is my own blood that you see." "Attacked by Maestro Torani?" The Savio stiffened. "The very idea affronts me."

"No, not by the maestro…not at all.…" I stammered. "By… someone else." I quickly unwound the cloth that bound my chest, revealing a thin, angry red line, still seeping in places. "I fought with…another man. Right here in this room. He attacked me with a stiletto. I managed to bloody his brow before he escaped."

Beatrice had left her mother and sidled over to stand behind her father. She looked white and frightened. Her pleading gaze drilled into me with palpable force. I drew a deep breath, frozen in indecision.

Telling the entire truth about my fight with Grillo would drag a young woman's name through the dirt. In Venice, married women who'd produced several children had a great degree of latitude. Fidelity had been out of fashion for decades. A man and his wife might attend funerals, christenings, and formal entertainments in tandem, and then pretend not to know each other when they met at the Ridotto with their respective lovers. The situation was quite different for unmarried girls. If they weren't convent educated, they were kept close at home, virginal and untouched. Many an advantageous betrothal had been scuttled by scandal.

How much could I tell without utterly destroying Beatrice's reputation?

"Who?" the Savio barked. "Who was this mystery assailant? And where is he now?"

"He left by the open window, right there." I pointed. "Take a look. You'll see a broken pot that he knocked over as he ran away."

I was almost surprised that the Savio did as I asked. He crossed the floor, and his head and shoulders disappeared through the casement. The moon had moved on in its arc across the sky; it would take a moment for Passoni's eyes to adjust to the darkness. I intended to put that valuable moment to wise use.

Steeling myself, I studied the maestro's earthly shell. He'd been struck on the head, perhaps while sitting in the overturned chair beside the tripod table. The fragile, old man's skin over his visible cheek and brow was abraded in several places, but it was obvious that one violent blow to the opposite temple had delivered the fatal injury. It looked to have swooped down from above and behind.

I extended my gaze. The chair was on its side, a few feet away, but the tripod table was upright with its pack of cards stacked in a neat rectangle and the candle stand I'd used to brain Grillo standing innocently by with burning candle in place. Had I righted the table before I'd left the room? Yes, I thought so. The candle stand? I wasn't sure where it had landed. But I hadn't stooped to pick up the scattered cards. I was certain of that much.

One more thing. When Grillo had leapt through the window, his green cloak had been draped over the chair's back. Now the cloak was gone.

Signor Passoni had pushed away from the window embrasure to address the room. His face had softened a bit. "I see the overturned rose tree, and I agree that it was upright before the reception. I took a turn in the garden, and I would surely have noticed it down. Now—" He crossed his arms. "Who did you fight with, Tito? I require a straightforward answer."

After one more glance at Beatrice's tight face, I took a moment to straighten the remnants of my shirt. Then I raised my chin and looked the Savio in the eye. "The fight was my own affair. Nothing that had anything to do with Maestro Torani."

"You refuse to give me the man's name?" Passoni's tone was incredulous. How dare I thwart a member of the Doge's inner council?

"That's right. I refuse." I felt Liya squeeze my arm. Hard.

Then the Savio did something that made my stomach roil worse than my old opening-night jitters: he smiled. "All right," he said. "Be obstinate with me if you wish. Here is someone who knows how to make a man beg to cooperate."

I looked over my shoulder. Messer Grande stood in the doorway. Swathed in his red robe of office, tricorne brim pinned up with a red and gold rosette, medal of San Marco hanging from a ribbon around his neck, Venice's preeminent officer of the law had never appeared less amiable or more official. A pair of uniformed sbirri at his back amplified his majesty. Without a word spoken or order given, the crowd in the room shuffled back toward the walls.

Messer Grande—in the present circumstances, I found it impossible to think of him as Andrea—moved to scrutinize the corpse. First he stared down from his six-foot height, then he knelt, his wide sleeves making a great sweep of scarlet. With one stiff forefinger, he raised Torani's poor old head, took a long look, and lowered it with a gentle sigh. Then he probed the maestro's clothing. From the brocade waistcoat, he withdrew a handsome watch attached to an embroidered fob; from the inside jacket pocket, a snuffbox and a purse that appeared as thin as an apple stamped by a horse's hoof. He passed all three to a waiting constable.

Messer Grande spoke only once. "Where is Maestro Torani's wig?"

A flurry of searching turned up his formal powdered wig among the pillows on the low sofa. Its curls were crushed, but I could detect no blood from where I stood.

Messer Grande turned it over and over in his hands, but his impassive expression gave no hint of his conclusions.

After a moment, he addressed the Savio, "Direct your major domo to cover this man, then clear the room. Your guests will await me in the salon."

◇◇◇

One of Messer Grande's sbirri conducted me to the Savio's study, where I spent a long, lonely hour in anxious thought, acutely aware of the constable stationed right outside the open door. At least throwing myself into the Savio's chair and grinding my plebian heels into his patrician footstool gave me a fleeting morsel of reprisal against his baseless, but understandable, suspicions.

But I was soon prey to a host of warring emotions: grief, bitterness, anger, and—slashing like a sharp-edged sword—regret.

It was hard to imagine the Teatro San Marco without Torani's guiding hand. Hard to imagine how I'd go on. I'd been dancing to his tune for so long, I wasn't altogether certain I even had my own tune to dance to. I recalled the day I'd first entered the opera house. It had been called the Teatro San Stefano then, and belonged to a reprobate nobleman instead of to the Republic. I'd crept in the stage door, a shy, reluctant castrato with more technique than art, and found Maestro Torani mediating an argument between two of the fieriest female sopranos who ever trod the boards.

My mentor had seemed old even then. Not decrepit, but aged with experience and steeped in the joy of making music. From the beginning of our collaboration, he'd devoted himself to pushing me toward the pinnacle of vocal artistry. He demanded that each performance be better than the night before. Together we analyzed my faults, experimented with new technique, and practiced, practiced, practiced in a constant quest for perfection.

When I came offstage after curtain calls—exhilarated, spent—he'd be waiting in the first wing to gather me into his arms no matter how my performance had gone. In many ways he'd been more of a father to me than Isidore Amato, the cold, unyielding man whose blood ran through my veins.

Now Torani was gone. And the last emotion I'd felt in his presence was anger. I cradled my head in my hands, elbows on knees. If only we hadn't parted in that manner. If only I'd had one more chance to talk with him—to express my frustration and come to an understanding. I shook my head. We don't choose the hour of our death—God disposes in that as in all things. But why, oh why, couldn't life have ended better for the old man?

Ambitious, passionate, and without family, Torani had come to see Venice's leading opera company as his monument to history—instead of leaving a son to carry on his name and work, he would leave the Teatro San Marco to delight our countrymen for generations. He had suffered the theater's recent reverses

keenly, and he'd died without knowing whether *The False Duke* would be the success that would save the San Marco from ruin.

I sank back against the soft upholstery. The regular ticking of the desk clock filled the room, seeming to grow louder with each second. Feeling closed in by the Savio's books and models, I forced myself to consider the murder itself.

Had *The False Duke* killed Torani? I asked myself with a sigh.

Venice, already hectic with carnival preparations, was buzzing about Angeletto and the revolutionary opera he would star in. Promenading on the Riva or the Broglio, or hobnobbing in the coffee houses, you rarely heard talk of the Teatro Grimani's *Venus and Adonis*. Unless someone happened to speculate that Emiliano, their primo uomo, would be so completely trounced by Angeletto's performance that he'd pack his bags and slink away to the mainland with his tail between his legs. Was Caprioli so desperate to prevent a San Marco triumph that his intimidation had escalated to murder?

Caprioli wouldn't commit the deed himself—I knew a physical coward when I encountered one. But Scarface or another of his bravos could have slipped through the garden and climbed through the open window as easily as Grillo. My train of thought skidded to a halt, reined in by the memory of that scoundrel's face at the window: the face of a man without pity or scruple. Grillo!

I jumped up and began to pace the study. Twelve steps to the edge of the Persian carpet, then back again. Messer Grande's man stuck his head in the door, alarmed at the sound of sudden activity.

"I'm thinking," I said with as much dignity as I could muster. "I walk when I think."

He shrugged and returned to his post.

If, as I suspected, Grillo was in Caprioli's pay to spread rumors about Angeletto's sex, then why couldn't Caprioli have also hired the libertine to kill Torani. Grillo wouldn't have put Torani on his guard nearly as much as Scarface. Grillo could have easily returned to the card room once I'd left and summoned Torani,

perhaps by the same method that he'd used to tempt Beatrice. After some desultory talk, Grillo could have struck the unsuspecting old man, and absconded. Only this time, Grillo hadn't forgotten to take his green cloak with him.

I was warming to this theory when Messer Grande entered. He was carrying Torani's silver-headed stick as if it were a ceremonial mace.

"We found this in the garden shrubbery—Signora Dall'Agata has identified it as Torani's. The silver is sparkling, wiped clean, but it could have served as a bludgeon." He thumped the knob into his palm with the cadence of a funeral march. "It wouldn't have taken much strength to crack the old man's skull with one well-placed blow. A small man could have done it. Or a woman. Don't you think, my friend?" Then he lifted one corner of his mouth and said, "Sit down, Tito."

I did as he asked, grateful that Messer Grande appeared to remember our friendship. He laid Torani's stick on the Savio's broad desk and sat across from me. He took some time arranging his robes, and then propped his elbow on the chair arm and rubbed his prominent chin. "What can you tell me, Tito?"

"Maestro Torani was killed by someone he knew."

"I was hoping you would start with something I couldn't figure out for myself."

I licked my lips. "It was someone who made him angry enough to strip off his wig and throw it at the nearest horizontal surface."

"Yes, I knew Rinaldo Torani well enough to also make that deduction."

"And I did warn you about Lorenzo Caprioli—after the maestro's gondola was rammed."

"So you did."

The chief constable fell silent, nodding. Surprisingly enough, it was a companionable silence. While the Ca'Passoni sighed and creaked under the depredations of time, water, wind, and hundreds of feet, Messer Grande—Andrea—and I sat quietly.

I couldn't guess what was in his mind, but I was remembering our previous partnership and taking his current measure.

The man who fulfilled the solemn duties of Messer Grande was of a much warmer humor than any other chief constable I'd ever sparred with. I knew Andrea to be both intelligent and fair, with a mild cynical streak that should have run much deeper considering what he must have seen in his tenure. By some miracle of principle or personality, this Messer Grande had escaped the inclination for bribery which plagued much of Venetian officialdom.

Which didn't mean Andrea wouldn't haul me straight to the guardhouse if he was convinced I killed Torani.

Eventually he said, "You understand I must know who mangled your chest."

"A mere scratch," I said under my breath. Then, louder: "The story isn't pretty, and it involves a young woman's honor."

He lifted an eyebrow into his high forehead. "Don't you mean her dishonor?"

I shrugged.

"We reap what we sow, Tito. Isn't that what the priests teach us? That should hold true for the kitchen maid or her mistress."

I'd almost forgotten about Andrea's Masonic ideals—he rarely spoke of them to men outside of that shadowy society. The equality of all was one of its more revolutionary notions. I suppose he'd once felt safe in confiding that philosophy to me; theater folk are known for tolerating conduct that others might find odd.

He continued, "Unless Signorina Beatrice bashed Torani's skull herself, I believe that I can keep her name under wraps."

"You're very quick tonight."

It was his turn to shrug. "I had Signor Passoni make a list of those who attended the reception. There were few unmarried women on it. Among them, Beatrice has the most to lose."

I nodded, then told him everything about Grillo, not stinting my suspicions or glossing over my efforts to neutralize his gossip.

He took it all in with an air of rueful disappointment at mankind in general. Only one thing seemed to significantly

trouble him. "Tito, I'm astonished. You really let that flagrant rogue dupe you out of twenty ducats?"

As I nodded shamefully, a light tapping came from the door. "Avanti," the senior constable cried.

The door opened on a slight figure—Giuseppe Balbi. The violinist looked miserable; his thin back was bowed, and his eyes were glassy. He stammered out, "Your sergeant...he said I could...well, that it would be all right..."

Andrea rose. So did I. He said, "You have something to tell me, Signor Balbi?"

Words spilled from the violinist's lips like the wriggling catch from a fisherman's net. "It's not right. Not right, I say. That Tito should be blamed for the murder. One of the guests tonight was saying hateful, awful things about Maestro Torani. And he wasn't even invited. He snuck in under cover of that mask, and he said to me, 'cats should claw Torani's skin, dogs should gnaw his bones, and lice should devour him.'"

Balbi came to a breathless halt. He regarded Andrea with wet, bulging eyes. More than half-afraid, I thought. A Messer Grande in full regalia does tend to have that effect on people.

"Who said these things?" Andrea made his tone smooth and mellow. He was trying to calm the twitchy violinist.

Balbi gulped air, then spat out, "Signor Caprioli from the Teatro Grimani."

"What?" That was me, booming at my loudest rasp.

"Yes, Tito." The violinist bobbed his head at me in the suggestion of a bow. "Signor Caprioli was masked...that's how he must have got past the footman at the door. He had the temerity to seek me out and ask me to come work for him at the Grimani. He talked against our theater in a vengeful, horrible way, but despite all, I stood up for Maestro Torani. For you, too. For all of us!"

"What did Lorenzo Caprioli want you to do at the Grimani?" asked Messer Grande.

"Why, he asked me to lead their orchestra. What else?" Balbi's diffident manner suddenly became so confident that I drew a shocked breath. He continued in a metallic tone, "Caprioli

offered to top my current salary by a quarter. I said no, never."
He twisted his shoulders. "I wouldn't play for that trash. He's
more interested in whoring out his ballet girls and orange sellers
than offering good music."

Andrea had opened his mouth to ask another question,
but I interrupted. "Wait, Giuseppe, you said that Caprioli was
masked? Did he cover his face with a white leather mask?"

"That's right. He shifted it to the side of his head as we talked."

"And was he wearing a suit of turquoise blue?"

Balbi rolled his eyes. "Just so—the dolt has execrable taste
in all things."

Andrea questioned me with a lifted eyebrow.

"I saw Caprioli, too, about twenty minutes before the concert
began. I just didn't recognize him at the time."

"When did Caprioli make his offer to you?" Andrea turned
back to face Balbi.

The violinist's timidity had returned. "I suppose…" He fin-
gered his lip, seeming to have trouble making up his mind. "Ah,
yes…it must have been right before the concert. I was on my
way to the kitchen where we musicians were to have our supper."

"Where precisely?"

Balbi spread his arms. His cheeks bunched in a frown. "A cor-
ridor. I don't know which one—a footman led us there—I hung
back when Signor Caprioli called my name. But it was not far
from the kitchen steps, I think." He nodded. "Yes…I could hear
the clanking of pots and smell the aroma of meat and onions."

"Where did Caprioli go when he left you?"

"Off, away from the kitchen. I don't really know where he
ended up—I didn't see him again."

"How was he?" Andrea was firing questions now, apparently
no longer intent on calming the violinist.

Balbi appeared to think, then said, "He was well."

"No, man. I don't care about the state of his health. I want
to know how he was behaving."

"Oh. Once I had refused him, he was angry. He cursed me
for a fool."

Andrea whirled. "Tito, did you see Caprioli again? During or after the concert?"

"No."

"Hmm…"

I was familiar with the look that settled on Messer Grande's face. Documents were leaping from drawer to drawer in the cabinet that made up his spectacular memory.

"You've been very helpful, Signor Balbi." He unfurled a red sleeve in dismissal. "Now you may leave us."

"As you wish, Excellency." Balbi bowed himself from the study, but not before sending me a covert smile.

I raised a smile in return. Balbi could be a genial idiot at times, but it had taken courage to seek out Messer Grande and volunteer his information. According to the clandestine ways of our Republic, Balbi's report to the chief constable could very well have the effect of pinning a target on his back. At the very least, one of the government's confidenti would shadow him to his coffee house, his snuff merchant's, and the theater for a few weeks. Many men in Balbi's position would have slunk out of the Ca'Passoni as soon as they had leave and tried to forget anything they had seen or heard.

Once Andrea and I were alone, I began spouting troubling questions. Chief among them was the issue of Lorenzo Caprioli's presence at the Ca'Passoni. Any of Caprioli's bravos—and Grillo—could slit your throat and listen to your death rattle without a trace of remorse. But if Caprioli had ordered Torani's death, he wouldn't have attended the reception. Indeed, the canny manager of the Teatro Grimani would have made himself very visible at the opposite end of the island, as far from the Ca'Passoni as possible. Wouldn't he? I peered into Andrea's ruddy face for confirmation.

My old friend gripped my shoulder, making me wince openly. "Perhaps not such a mere scratch, eh?" As I nodded, the fine wrinkles around his eyes deepened. His mouth made a hard line. "You can't help me this time, Tito. I must ask my own questions, find my own answers."

"But…" I sucked in a long breath, "but I must discover who murdered Torani. Don't you see? He was like a father to me. He was my father—my musical father."

"It is you who doesn't see. You have much to gain by Torani's death. With him out of the way, you have a clear path to become the permanent director of the Teatro San Marco. Some men would find that ample motive for murder." His lips drooped, and he inclined his gaze downward. "And then there's that bloody shirt."

"I told you how that happened!"

"I believe you. But until I can find Grillo and confirm the fight and the injury you delivered to him, certain…influential men…will remain convinced of your guilt."

"Did you look at the candle stand?"

He nodded. "Wiped as clean as Maestro Torani's stick."

An unpleasant warmth spread through me—Grillo might never be found—he could have made his delayed trip to the mainland and simply kept running. Andrea's hand on my shoulder suddenly felt very heavy. My voice came out in a whisper: "Are you arresting me?"

"Not tonight." His hand fell away, and he stepped back. Without a smile. "I think perhaps you should go home now."

"Yes," I whispered. "I think perhaps I'd better."

Chapter Twelve

One more humiliation awaited me.

When I returned to the foyer, Liya, Gussie, and Annetta were standing in a gloomy knot by the front entrance, watched over by Passoni's frowning major domo. All the other guests had apparently departed. I glanced into the salon. The huge chandelier had been lowered so that a footman could extinguish its candles. The glowing points winked out one by one, and the raspy rhythm of a dozen brooms sounded from the dimming hall. Near the archway, a maid was on her knees scrubbing on a stain with a soapy brush.

I met Liya's gaze as I crossed the foyer. Her eyes were heavy-lidded with weariness. Her lips looked as if they had forgotten how to smile. She was hiding inside herself, I knew, harboring emotions that would emerge later.

Before I reached her, the Savio materialized from a darkened room opposite the salon. Had he been waiting for me there in the blackness, working himself into a lather? He'd removed his wig and fine coat. His loosened cravat straggled down his shirt front. As he approached, he swung his arms deliberately, and his breath came quickly.

"Hold on, Signor Amato. I have something to say." His senatorial voice reverberated off the marble surfaces like chiming bells. His breath smelled of brandy. "You will not return to the Teatro San Marco—tomorrow or any other day."

A chill passed over me. "Are you canceling *The False Duke*, then?"

"No."

"But, I have singers who must be rehearsed."

"Do you not understand?" The Savio curled his lip. "I've made other arrangements to complete the opera. You are no longer in the Teatro San Marco's employ."

With that simple statement, I was cast into limbo.

◇◇◇

The next day dawned bright, cool, and clear, but I stayed abed as the morning waned. Part of me wanted to stay in bed forever. Liya had rebandaged my wound with a soothing balm, but her ministrations failed to roust me from between the sheets. My worried wife finally dressed for the day and set out for the market. She left the double doors to our small balcony cocked open with the outside shutters flung back against the stucco. Gauzy draperies billowed inward, and the seagulls' cries as they soared and dipped over the Cannaregio punctuated my gloomy thoughts. I was aching inside, and I couldn't decide which hurt more: Maestro Torani's death or the Savio's callous dismissal.

The corridor door clicked open, and Benito entered bearing a blue and white chocolate pot that exuded a wisp of vapor. Thank the Virgin for small miracles! I slid up onto my pillows and motioned my manservant over with a weary hand.

He shook his head. With deliberate steps, he crossed the chamber to the opposite wall. Then he deposited his tray on my dressing table, crossed his arms over his flowered waistcoat, and sent me a look that could have presaged the challenge to a duel.

"Benito, I warn you…" I started with a groan and finished with the growl of a boatyard cur.

"No, Master. If you want your chocolate, you must come and get it." He lifted the porcelain pot and poured an enticing stream into the cup.

Anger forced blood through my veins. I jerked the bedclothes aside. My feet hit the floor. "No one would blame me for discharging you for insubordination."

He merely shrugged and fixed me with his bright canary gaze.

My anger flew as quickly as it had come. "All right, Benito, you win." Glumly, I shrugged into my dressing gown. "I suppose I can't keep to my bed forever."

I had my chocolate in silence, then padded about the chamber in bare feet, stopping to splash my face at the wash bowl. Benito handed me a clean shirt and underclothes without comment. Once I began to feel like one of the living, I settled in at my dressing table and allowed Benito to arrange my hair. I closed my eyes as he drew the brush through my hair in long, relaxing strokes. Presently, he sensed that I was ready to discuss the previous night's tragedy.

Benito told me what he'd gleaned, and in truth, if I'd employed any other man, I would find it disconcerting that a servant could discover so much about his master's business. But Benito was Benito and as much a part of my life as my right arm—I filled him in on the rest.

"You want to believe Grillo killed Maestro Torani," he observed, cocking a graceful eyebrow.

"At Lorenzo Caprioli's direction, yes. Those two make a perfect pair of villains."

"But Master, it seems to me that Signor Caprioli had already achieved his first goal." Benito's beady gaze met mine in the dressing table's oval mirror. "By smashing Maestro Torani's gondola, he'd removed him from day-to-day preparations for the opera. You were put in charge and, according to everything I saw and heard around the theater, you were managing in fine style and headed for a great success. If Caprioli paid Grillo to kill anyone, it should have been you."

My hand flew to my bandaged wound. "He very nearly did."

"Sheer happenstance." Benito waved the brush airily. "Grillo wouldn't have attacked you if you hadn't interrupted his debauchery."

"Perhaps he was only saving me for later," I answered slowly. "Treat himself to the daughter of the house, then kill Tito Amato."

I paused to wonder how long the affair between Beatrice and Grillo had been going on. The speed with which he'd maneuvered the girl into an intimate position on the sofa implied an ongoing relationship. I also wondered who else might know about the lovers.

After a sigh, I continued, "There was another reason for Caprioli to put the maestro out of the way. Torani still had the ears of influential Senators—they've been depending on him for counsel on the state opera house for years. Even last night, he pulled himself out of his sick bed to rally support for the San Marco to retain its Senate sponsorship."

As Benito moved to fetch the curling tongs from his little alcohol stove, I felt a prickling along my spine. Last night, I hadn't fully digested Signor Balbi's information before the Savio delivered his final blow. This morning, the logical consequences of Caprioli's presence at the Ca'Passoni became clearer. The director of the Teatro Grimani hadn't gained access to the reception merely to seek out a new lead violinist; he had come for the same reason as Maestro Torani. With his identity disguised under a mask, Caprioli must have been seeking out Senators to toady, bootlick, and otherwise curry favor. His plans to destroy the San Marco were continuing apace.

"Ah, you're thinking. Good." Benito pulled the hair above my left ear onto two fingers and deftly rolled it on the warm tongs. "Move beyond your dislike of Grillo and Caprioli and tell me about the other passions aroused by *The False Duke*."

I smiled. For a moment I was carried back to happier days and the solving of puzzles that didn't cut so close to my heart. "Why don't you tell me about the passions you've noticed?" I countered.

"All right. Firstly, only a blockhead could ignore the heightened feelings swirling around Angeletto."

"Skirts or breeches, you mean." I had banned all talk and speculation about Angeletto's sex from the theater. I wasn't being naïve—I know an opera company dines on gossip—I was merely trying to tamp down the worst of it. I also hoped that

the rumors Grillo had spread among his patrician acquaintances were a flash in the pan, soon to be replaced by fresh scandals.

Venice usually offers endless diversions in the way of outrages: a genteel young widow marries her late husband's gondolier, or a kitchen boy is discovered in the papal nuncio's bed, or a popular courtesan inherits a tidy fortune and purchases her own vineyard. Unfortunately, my countrymen had been rather restrained of late; fresh gossip was at a low ebb.

While I'd been working long hours at the opera house, Benito had been gadding about the city, listening to the ribald tongues flapping fast and loose about Angeletto. As my manservant worked his tongs around my brow, he repeated what he'd heard in the salacious language of the tavern and the casino. No wonder Maria Luisa had taken me to task over Venice's boorish welcome to her brother.

Benito coaxed the rest of my hair into a neat braid asking, "Are you still quite certain that our angel is a valid castrato?"

I thought back to the beautifully dressed and wigged creature who had patiently greeted the Savio's guests, especially delighting the women. The fashion of the day called for excess in all things; Angeletto's face had been heavily painted right up to the smooth seam of his white wig, and layers of lace had obscured his neck and chest. As any woman will tell you, the stratagems of fashion can hide as much as they enhance.

"Let's say I'm wrong, Benito. Let's say that Carlo Vanini is really Carla—just for argument's sake, mind you." I turned my head this way and that to admire Benito's work in the mirror. "How would Angeletto's masquerade provoke an attack on Maestro Torani?"

"I don't know, but I sense something…off, something wrong where Angeletto is concerned. Don't you?"

"Possibly."

"Don't you want to discover what it is?"

I shook my head. "I don't see how Angeletto could have had anything to do with Maestro Torani's death. The first time he laid eyes on Torani was in the foyer last night—there wasn't time

to exchange more than a few words—and until the footman announced that Torani was dead, Angeletto was constantly on view. Besides, he is such a mild creature. It's his sister who burrows under my skin like some biting insect."

"Well," Benito was fussing with the ribbon at the top of my braid, "as you've always told me, murder is much like the opera—it hinges on life's great passions: love, hate, envy, revenge. Any of those motives floating around?"

His comment suggested a new train of thought. "No one envies Angeletto more than Majorano," I said.

Benito broke into gleeful soprano spasms that sounded like a peahen clucking over a chick. "Majorano can strike a belligerent pose with a pasteboard sword. But…" The laughs were still coming. "Wielding an actual weapon? Bashing Torani over the head? That scrumptious poppet drawing blood? Oh, it's just too funny."

Shoulders shaking, he crossed to the wardrobe, pulled out a drawer, and held up several neckcloths for my inspection. I ambled over and chose one of plain linen. I lowered myself to the cushioned window sill so that my much shorter manservant could tie it.

"Besides," Benito continued, "why would Majorano take his spite out on the maestro when his rival was also on the spot?"

"Because it was Maestro Torani who assigned the roles— while you and I and Gussie were in Milan. The day I returned, Balbi was nearly out of his mind with frustration as he tried to instruct Majorano in one of the huntsman's arias. It makes sense that a singer would direct his anger at the director who gave him the inferior part, but…No!" I pushed Benito's hands away and jumped up. Pacing the floor, I stabbed my fingers through my newly curled locks. Over Benito's groan, I cried, "What am I saying? Majorano wasn't even at the Ca'Passoni. He never showed up at the reception."

"Anyone could have climbed through that open window. Correct?"

"I'm not sure." I halted, thinking. "No, I believe the entire garden is surrounded by a wall. If there is a gate, it would surely be kept locked. But Grillo got in somehow. Oh, Benito." I sighed and let my arms flop at my sides.

The emotional ache that had kept me abed was welling up again, tightening my chest and making the wound throb.

"We know nothing, Benito. Messer Grande has shut me out. The Savio suspects me of killing Torani and would never allow me on his property to inspect the garden or question Angeletto. I'm not even welcome at the theater. All I have is a dog's dinner of random suspicions. Nothing certain—"

"No, Master," Benito interrupted my tirade. "There is one thing we know for certain."

"What's that?"

"That you didn't do it."

I nodded solemnly, then stepped through the curtains and out onto the balcony. The midday sun had turned the narrow canal that ran between our house and the next building to glistening jade. I stared down at the lapping water, gripping the iron railing. Every instinct told me that Maestro Torani's murder was tied to the opera. The very thing that was his life had become his death. I didn't know who, much less why, but someone connected with the San Marco or the rival Teatro Grimani had killed my old mentor. Finding his murderer would be the only balm for the throbbing ache within me.

But where to begin, persona non grata that I'd become? I could locate most of the singers and musicians at their lodgings or in a public place, but how could I question them without arousing suspicion? I didn't want to startle my prey. Or did I? Hunters trained their dogs to sniff out a rabbit and startle it into running right past their master's hidden stand. If the hunter was a sure shot, the rabbit ended up in the stew pot.

I entered the chamber and cast a brief, longing look toward my bed. It would be so easy to crawl back under the sheets and stay there, much as I had when I'd suffered the fatal injury to my vocal apparatus.

Benito looked up from tidying my dressing table, one eyebrow cocked expectantly.

"Fetch my hat," I said. "I'm going out."

◇◇◇

I decided to begin with the easiest quarry: Tedi. The soprano kept modest lodgings in the parish of San Lorenzo, but for the past several months she had been staying with Maestro Torani in the Calle Castangna. I shunned the most direct route so that I could take in a water view of the Ca'Passoni on my way.

I walked over several squares and found a free gondola near the entrance to the Ghetto. That curious compromise between Venice's acceptance and expulsion of the Hebrew race had been built on the site of an old copper foundry. At this time of day, the Ghetto's stout wooden gates had been thrown back to allow both Christians and Hebrews unfettered passage, as the Republic's law permitted from dawn to dusk. When night fell, the Hebrew population would be locked in behind closed gates that were guarded by a pair of sbirri. That the Ghetto officials were obliged to pay the salaries of the very guards who contained them formed a deep well of resentment in Liya's mind.

My wife wasn't forced to live in one of the lofty, slope-roofed houses behind those gates because she had submitted herself to the priests at the House of Catechumens. So that our lives could be forever intertwined, Liya had renounced her family's faith and kissed the cross of our Lord. Was it a false swearing? An outright lie?

Assuredly. A wise woman had performed our hand-fasting, because my Liya had years ago embraced the oldest faith of all, the secret worship of the mother goddess in the guise of Diana. My born-Hebrew, ostensibly Christian wife was a true Pagan. In a secluded garden lined with pomegranate trees, the wise woman had bound our forearms with a silver cord and proclaimed us "twined as the vine as long as love doth last." No matter that the Christian world looked on Liya as my mistress—a castrato is not allowed the sacrament of marriage at any rate—no matter that our upstanding neighbors thought of our household as a dirty

nest of theatrical riff-raff. As long as Liya loved me, I wouldn't have it any other way.

After all, what in Venice wasn't a masquerade in those decadent days?

Once the boatman had pushed away from the Ghetto landing, I had him row down the Canal Regio to the Grand Canal. After we'd passed under the Rialto Bridge, I directed him into the narrow waterway where the sprawling mass of the Ca'Passoni lay. Three times I ordered him up and down the canal that was barely five feet wide, pausing at certain points before finally sending him back across the city. At Maestro Torani's landing steps the gondolier accepted his coins with the irreverence of his kind: "Maybe next time the signore will be able to make up his mind."

At least I'd discovered one thing. The Savio's garden wall rose sheer from the water without handhold or foothold. A stone railing with urn-shaped balusters topped it. No tree branches or vines dipped to meet the canal. The garden itself, like most in my soil-poor city, was small and narrow. It ran only half the length of the side of the palazzo. The only way in, except through the house, was by an austerely barred gate at the top of a short flight of water-lapped steps. If Grillo—or anyone else—had entered the garden from the canal last night, he'd arrived by boat and someone had raised the gate's iron bar from the inside. Someone who'd been watching and waiting for him—the pretty maid, I'd be bound. One more thing: if Grillo had scrambled over the wall after our fight, he would have had a thorough dunking in the canal.

At Torani's lodgings, I was surprised to find the recessed door to the building's vestibule standing wide open. An untidy, twine-bound pile of musical manuscripts sat on the red and black tiles; the breeze sweeping down the canal ruffled the top pages. A *peota* was tied up at a nearby mooring post, and the cargo boat already held several wooden crates and a large trunk. Wondering what was going on, I trudged up the creaking stairs up to the maestro's apartments.

Instead of Tedi, it was Peppino who greeted me in the cramped foyer. Torani's gondolier had traded his boatman's sash for a canvas apron. His shirt sleeves were rolled up to his elbows, and his lank curls were plastered to his forehead with sweat.

Huffing from exertion, holding my aching midsection, I listened to Peppino's halting explanation.

"Signora Dall'Agata ordered us to pack it all up—at least everything she didn't take." He made a vague gesture toward the sitting room where Torani's valet was pulling books off shelves. Open crates stood ready to receive them. "She hired the boat down below. I don't know where it's taking Maestro Torani's things. A warehouse? Or maybe she's sold them." His voice broke with emotion. "The maestro wouldn't like this…no, not one bit."

"Where is Signora Dall'Agata?" I asked, irritated by this unexpected development.

Peppino shrugged. "She's gone."

"Yes, but where? Her lodgings?"

He shook his head violently. "No, Signor Amato. She ran out several hours ago. Said she had to get over to the mainland and meet the boat to Padua." His damp brow furrowed. "She spoke of traveling north to take the waters."

"*Dio mio!*" I could scarcely believe what I was hearing. "She's left Venice for a spa?" I was growing more disturbed by the second. It appeared that Tedi had taken flight less than a day after Torani's murder, leaving her lover's affairs to his pair of servants.

I stepped into the sitting room, momentarily confounded by its emptiness. The striped sofa and chairs and the marble-top table were gone. On the green flocked walls, lighter rectangles showed where paintings and mirrors had been removed. Torani's manservant was working at the nearly empty shelves. He was sharper than Peppino; his name was Maurino. "What is going on?" I asked him.

"Signor Amato." Maurino wiped his dusty hands on his apron. He was a small, white-haired, pot-bellied man of sixty years or so. Despite his age he was quite robust, but today Maurino's shoulders drooped and the wrinkles spreading from his

reddened eyes had deepened. The man's been crying, I thought, and it suddenly struck me that Maurino had served Torani for over ten years, the same amount of time that Benito had been with me.

Grasping his shoulder, I shook my head. "It's a terrible thing, Maurino. I can't make sense of it."

"No." He cleared his throat. "What is the world coming to—when a man like my master can be beaten down like a mad dog?"

"I mean to find out who did it." I gave his shoulder another squeeze before dropping my hand. "The killer will be punished, I promise you."

The old manservant nodded, sadly and without enthusiasm. He'd lived long enough to understand the vagaries of Venetian justice. Wearily he reached for another book.

"Wait," I said. "Tell me what's going on here."

"Signora Dall'Agata has gone. She charged Peppino and me with clearing the apartment, and…" He sighed from the tips of his toes. "When we're finished, that's it. We lock the door and go."

"Is it true she's set off for a spa?" I still couldn't credit it.

"Yes."

"Which one?"

"She didn't say, Signor Amato."

Damnation! Tedi could be headed practically anywhere. Mineral cures were the latest rage. On every Alpine foothill with a bubbling spring, a hopeful entrepreneur had built a hotel and offered a casino and other amusements to keep the health-seeker content between baths.

"No mention of a town or village?"

He shook his head. "Signora Dall'Agata awoke before dawn—I'm not certain she actually slept. Throughout the morning, she was in a great hurry, giving orders about the maestro's papers, his belongings. She sold the bedding and furniture to the first Jew who showed up—she accepted his offer without bargaining at all. I've never seen the like. And then Signor Passoni came, and she shut them both in the maestro's study for a long time."

Signor Passoni? The Savio alla Cultura paying a call on the mistress of a dead opera director? Well, the circumstances of Torani's death were unusual to say the least.

"I don't suppose you would know what they discussed?"

"When they came out, Signora Dall'Agata told us that tomorrow Maestro Torani would be given a funeral mass at San Nicoletto and afterward laid to rest in the crypt—in the Passoni family's own vault. The Savio agreed to bear all expenses of the ceremony."

"And Tedi won't be there," I said faintly, wondering if Liya and I would be welcome in the church founded by the Savio's illustrious ancestors. Then, as carefully as if I were picking my way across a rain-slick bridge, I said, "I know you for an honorable man, Maurino, always with your master's best interests at heart. Is it possible you were still caring for him by...ah..."

"Listening at the door?" He raised thick white eyebrows, daring me to criticize.

I wouldn't think of it—that was precisely what I hoped to hear.

Chapter Thirteen

Maurino pressed a forefinger beside his red-veined nose, then glanced warily over his shoulder. Peppino was shifting valises from the bedroom to the foyer. Maurino called to the gondolier, "Take those down to the boat. I'll have another crate ready in a few minutes." As Peppino complied, the manservant rubbed the back of his neck in a gesture of relief. "That will buy us few minutes. A snail moves faster than that facchino."

"You don't trust him?"

Maurino crossed his arms. "Peppino is a good lad, if you overlook his laziness. He doesn't cheat at dice and would never take a *soldo* that wasn't his. But," the manservant interrupted himself with a snort, "the poor boy's tongue is a slave to drink. If you sit Peppino down in a tavern and keep the wine flowing, he'll spill everything he knows and more."

I nodded. "What did the Savio and Signora Dall'Agata discuss that you'd rather all Venice didn't hear?"

Torani's manservant drummed the fingers of one hand on the back of the other. Several emotions warred on his face. After a momentary struggle, a sorrowful sheepishness took the field. "My master was ruined. He liked to call it 'a situation of temporary necessitude.' Penniless, strapped, beggared is what I say."

I was stunned, jolted. After years of service to the Teatro San Marco, Torani made a handsome salary, nearly as much as the opera's castrati stars. And he didn't live high. The maestro was

simply too busy to indulge himself in costly travel or luxuries. His new wig was the first he'd had made in years, and he always bought a modest grade of snuff, confining himself to one pound a month. Maintaining his own gondola—until it was smashed—would have been Torani's most flagrant expense.

"How could this be?" I asked, wondering if Maurino knew Maestro Torani's business as well as he thought he did.

"Some months ago, my master came to a decision. I don't know what prompted it. He wasn't ill. He seemed as vigorous as ever, but he took it into his head to retire to the mainland with Signora Dall'Agata. She argued for staying in Venice. 'Who wants to stare at a lot of pigs and geese and grapevines all day?' she said. 'There would be no amusement whatsoever.' But it was as if an insect bearing the idea had drilled itself into his brain." Maurino took up a dust rag and twisted it through his hands. "My master would talk of nothing else. He and Signora Dall'Agata would go to the banks of the River Brenta and live in a villa—not a modest villa, mind you, but an estate as grand as any owned by the families of the Golden Book."

The manservant regarded me pleadingly. "I ask you, Signor Amato, what made the old man hunger for something so far above his station? It's just not right."

I had no idea and told Maurino so. Then I asked. "Is that how Torani paupered himself? Sinking his savings into property that he couldn't afford?"

"No." The manservant's sheepish look became so pronounced and melded so perfectly with his tight white curls, he could have been an old ewe staring over a fence. "One night the maestro happened to enjoy a run of luck at the Ridotto. He doubled his money at the wheel not once, but several times. He was amazed to see his stake end up on the right square time after time. He couldn't lose! When he came home, quite late, he was so excited I could barely ready him for bed. He vowed to return the next night and repeat his feat. 'Dame Fortune has taken me under her wing,' he said. 'The Blessed Virgin has put a word in her ear, and I'm finally being rewarded for all my years of hard work.'

"My master truly believed he could amass enough ducats to buy the villa he longed for." Maurino spread his hands. "Of course, the miracle never repeated itself, but Maestro Torani kept trying."

I felt my heart sink to my knees. I knew this story so well, there was no need for further explanation. My father had also been convinced that he possessed a particular genius for beating the faro bank, and when he played against a banker who used an honest dealer's box, Papa would manage to win often enough to bolster that conviction to an out-and-out religion. Until his death at the hands of his creditors, he was certain that his last, great triumph—the win that would allow him a life of ease—was just around the next bend.

I hadn't realized that Maestro Torani had sunk so low. And so quickly. I thought it over while Maurino dusted a few more books and transferred them to the crate.

Because of my father's actions, I could understand why Torani had kept his gambling from me. But had he also been ashamed to let any of his other friends help him? If so, why? Nearly all my countrymen relished a chancy adventure. Gambling was in our blood. Venice had married her fortune to the sea long ago, as commemorated by the Ascension Day ritual of the Doge casting a golden ring into the Adriatic. Setting out in a ship laden with goods or soldiers was nothing more than a gamble on a grand scale. Fortunes were regularly made, then quickly lost to a tempest or marauding corsairs. Still and all, few Venetians were feckless enough to throw good money after bad at the Ridotto. Though the Republic maintained the gambling house to plump up the state coffers, any sensible man or woman enjoyed a few bets and then proceeded to other pleasures. We left reckless Ridotto gambling to the punters from England or France.

But not Maestro Torani apparently. A lucky wager had actually been misfortune in disguise and made him lose his head. If I believed in demons, I'd think a particularly powerful one had climbed on his back.

I found myself stating the obvious: "If Maestro Torani played, he lost. If he kept losing, he owed money to someone."

Maurino groaned, very faintly. "He did sell a lot of things."

I snapped my fingers. "The paperweight he loved so much, the Doge's gift—it disappeared from his desk at the theater."

"I know the one. It and many other baubles went to the Ghetto pawn shops—but they didn't bring in enough. Not by half."

"Did Signora Dall'Agata and the Savio speak of this while they were closeted in the study?"

Maurino nodded. "She explained about the bravos who'd sent the maestro increasingly violent warnings—his Ridotto losses were the least of it—he'd taken to frequenting a private casino that allowed him to run up a large tally. There were several nasty encounters he'd managed to keep secret. Then one early morning as he returned home, a man in a domino pushed him into a covered passageway and battered him with a cudgel. My poor master lay there for hours—thank Heaven it wasn't winter—he would have frozen to death. Signora Dall'Agata and I found him only by the grace of God."

I shook my head. When I'd noticed Torani's injury that day we'd talked on the Rialto, he fed me a story of a cat dislodging a roof tile. A cat! I'd swallowed the maestro's lies like an infant licking syrup from a spoon. Dolt that I was!

Maurino continued, "Signora Dall'Agata was frightened out of her wits and scrambled to raise money to pay those money grubbers—sold her jewels, every last one, I believe—but before she could complete the transaction..." His voice faltered.

"The bravos ambushed Peppino and Torani on the canal," I finished for him.

He nodded, lips set in a tight line.

Scales dropped from my eyes. I became aware of a novel emotion—a pang of guilt over that buffoon, Lorenzo Caprioli. I almost wanted to find him and apologize for my suspicions. Caprioli might be responsible for many foul acts, but he hadn't scuttled Maestro Torani's gondola as I'd been convinced.

"Oh, Maurino." I sighed, sick at heart. "Why did you not tell me of this?"

"I wanted to. Truly. Signora Dall'Agata wouldn't allow it. She said she had cleared my master's debts and would see to it that he didn't run up any more. How could he, anyway? After his dunking in the canal, he was barely strong to walk from his bed to his desk."

"What did Signor Passoni have to say about the maestro's misfortunes?"

Maurino grabbed a stout leather-bound volume, blew dust off the top, and swiped his cloth over the cover. He placed the book in the crate and talked as he continued his work. "The Savio was most gracious. I believe he felt some responsibility for the murder, for allowing a killer to invade his palazzo. He offered to take charge of the funeral and told Signora Dall'Agata to refer any of the maestro's outstanding bills to his own man of business."

"Generous," I murmured.

"Yes, in all things."

"Eh?"

"She asked for something else, in whispers. I couldn't make it all out, but I think she requested an allowance to put toward her own upkeep." Maurino turned toward the foyer. Peppino had returned. Quickly, the valet finished, "I believe Signor Passoni accommodated her."

Maurino beckoned to Peppino. As the two men shifted the heavy crate toward the foyer, I walked over to the window that overlooked the canal. I stood there for a moment wondering and worrying, then pressed my forehead against the cool glass. A gondola slid by, carrying a quartet of English dandies. The boatman was singing for their benefit, an old *barcarola* that resounded off the stones. On the opposite pavement, a girl shading her face with a parasol sent them a saucy wave. As her older companion batted her arm down, one dandy stood up and sketched a shaky bow. Only the steadying grasp of his fellows kept him from falling in the water. Everyone laughed, even the girl's duenna.

Despite the charming scene, a chill passed over me, and I involuntarily stepped back.

You lose the ones you love, I thought, but life rolls on its way unheeding—a joy, a sorrow, and a mystery.

◇◇◇

Maurino had one other surprise for me.

When he returned, I again questioned him about Tedi's hasty exit. He appeared truly bewildered and could offer no explanation, but he did conduct me into the cramped burrow of Maestro Torani's study. It was a slant-ceilinged room paneled in cream and light green with a frayed rush mat covering the floor. The single wing chair and side table I was accustomed to seeing in the window gable were gone. The writing desk, which was smaller and much neater than Torani's desk at the theater, was the only piece of furniture remaining.

"Did the Jew not buy the desk?" I asked.

"It wouldn't fit on his cart—he had it piled to the sky. He'll return for another load. That letter is addressed to you—Signora Dall'Agata left it." Maurino indicated an ivory-colored rectangle. It sat exactly in the center of a swath of ragged-edged blotting paper. A bulbous pottery olive-oil lamp held one curling corner in place. There was no inkwell set. It must have gone to the pawn broker along with so many other things.

I reached for the letter.

Tito, the front read, just *Tito*. It had been addressed in Torani's acutely sloping hand, folded in quarters, and sealed with a red blob of wax. I stiffened my thumb to remove the seal, but suddenly thought better of it. I glanced up at Maurino. Like the perceptive servant he was, he bowed and left me in privacy.

I stowed the letter in an inside pocket. I'd read it later—when I was ready. Now, I wanted to search the desk away from Maurino's curious eyes, however loyal they may be. Torani had sold anything that would plump up his pocketbook, but perhaps he'd kept a few treasures of the heart, sentimental relics that might furnish a clue as to who wanted him out of the way.

I poked my long fingers into all of the desk's little drawers and niches. They'd been emptied of everything except the usual detritus that tends to accumulate—soiled pen wipes, empty ink jars, dunning letters from tailor and wine merchant—but I wasn't finished. I lifted the blotter, remembering how Torani had concealed Angeletto's contract in his office at the theater. If luck was with me…yes! My fingers touched something. I withdrew a few crackling sheets. Music!

The light was poor, so I stepped over to the window that overlooked a sunny courtyard filled with drying laundry. I shuffled the papers into two matching piles, an easy task since two different hands were represented. One was full and rounded, the other spidery and slanting. Then I fanned both piles out on the wide window sill.

I was looking at two original compositions.

The one on the right I'd seen before. The composer had handed it to me himself. It was part of Rocatti's handwritten manuscript for *The False Duke*, actually one of the soprano arias that Oriana had sung at the reception last night.

I frowned as I scrutinized the piece on my left. The paper was older. It had aged to a tannish hue, and the musical notations that danced over the printed staves were slightly faded. Also an original, this score gave evidence of more tentative composition than Rocatti's. Some notes were crossed out with flurried strokes and others scratched in. Ink blotches smudged the margins. But—I quickly scanned the staves with the tune unreeling in my head—except for a few nuances, the arias were virtually the same.

Whose work was this? Squinting at the slanting letters, I could just make out a signature at the top right-hand corner of the yellowed sheet. A large A followed by a smaller N, then a T. Antonio!

The surname was even lighter, but it began with a large V that sloped to the left like a sail filled with wind, then an I and another V. The rest of the signature thinned out to a wiggly line, but there was only one composer who could have penned this score—Antonio Vivaldi.

What had Maestro Torani whispered to Signora Passoni after the concert? "Don't you hear the whispers of Vivaldi, my dear?" She'd jumped like she'd been prodded with a hot poker.

Whispers, my left foot. This was a shout of Vivaldi, a fanfare, a blast of trumpets.

I gathered the lot and took off at a run, recalling the bundle of scores I'd seen tied up in the vestibule downstairs. Was there more of this Vivaldi manuscript concealed in that untidy bale?

I clattered down the uncarpeted stairs with my heart in my mouth. The red-and-black-tiles of the vestibule were an empty chessboard. With a frustrated sigh, I stepped outside and looked up and down the thin strip of pavement along the canal. The scores were gone, of course.

And so was the anonymous boat Tedi had hired to carry off Maestro Torani's personal effects.

◇◇◇

I wandered aimlessly, stung by Tedi's mysterious decampment and puzzled by Rocatti's poaching of Vivaldi's composition. If someone had asked me where I was headed, I wouldn't have been able to say. The weather was fine, and the air held a whiff of autumn. Eventually, I found it pleasant to ramble alone with my thoughts, which had inexplicably turned away from sorrowful confusion to settle on the happier times I'd shared with Maestro Torani. Such is the way our minds seek to protect us.

A few squares east of the Calle Castangna, I passed the Greek church whose campanile listed almost as severely as the more famous tower in Pisa. Then I crossed several wooden bridges and wound through one quiet calle after another. Outside many doors, men occupied broken-down chairs, taking an after-dinner break. Their women gathered on balconies above, almost enveloped by curtains billowing out from open windows. At last I found myself on the pavement in front of the lofty, columned façade of the Church of the Pieta. The institution alongside the church was the Ospedale where Vivaldi had instructed his young female charges and where Signor Rocatti now held the same position.

I drew close enough to see the porter at the gatehouse, drowsing with his feet propped up on the counter. I could wake him. He would stretch his arms, rub his eyes, and inquire which young lady I wished to visit.

The residents of the Pieta were not all orphans, you see. Many were the natural daughters of aristocrats and their mistresses. In a society where only the oldest son of an illustrious family was encouraged to marry, the by-blows of the younger sons did tend to accumulate. While true foundlings were handed over to the nuns through a square window with nothing but their swaddling clothes, the noble daughters were consigned with generous donations to support the Ospedale and were generally acknowledged and visited by their families. Little stigma was attached to being a flower in the Pieta's garden. If their bloodline was illustrious enough, many of the girls went on to make good marriages.

Of course, it was Rocatti I would demand of the porter, not one of the girls. I stood there for some minutes, making up my mind. I finally decided to move along and confront the young composer later, once I'd had some questions answered. What did I know of Rocatti's background, after all? I'd especially like to know if the young composer had pirated just one aria for *The False Duke*—forgivable, perhaps—or the entire opera.

Borrowing a tune as an homage to your mentor was one thing. Presenting another composer's opera as your own, note for note, was quite another.

I strolled west along the Riva, pausing to take in the view of San Giorgio Maggiore. Across the sparkling, rippling waves of the Basin, the island's spires and domes could have been an immaculate stage set created by our talented Ziani. Continuing on, I came to the rose-pink arcades of the Doge's palazzo and the square beyond. The Piazzetta's pavement blazed in the afternoon sun, and I was glad of the stiffening breeze that whipped flags and banners into a flapping frenzy.

Fruit sellers were set up between the pair of columns that overlooked the Basin and the ships moored at its jetty. A trio of old women crouched on stools under a particularly huge

umbrella that appeared in danger of toppling in the wind. In return for helping them anchor their protective shade, they offered me the pick of their wares: melons, figs, and apples. Ripe apples! They must have come from over the Alps—Italy's wouldn't be ready for picking for another few weeks. The sight of that heaped, shining fruit, red-striped over a delicate green, reminded me I was famished. I'd had nothing to eat that day, only a gulped cup of chocolate many hours ago. I accepted one apple for my mouth and one for my pocket.

The juicy fruit only whetted my appetite. I continued along the pavement until my feet followed old habit and turned away from the water, toward the Teatro San Marco. I called in at the first café I passed. A spindle-shanked scarecrow in a greasy apron served me a salad so fresh it could have leapt onto the plate directly from the garden. He followed that with a simple dish of macaroni browned in butter topped by a filet of perfectly grilled fish. My stomach sang!

If my mood hadn't been mellowed by a full belly and fond reminiscence, I would've had the sense to avoid Peretti's, the coffee house frequented by musicians and theatrical folk. Men only—the single woman allowed in Peretti's was the ancient beldame who tended the steaming copper urn.

I deposited a soldo in the admission box and passed through the glassed doors. It took but a moment to realize my mistake. As I glanced up and down the long tables, news-gazettes abruptly rose to cover their readers' eyes. Pipes suddenly went out, necessitating a great folderol of tobacco and tinder boxes. Snuff cried out to be taken. These activities occupied my acquaintances who were embarrassed to encounter one of their number who was suspected of killing the revered maestro of the San Marco.

More forthright men—the sensation-seekers and morbidly curious—merely stared open-mouthed, as if I'd grown an extra nose.

For the space of a heartbeat, I stood frozen. I saw none of my particularly trusted friends and couldn't decide whether to stay or go. Suddenly, fiery coals of anger burst into flame beneath

my soles and impelled my steps toward my usual seat. By God's grace, I had as much right to take coffee at Peretti's as any other man! Struggling to maintain a dignified mien, I removed my hat, sank down on the bench, and called my order to the boy.

He dashed over to the urn, returned with the cup clattering in its dish, and pushed it at me with bulging eyes. I sent him a wink, which only served to make him go white as a sheet.

Sigh.

I'd taken only a few sips of the stimulating brew when the two men I least wanted to see in this world entered the steamy coffee house and headed straight toward me. Lorenzo Caprioli eased his bulk down on my right and Emiliano, his primo uomo, squeezed in on my left. I felt my jaws tense, my stomach flutter. After ordering a cup of coffee each, the scoundrels from the Teatro Grimani propped their elbows on the plank table as if they meant to settle in for a good talk.

Thus bracketed, I could only say my buongiorno through clenched teeth. More than the beverage distinguished coffee house from tavern. It was the fast rule of every coffee house from London to Rome that discourse remain sober and civil, all the better to foster brotherhood and free exchange of new philosophies.

There were other reasons to keep my demeanor in check. At least fifty pairs of eyes were watching. I hardly wanted to give Peretti's clientele a fiery show that would be talked about all over the city. That would seal my reputation as a volatile monster for good.

Chapter Fourteen

Caprioli slapped me on the back as if we were boon companions, hard enough to make my chest start throbbing again.

"I have to thank you, Tito," the impresario said with an evil grin. "You've given my *Venus and Adonis* an astounding advantage. If anyone even goes to see…ah, what do you call your opera? I can't seem to recall." He touched two fingers to his forehead. "*The Pretend Prince? The Counterfeit Count? The Misbegotten Marquis?*"

"*The False Duke*," Emiliano supplied. The hefty castrato was eating marzipan candy from a tin enameled with flowers and bows. He licked his fingers and held the tin out invitingly. "Tito?"

"*Grazie*, no." I could barely contain myself.

"Yes," a very self-satisfied Caprioli continued. "Anyone who takes a box for *The False Duke* will see an under-rehearsed mess sung by a second-rate prima donna and a so-called primo uomo with a slit beneath his breeches where his lonely, limp rod should hang. After the audience has a good laugh, they'll run back to the Teatro Grimani and stay there."

"*The False Duke* is a masterly piece of work," I stated flatly. "Venetians will recognize it for the true jewel it is." I inhaled deeply, and added in a quiet but firm tone. "They also recognize shit when they see it."

My insult pricked Caprioli's bubble of conceit. He bristled, sitting tall and tugging jacket sleeves over food-stained lace cuffs.

After a moment he said, "That's brazen talk for a man who's one step ahead of Messer Grande's long reach."

"You know I didn't kill Maestro Torani," I shot back loudly enough for the entire coffee house to hear. I glanced around. No man was making a pretense of reading his paper now.

"Actually, I tend to believe you." Caprioli paused for a slurp of coffee. "But the Savio obviously doesn't. He's put Niccolo Rocatti in charge of *The False Duke.*"

Rocatti! "Wha—" I began, before I could stop myself. Though Rocatti was the composer of record, I was certain that Signor Passoni would call on Giuseppe Balbi to direct. The violinist was so much more in tune with Teatro San Marco's ways.

"You haven't heard?" Caprioli stabbed an elbow on the table and propped his fleshy chin in his hand. "We had it from Majorano, didn't we, my good Emiliano."

The castrato nodded, gobbling another marzipan.

"No, I hadn't heard." I cleared my throat. "But Rocatti... he is the composer, after all." I wouldn't publicly deny Rocatti his laurels until I was certain that he didn't deserve them. "He should be able to whip *The False Duke* into shape."

"Poor Rocatti is a tolerable composer, I'll grant you that. But a man who finds it difficult to organize the giggling misses at the Pieta won't be able to bring a rebellious opera company to heel."

"Rebellious?" I repeated under my breath.

Emiliano slid his candy tin back in a deep pocket. "Majorano isn't happy—not happy at all." He paused to suck on his teeth. "Who would be, suddenly forced to play second fiddle to Angeletto? I don't blame Majorano for arranging for a claque—I would do the same if I were in his place—and tell them to lay on plenty of rotten tomatoes and a few stones."

I was reminded how much I truly disliked Emiliano. Everything about him was false—the cosmetics that accentuated his classic profile, the pads his tailor inserted to broaden his shoulders, the corset that kept his belly firm. I wiped a hand over my damp forehead. I needed to leave Peretti's, but the two Teatro

Grimani fools had me neatly wedged in, especially now that someone else had squeezed in behind me.

Caprioli grabbed the conversation back. "Can you imagine *The False Duke* suddenly bereft of its huntsman?"

"Are you planning to steal Majorano for your company?" I asked.

The villain laughed outright. "I don't need that pretty boy, not when the Grimani's subscribers worship Emiliano. No, here's what I mean to say: If Messer Grande arrests Majorano for Torani's murder, that would leave quite a hole in the company."

"Majorano wasn't even at the Ca'Passoni last night."

Caprioli had dropped his air of false bonhomie. His piggy eyes glinted with malevolence. "He was. You just didn't see him."

"What?" I sputtered.

"Oh, yes." The impresario nodded deeply. "I saw him. I came *en masque*. Didn't notice me, did you?"

"Yes, I did." Grateful for a small triumph, I stretched a point. "I recognized you by your ill-fitting turquoise breeches."

"Well…" He worked his brows up and down, momentarily knocked off stride, then continued. "Majorano blundered through the front doors when most of the guests had either departed or hurried from the salon to view the late lamented Torani's body. The boy was drunk as a sailor on his first night home, railing against Torani and Angeletto at the top of his prodigious lungs. He had a few choice words for you and Signor Balbi, too. He didn't stop there—he'd like to see the entire Teatro San Marco sink beneath the lagoon!" Caprioli paused to pick at his teeth with a fingernail, then laughed and nodded. "With everyone else otherwise engaged, I had to help the footman get Majorano back outside and into a gondola."

Emiliano sighed and stared into the middle distance. "I would love to have seen that. I should have put on a mask and accompanied you."

"You were perfectly welcome. I told you.…"

"But it would have been embarrassing to be thrown out if the Savio had recognized me."

"I told you not to worry."

They were talking over me now, as if I'd suddenly disappeared. I gripped the edge of the table, unable to endure one more minute. I twisted around as far as I could and thrust an elbow into a belly covered with a linen waistcoat. *If this buffoon behind me would just move out of the way....*

The buffoon turned out to be Aldo, a most unlikely rescuer.

The San Marco's stage manager placed a hand on my shoulder and announced loudly, "I'm glad I found you, Signor Amato. You're wanted at the theater. We must go now." He sent Caprioli a pointed look.

The impresario rose, his face cloaked by a puzzled expression. Emiliano followed suit. I was puzzled, too, but resolved not to show it.

I'd clambered over the bench and turned to follow Aldo when Caprioli spun me halfway around with a rough hand on my arm. In a caustic whisper, he said, "You won't win, Amato. Whatever is going on here, the Grimani will end up with the Senate's backing. I can't fail—I hold the whip hand."

I shook his hand from my sleeve. "I don't see any whip."

He snorted. "It wouldn't be of much value if you could see it, now would it?"

◇◇◇

On the crowded pavement in front of Peretti's, still simmering over the conversation inside, I turned to Aldo. "I'm not really wanted at the theater, am I?"

The stage manager gave an exasperated grunt. "Oh, you're wanted all right—by Ziani, the singers, the musicians, the dance master, the trash collector—by everyone except the Savio."

"Does that include yourself?" I put in quickly.

Aldo pursed his lips like he smelled cabbage burning, but he nodded and said, "Yes. Me, too. Without you, the opera is in danger of becoming a shambles."

"What's gone so wrong? Rocatti has been the director for less than a day."

"We need a quieter spot." Aldo jerked his chin towards something behind me. I followed his gaze and saw Scarface, one of the bravos who carried Caprioli's chair, leaning against the side of the building, regarding us with poorly concealed interest. An actor, he wasn't.

"This way." I headed up the pavement, away from Scarface and the once comfortable coffee house now poisoned by suspicion. In silence, Aldo and I passed a line of shops, some still shuttered for the dinner hour. We turned a corner at an apothecary establishment displaying a wickedly tentacled aloe plant in its window, and eventually stopped at a long quay where four or five untended gondolas bobbed. "Here?"

He nodded and we rested on a low granite wall enclosing a shallow flight of steps that dropped to the water's edge. The damp, cool smell of low tide rose from the tangled fronds of green moss that flourished in the space between the water's highest and lowest marks. On the pavement, women passed in bright shawls or an occasional black zendale, men in rough work clothes. We had passed out of the theater quarter. I was not well known here, and no one seemed to pay us any particular attention.

"What has happened?" I burst out. Though painfully curious, I was also uncomfortable in depending on the observations of a man who'd made it crushingly obvious that he didn't care for me.

Aldo still hesitated. He must have been feeling the same. After a wry grimace, he began, "The Savio gathered us all at the theater this morning. After a few words about Maestro Torani's death—and nothing said about you, as if you'd also ceased to exist—he introduced Rocatti as our new director. The Savio had to push the man forward. Literally push him with a hand to his back. Rocatti mumbled his buongiorno and started into a pretty little speech about how we'd all soon be fast friends."

Aldo crossed a booted foot over his knee and threw his head back as if imploring Heaven to deliver him. With a deep sigh, he returned his gaze to me. "Can you imagine? Oriana giggled outright. And Majorano kept asking who was the fool the Savio had brought in." Aldo's gaze sharpened. "He looked a sheet or

two to the wind, blinking and rubbing his eyes to keep himself awake…Majorano, I mean."

"Still drunk? At that hour?"

The stage manager shook his head. "More likely the effects of drink the night before. I'm surprised he was able to stumble into the theater. But Tito, that wasn't the worst of it. Angeletto and his entourage arrived while Rocatti was still trying to learn everyone's name and connect them with the parts they sing."

An image leapt to mind—Angeletto being carried onstage by his troop of sisters like a plaster saint borne aloft in a feast-day procession. Apparently, I wasn't far from wrong.

Aldo described the scene: "The Vanini women just kept coming, the old mother in the lead and the others following like a gaggle of geese. Then the mother cackled her orders and they all scattered. She started in on me with a steady stream of demands. Carlo must have the biggest dressing room, with at least two windows, and plenty of candles—and a pitcher of fresh water to be on the table at all times lest his precious throat dry up. I'm to furnish his sisters with everything they need. There's one to mend his costumes, one to iron them, one to fetch his dinner—" Aldo threw up his hands. "One to wipe his butt after he takes a shit, for all I know."

"Was Maria Luisa with them?"

"The horse-face with the spectacles? Looks like she's forever doing sums in her head?"

"That's her. Did she have her own set of stipulations?"

Aldo puffed out his cheeks and exhaled noisily. His gaze lit on a passing water carrier, a pavement goddess with a straight back and sleeves rolled above muscular forearms bearing buckets. Thus burdened, she still managed to twitch her hips at him. Aldo grinned before switching his attention back to me. "The sister didn't have any orders for me. She stationed herself in the wings—stood there waiting and watching for some time. Not much gets by her, I'd guess. Once Angeletto was escorted to the costume workshop, this…Maria Luisa?"

I nodded

"Well, Maria Luisa made a frontal assault on Signor Rocatti—a daring piece of work since he was in conversation with the Savio and Ziani. The Savio had demanded to see how his cursed shipwreck was progressing—Ziani was demonstrating how he'd rigged the deck to split in half at the finale's crescendo. The Savio was impressed, but he wanted it even bigger and grander. " Aldo danced his hands one around the other to signify the inflated trumpery of Signor Passoni's orders. "Anyway, Maria Luisa strides right up, tears Rocatti away, and draws him into the corner by the stairs. She was shaking her finger, laying the law down about something. I couldn't hear, but poor Rocatti looked even more unhappy than he had all morning."

Poor Rocatti. Aldo was the second person to employ that phrase within the past hour. I asked, "Has any rehearsal been accomplished today?"

"Only because Balbi pulled himself out of his doldrums. He's taking the old man's death hard—I've never seen him so affected. He sat in the orchestra pit with his head in his hands for nearly an hour. Finally he removed his violin from its case and had his musicians strike up the overture. The singers naturally drifted onstage. Then Balbi suggested that the company run through the opera as it stands so Rocatti could form a clear picture of what needs to be done."

"Was Signor Rocatti pleased with *The False Duke*?" It must be a treat to see your music sung well in the proper setting, sheer torture to see it mangled. But then, if it wasn't really your music, how would you feel? Embarrassed, guilt-ridden, afraid of being found out? Or perhaps Rocatti was one of those men who possessed a stone cold heart that felt nothing. No, I thought forcefully, last night Rocatti greeted Signora Passoni with true warmth. He feels something for her.

Aldo was slowly shaking his head, fingering his lower lip. "Hard to tell what Rocatti thought. He and the Savio watched from the Doge's box without comment or interruption. When they came down to the stage, the Savio quickly released everyone for a late dinner break, promising that Rocatti would deliver his

impressions when we resume." The stage manager consulted a watch connected to a long, hand-woven fob. "Which should be in about ten minutes."

He closed his eyes for a moment and massaged his lids, then he looked at me sidelong. "I loved the old maestro as much as you did."

"I know." I recalled the many times that Torani had urged me to cultivate better relations with the stage manager, but Aldo had never responded to my overtures. I'd decided that he was jealous of the musical bond he could never share.

"Did Torani ever tell you how we met?" Aldo cocked his head. I shook my head.

Aldo crossed his arms. "I was born on the mainland, in Ceneda. Ever heard of it?"

"Barely." I knew of Ceneda only as a backward city of the hilly country to the north.

"My four brothers and I had the misfortune to lose our mother when I was only five. Our father was a tanner, and in his grief he gave us little heed. My brothers and I grew up wild and free, like the black savages of Africa." He paused to chuckle. "The parish priest and the few neighbors who could bear the stench of the tannery tried to contain us, but it was useless. Under my brothers' tutelage, I learned to scrounge and pilfer what I needed. I excelled in relieving men of purses and wallets. Small hands, you see." He held one up for my inspection, wiggling its digits. "Eventually I made my way to Venice on foot, where the better dips were."

A pair of sbirri passed, bathing us in their all-encompassing stares. Aldo kept silent until they had walked out of earshot. Then he continued in a wistful tone, "I thought I was brave, that I could get away with anything. Looking back, I can't believe how rash and careless I was. I made an art of dancing my fingers into richer and richer pockets. One day, I chanced to dip into Maestro Torani's pocket, and one of that bunch," he said, jerking his chin toward the sbirri, "caught me red-handed. The old man was amazed—he hadn't felt a thing. Before I was dragged

away, he said, 'You must be a clever lad. Why do you want to end your life at the end of the hangman's noose? It's not a pleasant death.' I think I muttered something about starvation not being too pleasant, either. No need to gild the tale. Torani refused to testify before the *avogadoro*, so they let me go free. Then the old man gave me a job sweeping up at the theater. He checked on me every day to see how I got on, and he seemed to genuinely care...." Aldo shrugged. "So, I stayed."

"I had no idea," I said quietly.

Aldo twisted around and gazed down at the sea-green canal as if it held the answer to an age-old mystery. "In this cruel life," he said, "I've noticed that most men end as they begin. If it hadn't been for Rinaldo Torani, I'd have been hanged long ago. Or worse, locked up under the Leads until the heat and confinement drove me mad." He looked up, raised both eyebrows. "They put you in a closet, you know, not much more than a box. Even a man my size can't stand up in there."

I nodded, well aware of how the Republic treated its prisoners, but something he said bothered me. I replied, "It's my philosophy that men can change if they embrace a new code and resolve to live by it."

His lips pulled in a frown. "A man may walk a new path, but those around him put more faith in his past than his present. Many times the sbirri nab an innocent man. They don't care. An Inglesi has his purse lifted and wants someone to take the blame. As long as someone—anyone—is punished, he doesn't care, either."

Aldo slapped his hands on his knees. "Maestro Torani was different. He saw beyond the obvious. *Allora*, if I can be useful in finding his killer, you have to tell me how. I know you well enough to think you must be on the hunt."

I held his gaze for a breath, then: "Haven't you heard the talk about how I must have removed Maestro Torani to advance my career?"

"Don't waste my time, Tito. I have to get back to work."

I detected no hesitation in his reply. "All right." I licked my lips, nodding. "Has anything been removed from Torani's office?"

Aldo dug in the pocket of his linen waistcoat and came up with a brass key that he displayed between thumb and forefinger. "As soon as I got in this morning, I did a sweep of the entire theater. The door to Maestro Torani's office was locked—just as it's been since the gondola accident. I let myself in and took a look around. Everything seemed in order."

"Tedi hasn't been in, perchance?"

"No, not for some time."

I told him about her departure for an Alpine spa. The stage manager merely rolled his eyes and muttered something about "perfidious females." Then he pressed the office key into my palm. "Perhaps you'll see something I didn't."

"I need to look through Torani's scores."

Aldo whistled under his breath. "What? All ten thousand of them?"

I nodded. "I'll need some time—preferably away from prying eyes and without danger of interruption."

Pushing on his knees, Aldo rose from the stone wall. His last words were low and pointed. "Come to the theater tonight then—Ziani has been burning the candle at both ends, but he should be out of his workshop by eleven at the latest. I'll be waiting at the stage door."

I didn't move right away, merely watched Aldo saunter up the pavement with his usual bantam rooster strut. Had my old enemy really become my friend?

◇◇◇

I eventually scrambled to my feet, dusted off the tails of my jacket, and directed my steps toward home. But not before wiping my neck with my handkerchief as a cover for sending a discreet look in every direction.

At several points during my conversation with Aldo, I'd had the uncanny sensation of being observed, that prickling at the back of the neck that forces you to turn and scan the scenery behind you. Scarface hadn't followed us, and I'd identified no one on the canal or the pavement who didn't seem to be going about his day-to-day duties. Besides, the stage manager and I had

been talking softly in the open air. No one could have possibly overheard without giving his presence away. But as I entered the Cannaregio, the feeling of being watched returned emphatically.

My neighborhood consisted of long, straight canals bordered by wide pavements, a gondolier's dream. Connecting these main thoroughfares were slender threads of water crossed by bridges of wood, stone, or iron. I stopped in the exact center of one of the crooked bridges that doglegged into the intersection of two calli. The surrounding three-story houses rose straight up from the water, framing a rectangle of sky. Against that pale canvas, gray clouds scudded in shifting layers. I propped my back against the bridge's iron railing and gazed upwards as if assessing our chance of rain.

I feigned that pose for some minutes, keeping my expression unconcerned but my muscles expectant and tense. If any lurker had business with me, I was handing him—or her—a very tempting invitation.

No one responded—and it really did look like we were in for a storm.

Pushing more deeply into the Cannaregio, I decided that one of Messer Grande's spies must have been detailed to keep a discreet eye on me. My foray into Peretti's coffee house had proved disconcerting in more ways than one: it was obvious that at least some of my musical comrades were taking it for granted that I'd killed Torani and would soon be arrested. I had to wonder exactly where I stood on Andrea's present list of suspects.

Fat raindrops bounced off the pavement just as I came in sight of the house. I ran the last few yards. Liya heard me jiggling the latch and came to open the door herself. A strand of her long black hair had escaped her chignon, and her eyes looked weary.

"Where's Benito?" I asked. Since my manservant was no longer needed to care for my costumes at the theater, he had taken on more responsibility around the house. Minding the door was one of them.

"Come into the sitting room, Tito."

One candle burned there, on the table where Liya had been studying her cards. Instead of being laid out in their usual neat array, the brightly-colored rectangles were scattered across the tabletop as if a child had been playing with them. One had fallen to the floor. I returned it to the table—a winged angel pouring water from a pitcher into a chalice of wine. From previous discussions I knew this card represented Temperance and Harmony.

I could use some of that.

My wife clapped her hands for the maid, and the girl stepped in from the hallway. Liya told her to bring wine, and after a sharp glance at me, a plate of bread, olives, and cheese.

"Liya…" I began uneasily. I craved the normalcy of home, but the atmosphere in the house felt decidedly wrong. Even the shadows gathering in the corners seemed to harbor some somber secret. Where was Benito?

"He's gone," Liya told me, once I'd flopped down on the tapestry-covered sofa.

"Gone?"

"He packed a bag and left around noon, not long after you did."

"But…where did he go?"

"I asked him, of course, but he insisted on being mysterious. Benito absolutely refused to explain where he was going or why—only stressed that I'm to tell you that he pledges to return with information you will find beneficial."

"How can he make such a pledge?"

Liya shook her head. "His last words were, 'I will find answers for my master or die trying.'"

Dio mio! My heart became a tiny hammer, pounding my ribs with a staccato beat. It went on as the maid crept in with her tray and Liya pressed a glass of Montepulciano into my hand. First Tedi, now Benito. While Tedi's desertion struck me as a betrayal, Benito had obviously formulated some misguided, spur-of-the-moment, overwrought plan to help my situation. What and where, I couldn't immediately fathom. Oh, Benito, I thought, what kind of trouble have you started? I bowed my

head and mumbled a prayer for his protection. What else could I do? Sending after him would do no good. He'd been gone for hours, and his trail would be cold.

As Liya moved about the room lighting more candles with a tightly twisted length of paper, I calmed gradually. The hiss of the wicks catching fire melded with the patter of rain sounding on the shutters. I took a sip of wine and let its warmth fill my mouth before swallowing.

"Your face is so gloomy," Liya said, as she kicked off her shoes and settled beside me with her legs drawn up under her skirts. "Are you in pain?" She touched my chest lightly. "I must redress your wound."

"It's all right." I moved her probing hand away.

"Is it Benito? You mustn't worry. He knows how to take care of himself."

She was right. My manservant had shown himself to be resourceful in a number of ways—God had given him the gift of dancing between raindrops without ever getting wet. Perhaps I was needlessly anxious.

"Well, did you discover something upsetting while you were out in the city?" Liya asked. Her black eyes, slanted sidelong and illuminated by candlelight, gave off an eerie gleam.

"You be the judge," I challenged and began to recount my afternoon's activities. When I reached the part where I entered Maestro Torani's study, I remembered his letter that I'd stowed in my pocket. I quickly retrieved it, then broke the seal on the outermost paper that had been folded around three inner pages scrawled with my mentor's loosely sloping hand.

Wine glass abandoned, I read Torani's last letter aloud with Liya's head snuggled into my shoulder. He must have written it while I was away in Milan, because it began thusly: "My dearest Tito, My heart is heavy and my head confused. Whether you return with Angeletto or not may matter little. Powerful forces are arrayed against our Teatro San Marco, forces that a tired old man can no longer gather the strength to fight. If you are reading this, I am gone—to a happy place far from Venice, or

more likely to the dark and mysterious fate that we will all face in time. I have much to reproach myself with and hope you will not despise me if my actions have led to the demise of our beloved opera house. Forgive me, my boy."

I glanced up with a puzzled grunt.

Liya stirred beside me. "What does he mean, Tito?"

"I only wish I knew, my love." I heard my own voice tremble as I considered which forces he could have been referring to.

Settling back down, she murmured, "It's almost as if he had a presentiment of his own death."

I nodded, scratched my cheek where Liya's hair was tickling it, and turned to the next page. It was a list of instructions Maestro Torani had set out in the event that the San Marco survived. My mentor clearly assumed that I would don his director's mantle. I sighed. What would he think if he could know that Rocatti was now in charge of the enterprise he had tended for over a quarter of a century?

The third page held a more personal message. "Heed me well," I read. "Tedi calls me an old fool. She speaks the truth. I'm vain, exacting, and over full of pride. Ambition bedevils me—I may as well be honest. Many times I squeezed and pinched you like a boot a size too small. Or otherwise held you back by tying myself to your coattails. You must forgive all this, too. I cannot change my nature. This is the important thing I want you to remember: Although I have no father's claim to you, indeed, I love you as my true and only son. My dearest wish is that you recall our shared years with happiness."

He'd signed it with a flourish and an embellished Rinaldo Torani.

"Oh, Tito," Liya breathed.

I stared at the words on the page so long that they ran together and became as meaningless as chicken scratchings. Then I hugged my wife with both arms and tightened my grip as if I were girding us both for battle.

Chapter Fifteen

Liya had extracted a promise that I wouldn't go to the theater alone. She had never liked Aldo any more than I had and didn't trust him. With Benito gone, there was only one person for the job of helping me search Maestro Torani's office: Gussie. My brother-in-law was always ripe for an adventure, and there had been precious little excitement in his life of late.

I arrived at the house on the Campo dei Polli—the house that had been my and Annetta's childhood home—just as my sister was taking the children upstairs to bed. Isabella squealed when she saw me. She wiggled out of her mother's grasp and fastened herself onto my leg. Now I had two more females to convince of the necessity and gravity of my mission to the theater.

Pulling at my cloak, my niece begged to come along so she could view the kitten that soon would be hers. Isabella was easily put off by a sugar stick that I'd tucked in my pocket for just such an emergency. Not so Annetta.

As Gussie donned cloak and tricorne, my sister crossed her arms and fixed me with a stare. Her brown eyes held a stubborn look I knew well. Once she'd absorbed the details of my suspicions about *The False Duke's* true composer, she said, "Let me see if I have this right. You're going out into a dark city filling up with all manner of scoundrels bound for Carnival, trusting a man who's been jealous of you for years, and crossing a patrician who would see you thrown under the Leads without batting an eyelash. Correct?"

"Annetta, I have to—"

"I know," she cut me off and heaved a sigh. "Don't forget that I was around when you first sang on Torani's stage. I know how you felt about the old man. Just…please…don't allow your zeal to cloud your judgment. "And," she paused to run a possessive hand over Gussie's shoulder and arm, "take care of my husband."

"You have my promise, Sister."

Annetta saw us off with kisses. A peck for each of my cheeks, and a long, deep one for Gussie.

◇◇◇

Venice never slept. Well, perhaps you could argue that my city drowsed during the worst of the summer heat, when the wealthy made their annual *villeggiatura* to cooler mainland estates. But a deep, snoring, head-buried-in-pillows sleep? Never. Gussie and I had plenty of company on our walk to the theater.

We began by circling the Campo dei Polli, where the bright, three-quarter moon shone on several men smoking long clay pipes around the central well that supplied the square with drinking water. They were bundled in cloaks against the chill, picking over matters of the day, their heads wreathed in gossamer threads of pale smoke. Above, several women murmured from balcony to balcony. Gussie and I didn't speak until we were hurrying along the Cannaregio's canal-side *fondamenti* where I advised him of Maestro Torani's gambling debts and their consequences.

Gussie had been minding the uneven paving stones; now his gaze slewed to me. "That rather widens the field of possible killers, doesn't it? I've heard that many of the private casinos are owned by cash-poor second and third sons of patrician stock—men with little to fear from the authorities and plenty of bravos at their disposal."

"You've heard correctly. But Torani's valet reported that Tedi had paid the old man's debts with money raised by selling her jewels."

Gussie pulled a face. "Tedi must be frightened, though. What else would drive her from Venice before Maestro Torani has even been laid to rest?"

"I'm thinking her sudden journey may have something to do with the object of our search. I don't know how or why—every time a piece of the puzzle comes into focus, another piece becomes blurry—but I also believe that *The False Duke* somehow bears on the murder."

We paused on a wooden bridge to watch a large gondola lit by lanterns, fore and aft, slip by. It was headed toward the heart of Venice, but the feathered masks of its chattering occupants and the mist rising off the water lent the pleasure boat an air of a barge bound for fairyland.

As we started down the bridge's steps, Gussie changed the subject. He spoke with uncharacteristic tartness. "Tito, I know Benito is devilishly clever and capable and all that, but disappearing on this impulsive jaunt without securing your permission…" He trailed off and shook his head disapprovingly.

"Italian servants can be unfailingly loyal, but they're not nearly as stuffy about it as your English ones." I had this on firsthand observation. I'd spent one exceedingly damp and dreary London season singing at the Royal Opera House in Covent Garden. Never again! "Italians have considerably more imagination and a definite independent streak. Benito must believe he's doing me a service."

"But you didn't tell him he could set off on his own? Even by implication."

"No." I scratched my head as our long legs ate up the pavement. "At least I don't think so. This morning seems like ten years ago. We talked of the murder, of course, and we both had our pet suspicions."

"Suspicions of whom?"

"Majorano, Angeletto, Caprioli. You mark my words—Benito will return one of these fine days, having inveigled a deep, dark secret about one of them. Perhaps the secret will be useful. Perhaps not. But it will be true."

Gussie shook his head. "I'm just glad I don't have to contend with such an unpredictable servant." Once he'd settled in Venice, my brother-in-law had dismissed his severely correct valet and

never hired another. Gussie actually seemed to relish dressing himself and didn't mind that his yellow hair often resembled an untidy haystack.

He fell silent as a man and woman in concealing *bautas* passed by with their veiled hat brims nearly touching. Husky, amorous whispers reached our ears, then Gussie said, "I've thought of a service I could do you, Tito."

"You're doing one now."

In the dark, I felt, rather than saw, his smile. "Something else," he replied.

"What's that?"

"I want to paint Angeletto's portrait."

"Why on earth?"

"There is no better way to know…him…or her, damn it. Over the time it takes to paint a good likeness, the artist becomes intimate with his sitter—whether the subject intends it or not."

"You still believe Angeletto could be a woman? Even after Grillo as much as admitted that the story of their lovemaking was a whopping falsehood?"

We'd entered the Campo San Bartolomeo near the Rialto. The pavement was more crowded there, and I couldn't hear Gussie's reply over a large group of raucous Germans singing snatches of popular songs.

He raised his voice. "I believe my eyes, Tito. She's pretending, using masculine gesture and stance, but not totally at ease with it."

"I can think of at least ten men who naturally move with a woman's grace—one of them is Benito."

Gussie shook his head firmly. "As I live and breathe, Angeletto is a woman. She is! I'd like to prove it to you."

"Until then, could you indulge me by using the masculine pronoun?"

"If you wish," he replied stiffly.

We'd caught the Germans' attention. They pressed close, hemming us in, all wearing identical white masks with rounded cheeks and blunted noses. Standing on tip-toe, their leader

shoved his pig-snout into my face and demanded directions to a certain notorious casino. After we'd pointed the way, he tried to fill our hands with foreign coins. We tossed them on the stones for the ever-present facchini and went on our way. What did the ill-behaved foreigners think Gussie and I could do with their paltry thalers?

By the time we'd reached the campo on the landward side of the Teatro San Marco, I'd given Gussie permission to do as he liked about Angeletto's portrait. Against my better judgment, I admit. His unshakeable belief was based in part on his attraction to the singer. Was it a good idea for him to be spending long hours of portrait-sitting with Angeletto? I'd acquiesced because Gussie was so keen. He'd formulated the idea of announcing himself to the singer with the news that an anonymous admirer had commissioned the portrait—not an unlikely event in a city which was still being swept by castrato fever. Public gondolas were now flying pennants devoted to their boatmen's favorite singer, and on the Merceria, shops were selling ladies' fans and garters adorned with miniatures of Angeletto, Majorano, and even Emiliano.

I'd said yes, also, because I truly doubted that the Savio would allow Gussie to even talk with the singer, and certainly not to have a sitting within the confines of the Ca'Passoni. Signor Passoni knew very well that Gussie was part of my family.

The theater square was deserted. With no performance scheduled, it would be unlikely to be otherwise. Balls and dinners and other entertainments had drawn the crowds elsewhere. As Gussie fell back to follow me down the narrow slit that led to the opera house's stage door, a score of church bells rang out, tolling the hour. Eleven o'clock. We climbed the stairs, and I gave the thick planked door a double thump with the side of my fist. It creaked open.

A sigh of relief escaped my lips. I'd half expected Aldo to go back on his promise.

But there he stood in the lantern light filtering through the open door of his office cubbyhole. Frowning, he stroked the

gray bundle of fur snuggled into the crook of his arm. Isis. I could hear tiny, plaintive mews sounding from his office. Aldo shifted the cat from one arm to the other. "You've brought Signor Rumbolt, I see."

I raised my eyebrows. Surely the stage manager wasn't going to object. "Two pairs of eyes," I replied. "We've many scores to look through and only so many hours."

Aldo nodded slowly. He looked haggard, with deep blue shadows dragging at the skin under his eyes. It must be difficult for him, I thought. Over his years as stage manager, Aldo had developed his own comfortable routines. Maestro Torani's murder and the change in directors had thrown a wrench into his well-oiled machinery. He had much to contend with; no wonder he looked exhausted.

"You have the key," Aldo said. "I'll stay here until you've finished in the maestro's office."

"There's no need. I've put the theater to bed many a night. Rest assured I'll lock her up tight. You go home and get some rest."

"Well…" Aldo gently deposited Isis on the floor, and the animal ran to nurse her offspring. He moved toward the stage, rubbing his chin. Gussie and I followed. From around the edge of a canvas flat, the stage manager peered into the velvety, silent blackness of the auditorium. "I suppose everything is in order."

I was more interested in the stage. The backcloth had been raised into the flies, revealing a deep forest of dangling ropes and sandbags partially obscured by a massive shadow. Before I could make sense of its contours, Gussie whistled appreciatively.

"I say, that's a fine ship. It covers nearly a third of the stage!"

My eyes adjusted, and I began to discern the contours of the dark hulk. A pointed bow. A broad stern with a raised captain's deck. And amidships, a mast that rose as straight and tall as the trunk of a hundred-year-old oak. Crossing the boards for a closer look, I burst out in admiration. "Ziani has spared nothing. This is twice the size of any ship he's built before. Has he completed the mechanism's overhaul?"

"Ziani certainly hopes so." Aldo was suddenly at my elbow. His voice had changed. No longer hoarse with weariness, it held a new energy. "He demonstrated it for Rocatti just an hour past. Our new taskmaster seemed to approve. I hope the Savio will agree—he's the one who must be pleased in the end. Would you like to see it in action?"

I was about to refuse—we had much work ahead of us—but caught sight of the excited glint in Gussie's eyes. He loved these mechanical marvels almost as much as the Savio. "All right," I said, "but be quick."

Aldo pointed downstage. "You two stand there, by the foot lamps." As Gussie and I complied, he disappeared behind the huge set piece. After a moment the stage manager's head popped up near the steering wheel, and he clambered onto the deck. "Imagine the billows rolling in the background," he called. "They swell higher and higher, tipped with white sea spume. The duke and his lady have lashed themselves to the steering wheel. A huge crack of lightning splits the sky. It actually seems to hit the mast. And..."

Aldo braced his feet in a wide stance and bent his back to the wheel. He cocked it right—once, twice—then left. With a groan I could feel through the floor boards, the great ship lifted several feet. When it seemed the ship could rise no farther, its deck gave a sharp, sudden creak and split directly in half. Each end hit the stage with a thunderous crash, raising a cloud of dust that swirled in the beams of light filtering through the wing flats. What a miracle of automata Ziani must have created below stage!

Gussie whooped. I applauded. From the sloping deck, holding tight to the wheel with one hand, Aldo bowed as if he'd designed the shipwreck himself.

The effect would be even grander once all the accoutrements were in place. A long wooden box filled with stones would be hauled up to a catwalk in the flies; when the box was tipped end to end by means of a block and tackle, rolling thunder would sound from the heavens. A boy would shake a smaller box filled with dried ceci beans to serve as pelting rain. The howling of

the wind came from machines set up in the left-hand wing. Gianni, the burliest of the stage hands, would put his muscle to turning the crank attached to a barrel-like wheel loosely covered with canvas. The faster Gianni turned the crank, the harder the wind howled.

And the lightning! What a show, but so terribly dangerous. In my opinion, fireworks should be confined to the out-of-doors. There'd be fewer theaters destroyed by flame if they were.

As Aldo went below stage to reset the complex machinery, I dragged Gussie away, and we traversed the long corridor leading to Maestro Torani's office. The brass key grated in the lock, at first stubbornly refusing to turn, then giving way all of a sudden.

I expected to be greeted by the smell of stale air and musty scores. Instead, a draft of cold air whistled past my ears. Shafts of blue moonlight falling through the casement windows revealed the source. One of the diamond-shaped panes had been broken out. Gussie located a tinderbox and candles, and we examined the damage by their wavering light.

"Broken from the outside," my brother-in-law said, poking at the shards of glass on the wide sill. "Was someone trying to get in?"

"Unlikely. At this point the exterior wall drops sheer to the water. There are other, easier windows to breach on the landward sides."

"But this is the only set of windows in Maestro Torani's private office." Gussie sent me a meaningful look.

"True." I took up a branched candlestick and bent nearly double to hunt the terrazzo floor. I found the culprit under Torani's desk: a rock of the sort you find in mountain streams, its sharp contours smoothed by centuries of running water. It fit into my palm as if it had been made for it.

But that wasn't all. Wrapped around the missal was a picture of some sort, held firmly in place by an overlay of twine. I rose, divested the rock of its wrappings, and tossed it to Gussie.

"What have you there, Tito?" He asked, snatching the stone from the air with one hand.

"An angel—at least a picture of one."

"Well, I'll be blistered." He covered the space between us in two bounds.

"It's a card from a tarocchi deck." Indeed, it was the very card that had fallen from Liya's deck earlier that day—a winged angel pouring water into a wine goblet. I handed it to my brother-in-law.

"How long has it been here, do you think?"

"A storm came through early this evening. It rained quite hard."

"So it did. It didn't stop until…" Gussie thought for a moment, still studying the creased card. "Oh, eight o'clock or so."

I crossed back to the windows. Avoiding the broken glass that glittered like scattered diamonds, I patted my hand along the sill and the floor beneath it. "Dry," I announced, straightening. "The stone was thrown during the last several hours."

"Who knew you were coming here?"

"Just Aldo." I shrugged. "And Liya, of course. I don't think this card was meant for me to see. No, I think it was meant to send a message about Angeletto taking on the primo uomo role."

Gussie handed over the card, accompanied by a wry look. "For or against?"

I shook my head. "Only the one who threw the rock could tell you that."

◇◇◇

Once we'd settled in to survey the music that filled Maestro Torani's cabinets, our search moved along faster than I'd expected. We quickly discovered that, while bound and printed scores, fragmentary manuscripts, and libretti appeared to be piled haphazardly, each shelf was actually devoted to one letter of the alphabet and arranged by the composer's surname.

I'd already cleared the desk of clutter and stained chocolate cups. The only thing that remained was the bust of Minerva. I placed her in the center of the battered mahogany surface. Perhaps she'd imbue us with some of her reputed wisdom. Then Gussie and I surrounded her with all the manuscripts from the

"V" shelf. We lit a few more candles, pulled up chairs, and went to work. My brother-in-law sorted out the operas by Valentini, Veracini, Vinci, and the like, while I skimmed through the compositions by Vivaldi. There were many that I knew, more that I didn't—the maestro of the Pieta had certainly wielded a prolific pen. Vivaldi had the reputation of making music in his head while his hands were playing billiards, carving a joint of beef, or caressing his mistress. He would later set the tunes to paper in a fury of composition. Unfortunately, I found nothing in Maestro Torani's stock of Vivaldi that remotely resembled the arias and ensembles that made up *The False Duke*.

Gussie had thrown up his hands in frustration and gone to look out upon the moonlit canal, when it struck me all at once: Torani wouldn't have left Vivaldi's score sitting in plain sight. In his last letter, the old man had referred to something that brought him shame. He'd asked me to forgive him. I interpreted his words to mean that although he knew Rocatti was not *The False Duke's* true composer, he was so set on using the opera to reinvigorate the Teatro San Marco that he was going along with Rocatti in presenting one man's work as another's. I could follow his flawed line of reasoning. Maestro Vivaldi had enjoyed his time in the sun; now he was dead and gone. Who would be hurt? And who would be the wiser?

To cover this contemptible act of piracy, Torani would have hidden the original Vivaldi manuscript. Or perhaps destroyed it altogether. But if he had kept it…

My gaze darted around the office. It wasn't a large chamber. The door on one wall, then windows overlooking the water, glass-fronted cabinets covering the two other walls, desk and three chairs in the center. The floor presented a surface of hard, smooth terrazzo. No loose boards to pry up.

I sighed, drumming my fingers on the desk top. Minerva's enameled eyes stared at me over the piles of scores which had grown to reach her nose. In the candle flame, her blue eyes glowed like lapis lazuli instead of mere paint. "If only she could

talk," I said to Gussie as I gestured toward the statue. "She could tell us if Maestro Torani hid the score in this office."

"She's a pretty thing." Gussie came back to the desk and ran his hand along her crested helmet. "This looks to be gold leaf. I wonder why Torani didn't sell her when his creditors were at his throat."

His words jerked me up straight. "Why, indeed?" I asked, my skin suddenly crawling with anticipation.

We fell on the statue in the same breath, prodding, stroking, pulling, twisting.

"It's hollow," Gussie cried, rapping his knuckles on Minerva's relatively flat back. "Hear that?"

I didn't, but I knew he was correct. He had to be. "Let me see the other end, Gussie."

He pulled the bust's helmet into his generous midsection and balanced the rest of her on some bound scores. Immediately I saw that the bottom of Minerva's square pedestal was covered with a thick, felted pad. It wouldn't give to my fingers so I unsheathed the stiletto I should have carried with me last night—if I'd had it when Grillo attacked me, we might not be here now. Under my blade, the felt peeled away to reveal a lighter circle within a darker square.

"He's plugged it." I grunted, digging the stiletto point into the newer plaster.

"Here, Tito. That'll take all night." My brother-in-law grasped Minerva's helmet in one hand, her pedestal in the other. He moved away from the desk, raised the bust high above his head. Looking as stalwart as the hero Horatius at the bridge, Gussie questioned me with a twitch of his eyebrow.

At my nod, he dashed the statue to the expanse of bare terrazzo with all his might.

Chapter Sixteen

Coughing my way through a haze of plaster dust, I retrieved a tightly rolled sheaf of papers from the litter-strewn floor. I carried it to the candlelit desk and pinned the corners down with spread fingers. The first page displayed the handwritten title followed by the obligatory dedication. Vivaldi's own hand—I recognized it from the jottings on the aria I'd found in Maestro Torani's study. Peering closely, I took an involuntary gulp when I read what Venice's beloved Red Priest had written.

He had entitled this opera *The Noble Peasant*, a much more inflammatory title than *The False Duke*. The sentiment was flagrantly defiant, especially for 1713, the date of the composition. Then, the ruling aristocracy still enjoyed their God-given powers with few challenges. I shook my head—how tremendously the world had changed in my short lifetime. Now the sentiments of revolution were in the very air.

There was more. Instead of a flowery piece of grateful prose dedicating the work to a patron or ruler, Maestro Vivaldi had inscribed it to *All tyrants, degenerate, deceitful, lustful, and depraved. Those whose foul deeds are covered by their cloaks of nobility. Those mediocrities elevated by their happy accidents of birth—*

I had to stop and wipe my brow before following the scathing language as it burned its concluding way to the bottom of the page.

"That's it? That's what you were looking for?" I looked up to find Gussie regarding me with wide blue eyes. His jacket and

breeches were coated with plaster dust, his ruddy cheeks streaked with gray. I must have looked an equally frightful sight.

"What? Oh, yes, I think so." I leafed quickly through a few pages, scanning measures here and there. I nodded. Yes, it might carry another title, but this was the original manuscript for *The False Duke*. Besides the matching music, even most of the comments on the singers' positions and the cues for sound effects were the same as those I recalled from Rocatti's score. The young Pieta violin master had simply transcribed his master's opera into his own handwriting, given it a more innocuous title, and meekly dedicated it to "our gracious prince," the reigning Doge.

I dropped into a chair and propped my chin on my hand. "This is the same opera, all right. And I can see why Vivaldi never had it produced."

"That's something I've been wondering about." Gussie moved into the circle of candlelight around the desk. "If this opera is such a marvel, why did Vivaldi hide it away?"

I passed the title page to Gussie. His eyes narrowed and his forehead crinkled as he read.

"You can see what a monstrous slap in the face this opera would be to his benefactors," I continued. "The Pieta has always been supported by the aristocrats whose bastard daughters are raised there. If the headmaster had seen it…or worse, the board of governors…" I shook my head, scarcely able to imagine the consequences. Instead of becoming one of Venice's treasures, Maestro Vivaldi might have found himself under the Leads for the rest of his natural life. "You notice the date?"

"Here." Gussie stabbed the page with a grubby forefinger. "1713."

"Thirty-one years ago," I rapped out before Gussie could even begin to do the sum on his fingers. "My birth year. Maestro Vivaldi must have been a young violin teacher at the Pieta then, much like Rocatti is now."

My brother-in-law nodded thoughtfully.

I continued, "What would once have been roundly condemned now makes *The False Duke* exciting—it's the story of a

master becoming aware of injustice and the power of Reason, and of a servant learning to think of himself as an equal—it's still revolutionary at its core, but people are primed to take in the message. Especially as it's presented with plenty of humor."

"Maestro Vivaldi was ahead of his time, then." Gussie replaced the title page, smoothed it out, and tented his fingers on the stubbornly curling papers.

"I suppose he must have written it for his own amusement, during his leisure hours, then hidden it away. Perhaps he anticipated a day when the opera could be safely performed before a public audience. A day when freethinking had spread."

"But, Tito." Gussie smacked a heavy hand on the opera score. In his simple, direct way, my brother-in-law swept the philosophical cobwebs away and bore straight to the heart of the issue. "How do you suppose Maestro Vivaldi's opera came into Torani's possession?" After a slight pause, he added, "And how did Rocatti come by it?"

"Oh, Gussie, I have no idea." I hung my head. With one hand, I massaged the aching muscles at the back of my neck. With the other, I rubbed the cut across my chest, which now felt warm and tingly. Instead of answers for Gussie, other questions spun round and round in my mind: Why had Signora Passoni been so anxious to see the opera produced? Was she aware of its content, or was she more interested in its composer? If it was the composer who had stirred her to have Franco give me the purse filled with zecchini, whose opera did she believe *The False Duke* to be—Rocatti's? Or Vivaldi's?

"Look here, Tito." Gussie consulted his watch. "It's nearly two. Can't I persuade you to come away? We've found what we came for. There's no sense in combing through that score here. Take it home and look at it tomorrow." Gussie stretched his arms over his head and emitted a mammoth yawn.

The back of my throat itched to follow suit. I was as tired as if I'd sung two four-act operas back-to-back.

"Wait!" Gussie dropped his arms and whirled toward the door. "What's that?"

I heard it, too. Footsteps slapping down the corridor, making no attempt at stealth.

"Is Aldo still about?" he asked in an urgent whisper.

"That's not Aldo." Tensing, I bounded to my feet. "He wears soft-soled boots."

Gussie handed me my stiletto, forgotten on the desktop, and made fists of his meaty hands.

A tall figure stepped through the doorway. In the dimness beyond the candles' glow, it took a few tense seconds for his face to become recognizable.

A husky, sardonic voice asked, "Have you two bloodhounds found anything interesting?" It was Messer Grande.

I felt a relieved breath cool my lips, then immediately wondered if the chief constable's presence might be a fresh problem instead of a reprieve. "Not much," I replied carefully. "We've made more of a mess than anything. We managed to knock over Maestro Torani's bust of Minerva. So clumsy…"

Feigning nonchalance as I rattled on, I used the Vivaldi score to sweep debris from the desktop, rolled it back into a sheaf, and tucked it into a cabinet. I preferred to keep our discovery to myself until I'd had a chance to chew over it more thoroughly.

Andrea had traded his red robe of office for a roomy black cloak, but his aspect was nonetheless impressive. In his role as Messer Grande, Andrea always managed to be enormously present no matter what his garb or what his errand. Gussie and I stared as he sauntered around the office as comfortably as if he were making the rounds at his favorite coffee house.

"Did Aldo let you in?" I asked.

He shook his head. "I let myself in." His boots crunched on the mixed debris of broken plaster and shattered glass. "Would it surprise you to know that my headquarters contains a little room with hundreds of hooks—six banks of hooks, one for each of Venice's six *sestieri*? And that on each hook hangs the key to an important building?"

I sat down, crossed my arms, and tipped back in my chair. "It wouldn't surprise me a bit."

With a long, drawn-out "Hmmm," Andrea took up a three-branched candelabrum. First, he inspected the broken window pane, removing his glove and patting the sill and floor as I had done. Then he palmed the missile stone that Gussie had left on the sill, nodding judiciously.

While the constable was thus engaged, Gussie sidled toward the cabinet where I'd placed the rolled up score.

No, I thought desperately, *get away from there, Gussie*. Didn't he realize that Andrea had eyes in the back of his head, and probably on both sides, too?

With an air of innocence that wouldn't fool an infant, my brother-in-law halted his progress directly in front of Maestro Vivaldi's score. All I could do was avert my gaze and attempt to distract Andrea by pulling the tarot card out of my pocket. "This was wrapped around that stone with a length of twine."

Andrea took the card and dropped into the office's third chair. He examined both sides of the pasteboard rectangle, then shrugged. "Are we to assume that this angel represents the Teatro San Marco's latest primo uomo?"

"Who else besides Angeletto?" I asked.

"Who else, indeed?" Andrea sent me an enigmatic smile. "I suppose the stone could have been thrown by one of Emiliano's partisans in a manic frenzy—shocking, the lengths these opera lovers will go to. Do you realize an enterprising shopkeeper is selling ladies garters with badges of his likeness attached? As if the bearer of that likeness would be interested in what's under a lady's skirt!" He chuckled, but stopped abruptly when he noticed my scowl. "*Scuse*, Tito. I forget…"

He cleared his throat and continued in a solemn tone, "It could have been a gondolier on his way home, a roving gang of students…or closer to home, Angeletto's rival at this very theater could have let his resentment boil over."

"Majorano?" Tossing a rock through a window seemed like a petty response for a star performer.

"It's possible," Messer Grande declared. "The hot-headed boy reserves his noble sentiments for the stage, does he not?"

"That is true." I leaned forward, extending my hand palm-up for the card.

Smiling once more, Andrea slipped the card beneath his black cloak. "Enough about this trifle, I've tracked you down to deliver good news. I found our man Grillo, and it was as you reported in every respect. He admitted entering the Ca'Passoni to keep an assignation with Beatrice. Her maid was waiting to admit him through the garden gate—a hole-and-corner affair of just the type a young miss finds enthralling. Grillo even admitted fighting with you. He wore the injury to his brow with pride— claims to have given better than he got."

"I daresay he's right about that." My chest was throbbing again, and the uncomfortable warmth had climbed to my cheeks. They felt like they were roasting before a blazing cook stove.

"Where did you find Signor Grillo?" Gussie spoke up for the first time.

"At his favorite brothel. According to the proprietor, who happens to be a keen observer of human foibles as well as everything else, Grillo arrived soaking wet around the time that Passoni's footman discovered Maestro Torani's body in the card room. Grillo had stopped there ever since." Andrea threw one leg across the other and dug under his cloak. He looked as if he might take snuff, but his hand came away empty. He shook his head and continued, "Since this establishment is some distance away, actually on the other side of the Arsenale, we can rule Grillo out as the murderer."

"What about Tito?" Gussie put in quickly.

Andrea locked his gaze on mine. "Tito lacks the willful selfishness of a murderer—the cold heart that puts one's own needs above all else."

"Even to reach the pinnacle of an operatic career?" I asked quietly. "To make a last grab at the only glory left to me?"

"Even that," he replied. "I never doubted your story of how you came to be bloodied, but now I have the proof to convince... others. Before Grillo set off for Terra Firma, I had him sign a

statement admitting his presence at the Ca' Passoni and his fight with you."

"He's truly gone?" I asked, recalling how neatly he'd tricked me. "Girolamo Grillo is as much a creature of Venice as a canal rat—I'm surprised he would consent to leave."

"Especially at Carnival time," Gussie added, "with so many foreigners ripe for the plucking."

"I gave him a choice." Andrea rose, his gaze straying to Gussie's right, then his left. "It was either voluntary exile or a stint under the Leads for swindling fools out of their money with that deceitful oracle of his. Grillo took but a moment to declare his preference. I personally escorted him to the San Giobbe quay and watched him sail away."

"What was he wearing?"

"Wearing?" Messer Grande transferred his attention to me with a puzzled look. "He'd outfitted himself in a suit of some dark stuff that he'd sent to his lodgings for."

"And his cloak?"

"Also dark."

"Not bright green with yellow lining?"

"No. Why?" A muscle near his mouth twitched. For once I was a step ahead of the crafty chief constable.

"When he leapt through the window, Grillo left a cloak of this description in the card room. As everyone poured in after Torani's murder, I noticed that the cloak had disappeared."

"Perhaps the young footman who discovered Torani's body took it." That was Gussie.

We both sent the Englishman withering glances.

"No, makes no sense." Andrea tapped the fingers of one hand on the back of the other. His impressions came out with rapid-fire precision. "Either Maestro Torani's murderer took the cloak—perhaps to later implicate Grillo in some manner—or to erase his presence and shift blame to you," he pointed toward me. "But in either case, the killer would have been watching and seen Grillo leave after you fought." Now he raised the finger like a schoolmaster underscoring a particularly salient point.

"Or perhaps a golden demoiselle besotted with the whoring scapegrace took the cloak to protect Grillo?"

"Eh?" Gussie cocked his head, obviously not following.

"Beatrice," I advised him.

"Oh, of course. Right you are, Tito."

"Now, my fine friend…" Andrea took several paces toward Gussie. "The hour is late and my pillow beckons, but I find myself intolerably curious about that roll of paper you've been so intent on hiding."

Gussie's jaw dropped open. I could only shrug.

Messer Grande motioned Gussie away from the cabinet with the swipe of a forefinger and the faintest of smiles.

"Ah…" The chief constable let out his breath in satisfaction as he picked up the thick roll. He placed it on the desk where the candles' rays were strongest, and read the title page with keen interest. We exchanged a freighted glance.

Andrea turned a page, then another and another. He scratched his head, grunted, and turned to regard me soberly. The fact that I'd tried to suppress the score didn't seem to bother him one whit. Instead of berating me, he asked, "What do you make of this, Tito? I never learned to read music. I don't even know what I'm looking at."

I explained that the tattered music manuscript in his hands and *The False Duke* were one in the same, note for note.

Messer Grande rocked back on his heels, staring into the dimmest corner of the room. "This is something that Maestro Torani didn't want publicly known."

"Apparently—he certainly went to a great deal of trouble to hide the Vivaldi original. Though at the Savio's reception, I overheard him tease Signora Passoni by asking if she didn't hear the whispers of Vivaldi in the selections I'd given Oriana to sing."

Messer Grande's head swiveled abruptly. His dark eyes blazed. "And did Signora Passoni agree?"

I shrugged. "His comment seemed to upset her terribly—she left the salon in unseemly haste."

"Accompanied by the faithful Franco?"

I nodded. "I didn't see Signora Passoni again until after Maestro Torani was dead. I didn't see Franco again at all." I heard a throb of urgency take possession of my voice. "This original opera may well be the decisive clue that solves Maestro Torani's murder. Signora Passoni, Franco, Rocatti, and even Lorenzo Caprioli—they all have possible ties to the opera, and they were all there at the reception. With the overflowing crowd, it would have been easy enough for one of them to persuade Maestro Torani to speak in private without being noticed by anyone else. Don't you think so?"

Andrea rolled up the score, stowed it in a deep pocket, and yawned behind the fist clutching his black gloves. "Ah, Tito," he said, with his heavy features set in a sympathetic expression. "I make it a point never to come to conclusions in the small hours. That's when hags ride out on their night mares, invading men's dreams and confusing their wits."

I dropped my chin, closed my eyes, and rubbed my scratchy lids with forefinger and thumb. Messer Grande had often praised the French *philosophes* and advised me to follow the rational principals of these men of letters. He didn't believe in the bogey story of the night hag any more than I did. It was only his facetious way of saying that a rested mind is sharper than a tired one. He spoke wisely. I was so exhausted, my thoughts were going round in circles.

When I dropped my hand and looked up, a dark hole existed where Messer Grande had stood only a moment before.

"Let's go home," Gussie whispered, looking a little shamefaced.

"Lead on, my dear fellow," I shakily replied.

◇◇◇

Morning came much too soon—a dull gray morning that beat against our bedchamber's balcony doors in gusty, windy bursts.

"I feared this," Liya said, after she'd peeled my nightshirt back and given my chest a practiced look. "An infection has taken hold. Suppuration will soon begin." She felt my brow with the back of her hand and shook her head. Her manner

was the same as if Titolino had made himself bilious eating too many sugared *frittoli*.

I reclined upon a stack of pillows, my mouth as dry as parchment and my head feeling too big for my neck. Gathering my wits, I pushed up on one elbow. The skin around the linear wound, I noted ruefully, was a puckered, angry red.

Liya had already dressed. She stared down at me with arms crossed over her apron. "I can give you something for the fever, but your wound requires a special balm."

I rolled over towards her, wondering what time it was and if I was in danger of being late for Maestro Torani's funeral. "What you used yesterday made it feel much better."

"That was yesterday. Today, internal corruption has set in, and stronger medicine is required." She reached out to trace her fingertips along my ribs. They seemed to burn more warmly than my skin. "The ingredients for the compound are…not easy to come by. I may be gone several hours."

"Can't you obtain the proper ingredients from the apothecary in the campo?"

She chuckled as she bent to kiss my cheek. "The last time I checked, he was all out of spider webs gathered from a north-facing cave, and his stock has never run to moldy bread."

While I was still trying to decide if my wife was joking or not, she brought me a glass of milky, opalescent liquid and insisted that I drink it right down. I clamped my nose shut, certain the remedy would be foul. To my surprise, it tasted sweet and smelled faintly of fennel.

As Liya removed her thick red cloak from the wardrobe and rummaged drawers for her knitted gloves, she ordered me to stay in bed and drink plenty of water. "There will be no funeral for you—just as well—it would only end by making you angrier than you already are." She went on to say that the kitchen girl would be up with a pitcher of fresh water, then fired several more dire admonitions at me. At each one, I smiled complacently and settled into my pillows like a man who intended to take a long, refreshing sleep.

I waved to my wife as she left the bedroom. In a few moments, the thud of the front door floated up the stairs. I made myself count to one hundred. Then my feet hit the floor.

Chapter Seventeen

After a cup of inferior chocolate prepared by the kitchen girl, I dressed myself. I chose a plain suit of loden-green broadcloth, a starched neckcloth, and a black cloak. In deference to my fever, I donned woolen stockings instead of silk and wrapped a scarf around my neck. No curls, no lace frills, no feather in my hat. Without Benito's sartorial skill, I looked rather a sober, dull fellow. So be it. I was going to Maestro Torani's funeral, and I was going alone. Last night, Gussie had offered to accompany me, but this was a duty best fulfilled on my own. I didn't want him embarrassed if Signor Passoni felt the need to have me thrown down the church steps.

If truth be told, I'd found funerals particularly distressing ever since my days at the Conservatorio San Remo. Naples sat on unsteady ground. The roots of its smoke-belching, hump-backed mountain ran deep, burrowing under the vineyards on its sides and causing intermittent tremors that wreaked havoc on ancient buildings. On a schoolboy excursion, we'd once come upon some workmen removing broken coffins from the burial crypt of a church that had fallen in on itself. We boy singers had broken ranks, ignoring our maestro's strident commands to reform our double line. I'd never forgotten kneeling on the broken foundation stones, peering over into the pit, and coming face to face with a human head lodged in the debris.

Its flesh was sunken in decay, pulled back from a mouth gaping in a silent scream. The nose had collapsed to one side, its

eyes into cankerous depressions. A rotting veil held in place by gold chains swathed the skull, and shreds of that discolored cloth coiled through a tangle of gray-white hair. I popped up with a shriek and didn't stop running until I'd reached the next campo. In a boys' school, as you may imagine, I was never allowed to forget my cowardice. Even now, whenever I chance to encounter a gondola bearing a catafalque, a gloomy chill takes possession of my heart and fills me with despondency and foreboding.

The weather matched my mood. A Sirocco was coming, bound to bring an early *acqua alta*. I could smell it in the salty tang of the wind and see it in the shifting gray clouds that dirtied the sky to the southeast. Within days, the wind would turn ferocious, whipping the lagoon into waves topped with pea-green foam and flooding the piazza. Not an auspicious beginning for Carnival, or for the opening of *The False Duke*. I pushed my tricorne firmly down on my head, tried to ignore my light head and aching chest, and directed my steps towards the church of San Nicoletto where Maestro Torani would be laid to rest.

At its modest portico, I found a dozen or so facchini laboring as paid mourners. The men were putting on a grand show, weeping, moaning, and extolling Torani in fulsome terms. Their specialty was fastening themselves to the arms of passers-by who were obliged to give over a coin to be released from their supplications; thus the false mourners earned double pay. I'd hoped to arrive before the Savio's party, and for once luck was with me. I entered the church untroubled except for being forced to shake off one particular industrious mourner.

I dipped three fingers in the vestibule font—freezing!—and whispered a prayer as I made the sign of the cross. Then I slid into an out-of-the-way pew beside a small side chapel and divested myself of cloak and hat. Aldo, Ziani, Giuseppe Balbi, and few others from the Teatro San Marco had already arrived. They knelt down front with bowed heads and folded hands. I followed their lead. In addition to my uncharacteristic clothing, burying my nose and chin in my tented fingers might save me from attracting notice, at least for a bit.

Over my mask of sorts, I surveyed San Nicoletto's interior. It was considerably more impressive than its exterior, not an opulent cavern like the Basilica San Marco, but there was a fluid symmetry in the gilded arches that framed the three naves and a touching humanity in the painting of the Madonna behind the high altar. I inhaled deeply; traces of incense lingered, stale and sweet.

I was stalling, of course, but I couldn't put the moment off any longer. By force of will, I turned my attention to Maestro Torani's death box. Garlands of ivy and fall flowers girdled the coffin atop the black-taffeta-draped bier in front of the central nave, and at least a hundred tapers glowed in ranks to each side. I shivered, out of grief or fever or troubling memories. Or perhaps a mixture of all three. I couldn't stop myself from picturing the empty, deteriorating shell of the vibrant Maestro Torani I had known. Never again would I have his wise counsel. Never again share a simple glass of wine. Never again see the warmth in his eyes when we talked of music, our shared passion.

My grief was shot through with guilt. On the Rialto, when we'd first talked of *The False Duke*, Maestro Torani had expressed a longing for a life without care, much like Vivaldi's Duke who gave up a gilded existence to sport in a glade with his lovely milkmaid. I'd failed to realize how weary the maestro must have been, how drained from herding selfish singers and supporting a theaterful of workers, how weak from fighting off assaults by unscrupulous rivals like Lorenzo Caprioli. My dear mentor had actually carried the marks of a beating he'd received in his desperate quest for the life he craved, yet I had failed to see through his facile excuses.

I bowed my head. Not in prayer, but in shame. Once all Venice had reveled in my voice. I was the toast of any opera house where I chose to perform. I knew the dangers of fame and the difficulties of clinging to the pinnacle of my profession. Yet, I didn't see that Maestro Torani was beset by similar evils. I'd failed him utterly.

Someone touched my shoulder, and I jumped back to the present. Was I being dismissed from the service all ready? It

seemed cruelly unfair to be shown the door when I'd taken pains to make myself so inconspicuous.

It wasn't a Passoni bravo, only Oriana, sharp-eyed soubrette that she was.

Smiling a little too brightly for a funeral, she brushed her hat's wind-whipped ostrich plume off her cheek. The feather was black, to be sure, but only Oriana would choose such a modish hat and fitted jacket when the weather and the occasion called for a cloak with a tightly drawn hood. "My goodness, Tito," she said pertly, "what are you doing alone all the way back here? You must sit down front with us."

I flapped my hand to shush her, but the soprano plowed on without even stopping for breath, "You know we all love you. Others may say what they like, but no one from the company seriously believes that you killed Maestro Torani." She gave an exasperated sigh. "After all, who was closer to the maestro than you? The Savio was quite wrong to remove you as director—even though Niccolo is doing a manful job, it forces him to do double duty at the San Marco and the Pieta. He's been so terribly busy." She turned to beam at the man who accompanied her.

As I rose, I noticed her companion for the first time. It was Niccolo Rocatti, and Oriana was already calling him by his Christian name. She had never been one to let grass grow under her feet, where either men or casting were concerned.

"Signor Amato." Rocatti made me a small bow, which I answered with a nod. He wore the same white wig and severe suit that he had at the reception—perhaps it was the only one he owned. The young violin master continued, "I'm so glad to see that all is being done fittingly. Signor Passoni has obviously spared no expense—the cost of those tapers alone could feed an orphan for a year."

Suddenly I felt as sharp as a dagger and eager for an argument. "Ah, you must have known Maestro Torani before he gave me leave to produce...*The False Duke*."

Rocatti sent me a curious look.

"To be concerned over his arrangements, I mean."

Rocatti shrugged. A bit too obviously, I thought. He said, "We did have a slight acquaintance, but mostly I admired Maestro Torani from afar. You know how it is. One knows the greats better than they know you."

I pressed on: "I thought perhaps you might have shown him a copy of your score before I saw it."

"No," Rocatti answered slowly, as if he were speaking from far, far away. "What made you think that?"

"Simply that the maestro took to it so enthusiastically—almost as if he were already familiar with it."

"Did Maestro Torani say that?"

"No," I said shortly. "It was merely an impression I formed. When did you first meet Maestro Torani?"

Rocatti looked airily around the church before his gaze met mine again. His cheeks grew pink. "You know, I don't believe I recall."

If that were true, I was the Bey of Constantinople. I passed a hand over my brow.

"Are you all right, Tito?" Oriana's elegantly gloved hand was suddenly at my elbow. The floor had seemed to sway, but it righted when I gave my head a good shake.

"You don't look well," Rocatti added. "You've gone quite pale."

"I'm fine," I replied, mustering more confidence than I felt. Perhaps Liya's warnings were more accurate than I wanted to admit. My head was swimming, and it took a great deal of energy to stay upright. "You two go on. I'm better off here."

"If you're sure…" Oriana said under her breath as her companion drew her away.

I sank gratefully to my former pose and hooked my elbows over the next pew. Presently, an organ sounded from the rear loft, low and velvety. It was a mournful tune befitting the occasion, but heavy, so heavy that the windy notes pressed upon me with palpable force. A pair of acolytes threw the main doors open, making the church even chillier, and a steady stream of congregants entered. Black gloves and arm bands, black-edged handkerchiefs and fans, and silk veils the length of shrouds

were the order of the day. Though my city of pleasure tended to gloss over death, the twin scourges of age and illness could not be denied, and every person of consequence possessed a decent stock of mourning wear.

Out of the corner of my eye, I watched the luminaries of Venice's musical world fill the pews. Majorano was one of the last. He hurried down the center aisle, dressed in a rumpled jacket of tan camlet, a decidedly informal costume for a funeral. With an irritated grimace, Giuseppe Balbi pressed shoulder to shoulder with Ziani to make room for the singer. The common workers from all the theaters except the Teatro Grimani came, too—the scene shifters, the seamstresses, the prompters, the curtain raisers—but they stood in back or filtered into the side chapels. Only a few individuals from both groups noticed me, sending reassuring nods or indignant scowls according to their lights. No one handed me an outright challenge until the Passoni party arrived.

The Savio entered first, with his lady wife on his arm, and proceeded slowly down the center aisle in time to the organ's dirge. Long-faced, they both kept their eyes trained on the funeral bier. Franco followed closely behind, one arm hugging a purple and gold tapestry cushion that his mistress would kneel on during Mass. The castrato's expression was downcast; his brows tightly knit. I felt a stab of sympathy for the man. He was so completely Signora Passoni's creature. Really nothing more than a servant, even if he did dress in silk and live in luxury. Did Franco have his own dreams, his own ambitions? Or had he already fulfilled them?

Beatrice was next in the procession, lagging behind as if to distance herself from her parents and assert a small measure of independence. No dimples today! Her red-gold curls framed a sullen face before flowing down onto her green cloak. That cloak! The sight of it made me drop my hands and half rise. So that's where Grillo's cloak had got to. Beatrice must have removed it from the card room after I'd gone to tend my wounded chest at

the water closet basin. How bold she was to display her lover's cloak so obviously.

I plopped down quickly, but my sharp movements must have caught the girl's attention. She stretched her neck to look over the bowed heads in the crowded center pew. Oh, yes, she'd spotted me. She raised the leather-bound missal she carried in piously folded hands and shielded her face. From behind the holy book wrapped with her silver-beaded rosary, Beatrice fixed me with a stare and stuck out her sharply pointed, pink tongue.

The little minx! I'd placed myself in jeopardy to keep her scandalous secret, and this is how she repaid me!

I took a dry gulp—I felt so hot all of a sudden—and watched the Passoni family and their retainers proceed to the front of the church. Their party included Angeletto, Maria Luisa, and old Mother Vanini, who'd unearthed a fusty widow's gown that must have seen duty since the turn of the century. The entire party gathered around Maestro Torani's coffin as if they were the dearest friends he possessed. Several minutes of head shaking and dabbing handkerchiefs to dry eyes ensued. Eventually an elderly priest lumbered out of the sacristy. After bowing to the Savio, he made a series of fawning, hand wringing gestures toward the front pews, clearly anxious to begin the service. While Signora Passoni used Franco's long arm to steady herself onto her pillow, Beatrice plucked at her father's sleeve. His noble profile swiveled her direction, and the girl whispered something behind her hand.

Then Beatrice pointed directly at me. The Savio's gaze followed her finger, his dark glare as heavy lidded as a lizard's. Our eyes met, and the air between us seemed to vibrate with antagonism. Tedi Dall'Agata had taken Beatrice's measure correctly. This over-indulged girl was beyond mischievous; she was a troublemaker of the first water. I grabbed my things and made my feet move toward the church doors before Signor Passoni could send his bravos marching down the side aisle.

I didn't mind leaving—truly not. Prayers for Maestro Torani's eternal soul were all very well, but I could leave those to the priests. I meant to fasten my mind on the living, on the shadowy

one who'd taken Maestro Torani from us. On the villain who roamed Venice while my mentor's body slowly rotted in the crypt. Finding justice for Torani was the last gift I could give him, and that goal could be better served by asking questions instead of kneeling in church. It was just that my legs were so unsteady and my thinking so clouded.

"Has Tito taken to drink?" I heard someone whisper as I lurched toward the vestibule. Dio mio! I tried to quicken and straighten my steps at the same time. I had to get out of San Nicoletto's smothering atmosphere and breathe fresh air.

Someone else had also decided to depart before the funeral began. As I paused in the vestibule to wrap my scarf around my neck, the church doors parted, drawn back by black-robed acolytes. A woman was hurrying out from the opposite side of the sanctuary. She was more appropriately garbed than Oriana or Beatrice. A zendale edged in beads of jet swathed her hair and shoulders, a delicately embroidered veil hid her averted face, and her full black cloak almost covered her gown.

Almost.

As the veiled mourner gathered her skirts and darted down the stairs, I noticed a narrow strip of a delphinium blue dancing along the stones.

"Wait," I cried, fumbling with my own cloak and scarf.

The woman paused, as stiff as a statue. The pretend mourners clustered around her, but she ordered them away with a bold command. For an instant, she glanced back over her shoulder. Her look was direct, but the veil shielded her visage.

Stumbling forward, I raised my hand and called her name. I wasn't mistaken—was I?

One of the doormen grabbed my elbow: "Is the signore ill? Here, let us assist you."

I shook him off and hurried down the church steps with hat in hand. The woman had bolted. Her cloak caught the wind and billowed out behind her like a sail. She'd covered nearly half the distance across the small campo.

Growling at the facchini to let me pass, I followed on shaky legs. My quarry ducked into a narrow slit between two buildings. The sky above our island had darkened, and the light on the campo held a curious yellow tinge. Fighting the rising wind, I entered a short alley bounded by sheer brick walls. There she was! The woman turned as she reached the end. In her flight, the veil had dislodged. Now I saw her stricken face plainly. I wasn't mistaken. My throat closed in a tight spasm.

I limped the rest of the way, holding my side, and came out upon an unfamiliar riva by a deserted canal. A whimpering moan escaped my lips when I saw bearers liveried in French blue assist the woman into a gilded sedan chair. Without taking time to attach their shoulder straps, they manhandled the awkward box into motion. As they made haste away, I staggered backwards toward the alley.

I was in trouble. I couldn't catch my breath, and the wind whipping down the canal cut through my woolen cloak as if it were the most delicate silk, making me shiver uncontrollably. I clawed out for a handhold as gray spots whirled before my eyes.

My last thought before I crumpled onto the cobblestones: *Tedi hadn't left Venice, after all.*

◇◇◇

For some days, time made me its plaything. I existed in a dream impossible to measure in minutes or hours.

Often Maestro Torani sat at the foot of my bed, observing me from under half-closed eyelids. He looked younger, much as he had on the day we'd first met. He still had his hair—frizzled gray curls that wreathed his face in the shape of a young girl's cap. His jaw was taut and his cheeks were smooth and unwrinkled, not age spotted and withered as they'd become. I told him, over and over, "I recognized Caprioli's sedan chair, Maestro. I'd committed it to memory, just as you advised. I followed Tedi out of the church and saw her climb into Caprioli's chair. The chair of your enemy," I'd finish on a moan.

With each repetition, Torani merely nodded sadly, and I drifted along on my cotton-wool cloud until it was time for Liya

to make me drink some of the opalescent liquid or, with the muscular maid's help, apply a poultice and wrap my chest. Her mysterious poultice possessed an icy heat that dissected its way through layers of skin and muscle like a legion of tiny icicles. Surprisingly, it wasn't as painful as it sounds. "Open yourself to its healing," my wife whispered as she placed a feather-light kiss on my forehead. I imagined myself laced with the cold burn, much as Gussie's milky Christmas syllabub was laced with fire-warmed brandy.

Once, when the wind rattled the shutters and its eerie howling mixed with the screams of the seagulls, my father's face loomed up over Torani's shoulder. While the maestro faded to the background, Papa floated closer, puffed up like an operatic Zeus about to hurl a thunderbolt. I told Papa about chasing Tedi, too.

As it had so often in reality, his face registered a sneer. "You had her in your sights, boy. Why didn't you go after her?"

I raised my head as far as my strength allowed. "I did, Papa, but I was ill. I couldn't catch up to her…and then she was in the chair disappearing down the fondamenta." I flopped back to my pillow with a sigh. "Lorenzo Caprioli must have the fastest chair in Venice."

"Weak." My father sniffed, fiddling with the lace at his disembodied neck. "Weak as watered wine—you always were."

Yes, I always was. My older brother Alessandro was the robust son, the one who'd taught himself to swim when he was all of five years old, who'd climbed to the topmost branch of our campo's tree when I could barely clamber onto my chair for supper, the one who never backed away from a fight. And now Alessandro was a wealthy Constantinople tobacco merchant with a beautiful Muslim wife and a houseful of children. What was I? An emasculated singer who couldn't sing—with a wife I couldn't marry honestly and a son who was mine by adoption only—whose house was falling down around me—and who now had no way of supporting my unconventional household.

Against my better judgment, I looked to my father for solace. He had none to offer. As I searched Papa's face, it began

to change. His staring eyes grew wild. They glittered like rubies flaming with an inner fire, then abruptly extinguished to a barely smoldering orange.

I cried out in grunts, twisting and thrashing in my cocoon of bedclothes.

The transformation continued. Papa's domed forehead stretched up and up, his lean cheeks took on an alabaster hue, and his jaws broke in a cavernous smile—the visage of death I'd always feared.

I could no longer move. An invisible weight pinned me to the bed, and all the while my father's dreadful image grew larger and stretched above me like an all-encompassing canopy. I heard a staccato drumbeat and realized it was my own frantic heartbeat. Where was Liya? Why wouldn't she come?

Maestro Torani was my savior. He came around from the foot of the bed and mutely extended his hand. With great effort, I managed to work one hand free and grasped his. It was surprisingly warm for a dead man's. His warmth spread through me, assuaging my fear and shredding the horror above me into wispy streams of mist.

With the thumb and middle finger of his other hand, the maestro closed my eyelids, and I fell into a blessed sleep

Thankfully, not all of my sickroom visions were so unpleasant. I will always carry the exquisite memory of being visited by a quartet of boy sopranos. The beautiful youths wore white tunics with delicate, feathery wings attached to their shoulders that allowed them to fly like the cherubs on many a ceiling fresco. Each boy carried a gilded candlestick sporting an unquenchable flame. The quartet sang as they flew from corner to corner, varying their pattern from crisscross to circular; their pure voices swelled, and their melodies floated about the ceiling like the mingled scent of lilies and lilacs. The most spectacular of the individual tones hung in the air as slowly falling drops of liquid gold. Thus I was showered with a gentle rain of music that I believe healed me every bit as much as Liya's burning poultice.

Eventually, spirits no longer came to my bedside and my walls no longer throbbed with song. Small, everyday things nibbled at the edge of my awareness. One morning, I awoke to the sounds of the maid's heavy step in the corridor and the rattling of the chocolate pot and cups on her tray.

I'd returned to the real world. I greedily drained the cup she served me, reveling in its mix of bitter and sweet.

Later that day, I found myself enchanted with a crack on the ceiling that resembled a mallard duck. Why had I never noticed it before? Despite a persistent headache, I cast my attention beyond the bounds of my chamber. I knew that Benito had not returned. He would have been tending me if he had, but I wondered if my wandering manservant had sent any word. I asked Liya the next time she came in. When my wife shook her head at my question, the look on her face was so miserable that I sat up and put my arms around her.

Liya responded to my embrace for a moment, then gently pushed me back and stood up. "Don't fret over Benito. You must look to yourself for once. Rest."

"How long has he been gone?" I suddenly realized that I had no idea what day it was.

"Ten days now. You've laid abed for eight."

I gasped. That long in the land of phantoms!

"And when does *The False Duke* open?" I popped up again, thoughts suddenly focused.

"Sunday a week. Today is Saturday."

Questions streamed through my aching head—so many questions. Had Rocatti managed to make the opera presentable? Had anyone else tumbled to the fact that Vivaldi was its true composer? Were Angeletto and Majorano sharing the stage without bloodshed? Had Grillo stayed away from Venice as ordered?

Aloud, I asked, "Has Messer Grande located Torani's killer?"

"I don't believe so. Several times he's called in to see how you're doing—his visits caused quite a stir among the neighbors, I can tell you." She shook her head as she gathered some dirty linen for the laundry. "I'm sure Messer Grande would have said

if he'd arrested someone. At any rate, the news would be in the gazettes…and all over Venice."

An image sprang to my mind. Not another dream, but a memory. Tedi, her blue gown topped with black, her veil torn from her face, being handed into Caprioli's sedan chair by his bravo, Scarface. I threw my covers back.

"Oh, no you don't." Liya shifted her bundle and shot out an arm to restrain me. Her olive-skinned brow creased in deep lines of worry. "I'll send for Gussie to wrestle you to the mattress, if I have to."

I sank back, exhaling slowly. The truth was, I lacked the strength to wrestle a kitten. I plucked at my sheets in irritation. "Liya, I must talk to Messer Grande."

"Then I will send for him."

"Now, please."

"I know that trick." My wife crossed her arms. "I'll come back and find you looking for your breeches."

"I'll stay in bed this time. I promise."

She cocked her head skeptically.

"Let's make a trade. My inviolable promise for the answer to one simple question."

She smiled. "Go on—ask."

"Did that mess you cooked up really contain spider webs and moldy bread?"

Her slim brows jumped up. "You dare to call the unguent that saved you a mess?" Liya stood very still. Her tone had changed. "Tito, the corruption from that cut almost killed you. It festered so badly, it makes me wonder if Grillo hadn't steeped his blade in dung."

Suitably chastened, and more than a little sickened, I hung my head. "I just wondered what was in it."

Humor chased vexation from her snapping black eyes. "It contains just what I told you, my darling. Plus chicken fat, yellow watercress, sweet flag, poppy juice, and aconite. The last two are what caused your visions."

"You know about those?"

"I heard you conversing with Maestro Torani."

"He seemed so real."

"Perhaps he was."

"But, Liya," I replied, unbelieving. "Surely, his presence… and all the rest…surely they were fantastic dreams and nothing more."

My wife bestowed another kiss, then whispered, "Don't be so sure, Tito. If the salve's ingredients can send the wise women of Monteborgo flying across the sky, who knows what other wonders they can conjure?"

Chapter Eighteen

"Who's winning?" Gussie asked, as he surveyed the battle formation of gaily painted tin soldiers in the corner of my sitting room.

It was the next day, and I'd felt strong enough to creep downstairs. I leaned forward on the cushioned sofa where Liya had installed me full-length under a woolen blanket. While I visited with Gussie, Liya was paying a long-delayed visit to her Ghetto family. On the faded carpet, I saw my nephew Matteo arranging tiny men in dark blue coats on one side of a strip of aquamarine cloth from Liya's mending basket. This I took to be the River Danube. On the wide window ledge, Titolino was making neat ranks of red-uniformed men on horseback. The drapes had been thrown back so that the dreary Cannaregio afternoon made a backdrop for his army. On the other side of the glass, a mist lay low around the neighboring houses and over the canal.

"The Austrians are winning," Titolino proudly chirped. "That's me."

"That's only because you called the window ledge," his cousin Matteo immediately challenged. "You keep firing cannon balls down on my Bavarians."

Gussie sent his son a wise nod. "The high ground does have its advantages. Remember that for next time."

"Why can't we trade now?" Matteo proposed, looking to his father for support.

"No," Titolino wailed. "Papa, tell Matteo it's my turn. General von Neipperg just got his cavalry troops in place for a charge down the mountain."

My brother-in-law huffed and puffed and fiddled with his unlit pipe, clearly not willing to take sides. I found my watch in my unbuttoned waistcoat and clicked it open. "Boys, it's nearly twenty minutes after two. At a quarter to three, I'll call out the time and you must switch sides."

My pronouncement was met with grumbles, but the boys settled down to play once I'd pointed out that their time was tick-tocking away.

I placed my watch on the nearest table and nested in amongst my cushions. I was weak, but at least the headache had abated. "Tell me all the news, Gussie. Does half of Venice still believe I murdered Maestro Torani?"

"Not really." Gussie dropped into a tapestry-upholstered chair and propped one white-stockinged ankle on his knee. Over the cheerful clamor of the Austrian charge, he said, "I don't know how he managed it, but Messer Grande has let it be known that you are blameless and under no suspicion."

"I'll tell you how—his web of spies and go-betweens can disseminate information as readily as they collect it. A word here, a word there, and soon the taverns and coffee houses are buzzing." I sighed, observing the ceiling thoughtfully. "I appreciate his efforts, but people do tend to believe the worst. In some quarters, my name will always carry a taint of scandal."

"I'm certain it will all die down once the real killer is discovered," Gussie replied earnestly.

"Perhaps." I forced a smile. "Now, what else is going on?"

"Well, the acqua alta has come to the piazza."

"A bad one?"

"Just a modest influx so far. At high tide, the piazza shimmers like a giant mirror and everyone is driven indoors." He shook his head, fiddling with his pipe again. "But in a few hours, the water drains away, and the people return to their easy pleasures as if it were nothing."

I nodded. The piazza was center stage for the Carnival that would open on the same day as *The False Duke*. That large, open space was also the island's lowest-lying area and received the brunt of fall and winter flooding. The Sirocco wind made it worse by sweeping northward up the length of the Adriatic and preventing the tide from flowing back out between the lagoon's barrier islands. I was grateful that both the Teatro San Marco and my own home sat on less flood-prone sites. If it lasted, perhaps the storm-driven acqua alta would have the proverbial silver lining. With the piazza flooded, more people might attend the opera premiere.

"And what of Angeletto?" I asked. "Did you manage to speak to him about painting his portrait?"

Gussie settled more deeply into his chair. He pocketed the pipe and took on a dreamy expression. "You were right about Angeletto being hard to get at. The poor thing is always rushed to and fro, surrounded by relatives whose one purpose in life seems to be to prevent *him*…" Here I was favored with an accusing look. "To prevent him from interacting with any of the hoi polloi. Eventually, I was forced to dawdle near the stage door like a lovesick puppy. Angeletto snuck out for a breath of air between rehearsals, and we struck up a conversation that allowed me to propose a sitting."

"Did he swallow the story of an anonymous benefactor?"

Gussie nodded. "Without question. He told me a story from his days in Naples. After a particularly popular opera, a masked admirer once pushed through the crowd in his dressing room and pressed an emerald bracelet into his hand. The fellow disappeared without a word. Angeletto never found out who it was." Gussie snorted. "My fees don't run anywhere near as high as emeralds, so I suppose Angeletto merely took it as his due."

"Hmm…I suppose Maria Luisa sold the bracelet." I couldn't help thinking back to my own share of baubles. Never an emerald bracelet for me. A diamond-encrusted snuffbox from the Elector of Bavaria had been my most magnificent gift, and a silver-hilted smallsword the most ludicrous. I was an artist, not

an aristocrat in formal dress with a hanger at my side. I'd directed Benito to sell both to help pay for the house that surrounded us. My manservant drove a hard bargain. I'd wager Angeletto's business-minded sister did the same. I turned my attention back to my companion.

Gussie was happily announcing, "And so it's all arranged, Tito. Our angel agreed to drop by my studio. Tomorrow morning, in fact. I can decide on his placement, make some quick sketches. That way I can start filling in the background without him and work on his likeness later, when his days are free. Just now Rocatti keeps him very busy in rehearsal—the first *provo* is scheduled in a day or so."

I had to smile at Gussie's use of the Italian term that describes a dress rehearsal, the *proof* that the myriad preparations have melded into a cohesive production. If he continued to absorb our words and ways, my brother-in-law might someday become as Venetian as I was. Though I'd be shocked if he ever gave up his English breakfast of greasy eggs and sausages.

I said, "You're going to enjoy all this, I presume."

"Painting Angeletto will be a damn sight more interesting than the sittings with the cloth merchant's wife I've been suffering through lately. A more vapid, simpering woman never existed." Gussie's jaws split in a lopsided grin. "One more thing: Angeletto said he'd very much like a word with you."

"Me? The disgraced director of the Teatro San Marco?"

"Yes."

"About what?"

"Some musical business, if I heard him aright."

A loud rapping at the front door prevented further speculation.

The maid scurried through the hall, and momentarily Messer Grande strolled into the room as if he had nothing more on his mind than taking a glass of wine and a biscuit and perhaps playing a few hands of *tresette*. "Good afternoon, my dear friends. Tito, I was told you are back among the living and wish to see me. No, don't get up." He hooked his left thumb in a waistcoat

pocket and looked around, smiling at the boys who were deeply engaged in their play. "It's a pleasant surprise to see you looking so well. No doubt the bosom of your family has a salutary effect."

I sensed an undercurrent of envy. Did Andrea have a family? I suddenly realized that in all our conversations during the investigation of Zulietta Giardino's murder several years ago, he'd mentioned a retiring wife several years his senior, but never spoken of children. I gestured toward the nearest chair. "Won't you sit down?"

"After I give you this," Andrea replied equably. He'd kept his right hand at his side. Now he used it to hand over a tarot card. A very familiar tarot card—the angel of Temperance and Harmony.

It was the same that had been thrown through Maestro Torani's window at the theater—only this card wasn't ragged and creased as the card around the stone had been—it was just the slightest bit limp, as if the pasteboard had been exposed to the damp. I lifted my brows in question.

"I found it tucked beneath your rather substantial lion's head door knocker, and I have to wonder how long it's been there."

Gussie had come over to view the card. "Wasn't there when I came in around noon," he said. We exchanged mystified glances, and I added, "Liya left the house just under an hour ago. She would surely have noticed it. No one else has been in or out since then."

Andrea's jaw worked back and forth. "It's a shame no one saw who left it."

"I saw him," Titolino piped up from the window, holding a miniature artillery caisson in each hand. "A man came to the door right after General von Neibberg's charge."

My feet hit the floor. I grabbed my watch. "That was fifteen to twenty minutes ago. Who was he, Titolino?"

"Don't know," he muttered, shrugging.

"Think, boy," Andrea rapped out. He strode across the room to loom over my son, asserting his noble height and his office of Messer Grande. "Had you ever seen him before? Anywhere?"

Titolino suddenly appeared smaller. "No…but he looked like Papa."

Andrea glared.

My son dropped his toys, and his lower lip trembled. His cousin retreated to the dining room and peeked around the archway with saucer-shaped eyes. Titolino continued haltingly, "I thought…I thought the man must have come from the opera house…with a message. I was going to tell Papa, but then the Bavarians made a sneak attack from the bend in the riv—"

"Never mind about that." I pushed up and limped over to embrace my son. Gussie was on my heels. "It's all right," I told Titolino as his small hand tensed on my shoulder. I'd knelt so that we were nose to nose, and I stroked his smooth, jet-black hair. "I just want you to explain what you meant—about the man looking like me."

"It wasn't his face." The boy looked past me, into the empty air, and twisted the fingers of both hands. "It was that he had long arms that hung down farther than they should…and I saw when he flipped his cloak back that his chest was big and round like a barrel…and when he walked away, his knees almost knocked together."

Titolino's evidence was precise. He'd described the bodily changes that befall a surgically emasculated man. I looked up at Gussie and Andrea. "It was a castrato that delivered the angel card to my door."

They both nodded their understanding.

I turned back to Titolino. "You know Majorano, don't you? You've seen him at the theater several times."

"Yes, Papa. I know him."

"Could Majorano have been the man at our door?"

Titolino shook his head earnestly.

Andrea rocked back on his heels. His gaze grew steely. "That narrows the field—if the boy knows what he says—the number of eunuchs involved in this case is limited."

"Titolino tells the truth as a nine-year-old child sees it." I gave the boy's hand a bracing squeeze. "He's not wrong about

Majorano. But he's never met Angeletto and probably wouldn't remember Emiliano…though he did meet him several years ago."

Gussie jumped in to defend the singer who held his fascination: "How would Angeletto get loose from his sisters long enough to come all the way to the Cannaregio on his own? How would he even know where you lived?"

Andrea harrumphed. "The idea is rubbish at any rate."

I rose and told Titolino to take Matteo to the kitchen and ask the girl for some dates and almonds. Once the two boys had trotted off, I said, "What do you mean by rubbish?" I was not so inclined to give up on Angeletto as my two companions.

"I'll tell you, but come, Tito, sit. You look all in."

I was feeling unsteady again—but not too weak to concentrate once I'd settled back under my covers on the sofa and the others were also seated.

Andrea leaned forward. "With the delivery of the card to your door, it's clear that someone is calling your personal attention to Angeletto—not to his star billing over the Teatro San Marco's resident primo uomo. As you are no longer in charge at the theater, that would make no sense. But your penchant for solving a mystery is common knowledge. In this case, you've had not only the sting of being suspected, but also the close relationship you shared with Maestro Torani to goad you toward finding the killer. Why would Angeletto call your attention to himself in this way?"

Gussie nodded appreciatively. "I see. It's much more likely that someone else is trying to make Tito believe Angeletto killed Torani." He rested an elbow on the arm of the chair and applied his chin to his palm. "Emiliano? Perhaps at Caprioli's behest?"

"You may be sure I'll be inquiring into Emiliano's whereabouts at half-past two. And also into Majorano's—just to be safe." Andrea tapped the toe of his boot in a rhythmic staccato. "Now, Tito. Do you suppose our young Rocatti has any castrati at his beck and call?"

"I wouldn't think so. He teaches at an institution confined to the education of girls and young women. He's not even a

voice master. He gives lessons on the violin. Besides, I barely know Niccolo Rocatti. You may know more about his circle of acquaintances than I do…if you questioned him about the Vivaldi manuscript."

That statement hung in the air for a moment, then Andrea nodded briskly. "I did pay a call on Signor Rocatti at the Pieta. When I placed *The Noble Peasant* in front of him, he denied ever seeing that particular manuscript before—"

"What the devil?" I burst out. "Now that Rocatti has the Savio's confidence, does he think he can get away with boldfaced lies?"

"*Pace*, my friend. Rocatti claims that he wrote *The False Duke* from exercises given him by his teacher. Maestro Vivaldi would supply a libretto and the skeleton of a tune to go along with the poetry. Rocatti would expand on what he was given, experimenting and attempting to find his own style. Under The Red Priest's tutelage, Rocatti entered enough material in his student notebooks to compose several operas—or so he reports. Moreover, when Maestro Vivaldi left Venice for the Hapsburg court, Rocatti says he was given leave to do as he liked with them."

"Did Rocatti show you these notebooks?" I asked quickly.

"He said they were packed away—in his trunk, deep in the Pieta's cellars. I left him with instructions to send a porter to locate his trunk and bring it up. He was to notify me at the central guardhouse when he had the notebooks to hand."

"How many days ago?"

Andrea held up five fingers, accompanied by a sardonic grimace.

"So he lied to you." Gussie observed simply. "There aren't any notebooks."

"It would seem so," Andrea replied smoothly.

"Aren't you going to arrest him?" I asked, vexed at the constable's seeming unconcern.

He shook his head slowly. "The evidence is contradictory. Yes, Rocatti is holding information back, but his whereabouts during the time of Maestro Torani's murder are accounted for."

This was new information. I twisted in my covers while Gussie again went to the heart of the matter. "Accounted for by whom?" he asked.

"By Oriana Foscari. The soprano swears that she was glued to his side—or to some other part of his anatomy—from the time they entered the salon to do their musical turn until the party poured into the card room to view Torani's miserable corpse."

I jerked the coverlet off, planted my feet on the floor. "You can't trust Oriana. If she's made Rocatti her lover, she would say anything to protect him. Truth is as malleable as warm candle wax where that guileful creature is concerned."

Andrea chuckled. "I don't doubt it. But when questioned separately, both she and Rocatti tell the same story. After the applause, they left the salon, strayed from the main party, and found their way into a side chamber that contained some comfortable furnishings and a tall armoire painted with scenes of the Battle of Lepanto."

Gussie weighed in. "Not what you'd call inspiring artwork for lovemaking."

"The salient point is that the armoire is exactly as they described—I paid a visit to the Ca'Passoni to satisfy myself on that point."

I slapped both hands on my knees. "Be that as it may, Rocatti isn't simply holding something back. He's feeding you a ridiculous tale about *The False Duke*. The two opera scores aren't merely similar. One wasn't expanded from the other. They are exact copies." I sat forward. "It's much more likely that Rocatti purloined Vivaldi's score during the time he studied under the maestro."

"There is another possibility." Andrea rose and explained as he made a musing turn around the room. "I've looked into Maestro Vivaldi's journey to Vienna. He left our Republic like a hare with the hounds on his tail. No one knows precisely why—the best guess is that he was stung by what he considered unfair criticism of his latest opera in the gazettes. Since the Austrian emperor had welcomed him to Vienna in the past, Vivaldi apparently expected to find preferential treatment there. To finance his

sudden journey, the prolific composer sold off sizeable numbers of his numerous manuscripts at paltry prices. My sources tell me that Vivaldi's works still occasionally pop up at bookstalls." The chief constable paused in his pacing and raised one hand. His gaze was level and direct. "Rocatti could have bought the opera, realized its potential, and simply waited until the time was right to present the highly innovative musical work."

I followed Andrea's reasoning, but one mystery loomed in the background. I voiced it thusly: "If Rocatti bought or stole Vivaldi's handwritten score—then copied it into his own hand with a less inflammatory title—how did it end up secreted in Maestro Torani's office?"

"Perhaps Vivaldi wrote out two manuscripts?" That was Gussie. "Or a copyist transcribed at least one other?"

"Unlikely in the extreme," I observed drily.

"Or perhaps," Andrea cocked his head, "Maestro Torani had ties to Niccolo Rocatti that you were unaware of, Tito."

I found myself aching at the thought. I'd always sensed that Torani had been acquainted with *The False Duke* before I presented it to him, but I thought he'd been testing me, judging how strongly I would argue for my discovery and how thoroughly I would be able to translate it to the stage. I chewed on a knuckle. The alternative explanation appalled me. If my mentor had known that the opera was an early Vivaldi work...well, then he had maneuvered me into taking the risk. If someone else recognized *The False Duke* as the same opera as *The Noble Peasant*, I would bear the burden of blame for presenting a purloined composition. Was that what Maestro Torani had meant in his letter: *I have much to reproach myself with*?

"Tito..." Andrea repeated.

I could feel my cheeks flaming, but I forced my tone to remain mild. "If that's the way it is, I'll never understand what was in my maestro's heart—Torani's lips are sealed for good."

Neither of my companions could raise an argument to that. Andrea nodded resignedly and changed the subject. He asked,

"What was it that you wished to see me about in the first place, Tito?"

I recounted my tale of following Tedi as the soprano slipped away from Maestro Torani's funeral. Tedi's presence in Venice didn't surprise Andrea. With his usual thoroughness, the chief constable had set his men to combing all the quays for a boat that might have taken the statuesque woman and her trunks to the mainland on the date in question. Despite Tedi's stated intent to take the waters at a mountain spa, the sbirri had found no evidence whatsoever that Tedi Dall'Agata had left our island.

I did manage to surprise Andrea with the news that Tedi had climbed into a sedan chair belonging to her lover's arch enemy. Andrea's eyebrows flexed up and down, and his gray eyes turned to ice. "You're certain?"

"Oh, quite," I assured him.

After a distracted expression of hope for my continued recovery, Messer Grande prepared to depart. The maid, who'd been hovering in the hall, brought his cloak and tricorne. He offered one more comment before he made his ceremonious bow of leave-taking. "Tito, your news nearly caused me to forget the other eunuch who might have been the bearer of the angel card."

"Eh?" Gussie stroked his chin pensively.

I took the hint immediately. "Signora Passoni's devoted cavaliere servente."

Andrea nodded. "A man who would go anywhere Giovanna Passoni asked, perform any duty she required."

I returned his nod.

"Of course," Gussie whispered under his breath. "Franco."

◇◇◇

It wasn't long after my visitors had departed that Liya opened the front door and bustled into the sitting room fussing about my catching a chill. After she'd smoothed my tangled blanket, I brought out the angel card that Messer Grande had discovered under our door knocker.

"What more can you tell me about this image?" I asked.

My wife didn't answer at once. She decided that damp had entered the house to the point that a *scaldino* was required to keep me from relapse. I protested, but for naught. Liya ordered the maid to prepare the charcoal pot. Because Venice's climate is mild during eight months of the year, fireplaces and warming stoves are scarce except in the great houses. In the homes of modest folk, the winter chill is often kept at bay by a glazed pot filled with smoldering charcoal that can be moved from room to room with an attached handle. I didn't care for the fumes from the scaldino, but once its gentle heat had permeated my bones, I slipped down a notch on my couch and began to relax. Surrounded by warmth and softness, I couldn't have felt more safe and secure than an infant in its cradle.

Assured that I was well, Liya ceased her fussing and folded into the capacious armchair on the opposite side of our Turkish carpet. The sun had set behind a bank of fog, so she'd drawn the drapes and lit the candles. Holding a glass-fronted candle lamp closely, she studied the card for a brief moment. When she looked up, her dark eyes registered a wistful melancholy. "There's nothing much to tell, Tito. This is the fourteenth trump card—Temperance and Harmony—similar to the one from my own deck."

"Trump card?" I repeated from my drowsy, warm cocoon.

"Yes. You know the usual suits: cups, coins, wands, and swords...." She continued at my lazy nod, "You might say that the trumps make up a fifth suit—though that suit doesn't contain pips or court cards. Rather, it tells...a story."

"What's the story about?"

"It tells the tale of a fool's journey—really, an infinite variety of journeys. Each time the deck is shuffled and the cards spread, the Fool treads a different path."

I ran a hand over my face, forcing my consciousness back from the brink of sleep. I needed focused facts, not endless fairy tales. "Liya, just tell me this. The card in your hand is printed pasteboard—quite cheap and utterly common—from a tarocchi deck like those displayed in many shops. Correct?"

She smiled. "The cards are of common material, true. The value lies in the hidden meaning of the symbols." Her smile abruptly faded. She lowered her voice. "To those who have the ability to decipher them."

"Does the card picture a particular angel?"

Liya's shoulders trembled a little, as if she were forcing herself to gather her wits, and the candle flames in her lamp wavered. "Yes, it's Michael the Archangel."

Hmm. I closed my eyes. Saint Michael occupied the pinnacle of the Heavenly Host, right above fellow archangels Raphael and Gabriel. I pictured the many paintings on church walls that depicted a fierce, steely-eyed Saint Michael decked out in armor. The archangel had contended with Lucifer and vanquished him soundly. Cast him into Hell, hadn't he? I pushed up on one elbow, now alert and perplexed. "Isn't it odd that a warrior angel would represent the soft graces of Temperance and Harmony? And if the white-robed angel on the card is Michael, where is his sword and shield? Why does he wear such a mild expression?"

Liya placed both lamp and card on the side table. She sat forward, as if she meant to instruct me in a very important matter. "The Archangel Michael has many aspects. Did you know he is worshiped as the Hebrews' special protector? Some scholars say that he delivered the nation from the Babylonian captivity."

"I've never heard that," I replied, shaking my head. "Is that why Saint Michael is on the card?"

She gave a hollow laugh. "The rabbi at Papa's synagogue would burst a blood vessel if anyone so much as suggested a connection. No, I think it has to do with the belief that the Archangel Michael carries deceased souls to Heaven after weighing them in his perfectly balanced scales. If the trumps are put in perfect order, the card that comes before Temperance is Death, and the next one is the Devil. Moderation is to be cultivated if you want to avoid both, you see."

I wasn't at all certain that I did see, but I was willing to take my wife's word for it. At any rate, I'd decided that my unknown messenger attached no deep mystical significance to the cards

he'd tossed through the opera house window and posted on my door. He was merely using the angel card as a device to force me to consider Angeletto as Maestro Torani's killer. Still, to be complete, I asked, "Does this fourteenth trump perhaps hold a more esoteric meaning than Temperance and Harmony?"

Liya glanced toward the card but didn't seem to see it. On a sigh, she answered, "The full meaning depends on many things, Tito—the information sought, the card's position in relation to the other cards in the spread, whether it faces up or down. Even the phase of the moon can influence the meaning." Liya pulled a few pins from her hair and twisted her neck as if the burden of those massed tresses had grown too severe.

Then all at once, my wife was on her feet. She ran to my sofa and sank down on the rug beside me. She buried her face in the blanket.

"What is it, my love? What's wrong?" I stroked her hair, now falling from the remaining pins.

After a muffled gasp, she raised her chin and looked me in the eye. "I'm afraid I can't help you."

"But you've answered all my questions—you are helping me."

"No, no." Liya spoke in a wobbly, uncertain voice that I didn't know she possessed. "The old magic has forsaken me, Tito. Only six months ago I could have consulted my cards or my glass and told you who killed Maestro Torani—at least given you some special awareness or an important detail to investigate. But now...I look and...and there is nothing."

I could have swum in the depths of those glittering black eyes. "But you've not gone blind," I cried. "You see me, don't you?"

"It's the cards!" Liya grasped my arms so tightly they throbbed. Her words tumbled out on a moan. "They used to come alive for me. Now I see only dead pieces of pasteboard. It was the power of Diana that allowed me to peer through the ink and paper—straight through to a place between our world and hers. The goddess granted me the privilege of discerning their true meaning. And now..."

Liya dropped her hands and used them to beat mine away when I attempted to embrace her. In the night-darkened room, her face had paled to a bluish white. Despite the warmth of the scaldino, an icy shiver, worse than any I'd suffered during my fever, traveled the length of my spine. My mouth was dry as I repeated, "And now?"

"The goddess has abandoned me." Liya's strained whisper hovered in the air. My heart gave a lurch as she covered her face with her hands and wept.

Chapter Nineteen

At last I understood what had been causing my wife's hints of distress over the past several months. Her distracted silences. Those blue shadows under her eyes. The increased sharpness of her tongue. The more frequent visits to her family's Ghetto home.

Perhaps Liya been confiding her troubles in her favorite sister, the lovely, loyal Fortunata. Or in her father, Pincas? Probably not Pincas, I decided. Ever since Liya and I had returned to Venice some years ago, that worthy Jew had drawn firm boundaries around discussion of any matter related to his daughter's faith in the Old Religion. I heartily wished that Liya had revealed her worries to me sooner—or, digging more deeply into my soul, that I hadn't allowed the Teatro San Marco's plight to drive a thin, but sharp, wedge of estrangement between us.

If only I'd removed my ignorant head from the business of *The False Duke* just long enough to take the trouble to inquire what was ailing my wife.

I reproached myself with these thoughts while I cooled my heels in a corner of Gussie's studio the next morning. I'd arrived by gondola. Though a bright, brave sun had risen from the eastern sea to scatter the fog and dry Venice's rain-soaked domes and towers, I was feeling far from robust enough to make the usually pleasant walk from my house to the portrait studio on a shabby old square near the Madonna dell'Orto.

Gussie had consigned me to a tattered armchair, a cast-off I recognized from the house on the Campo dei Polli.

Around me, morning light streamed through an undraped, demi-lune window to illuminate canvases in various stages of completion. Paintings were everywhere, stacked on cabinet shelves, heaped against every vertical surface, and displayed on walls of smoothly dressed stone. In their midst, my artist brother-in-law was deeply engaged in the work of his heart. Wearing a brown smock freckled with dried paint and humming an off-key tune under his breath, Gussie sketched at his easel.

It was quite a process. First, he would crane his neck around the board that held a large rectangle of drawing paper. Then he spent some minutes taking grave account of the young castrato who stood on a dais in the center of the workroom. His model comprised my entire reason for visiting the studio. With one elbow supported by a stone plinth, flawless features set in a heroic expression, Angeletto posed before a looped-back drapery of bottle-green velvet.

Once Gussie had made the required observations, he ducked back behind his easel. There, he wielded his charcoal stick with quick, confident strokes, moving up and back, almost dancing before his sketch. Eventually he would feel the need to contemplate his muse again before repeating another burst of artistic activity. As soon as Gussie indicated that he'd completed the sketch depicting one pose, his apprentice—Paolo—halted his work of grinding paints and affixed another large rectangle of drawing paper to the board.

Then Gussie instructed Angeletto to turn his head thusly… rest a hand on his waist…no, not like that…he must bend his elbow like the handle of a caudle cup, let his fingers curve just so. Excellent! Perfect! Maintain that stance, if you please.

So it went for well over an hour, plenty of time for my thoughts to range over Liya's problem, then to switch onto bringing Maestro Torani's killer to justice. An idea that seemed to fit the facts of what I knew about Maestro Torani's death and the purloined Vivaldi manuscript was shaping itself in my mind. More correctly, the ghost of an idea, with wavering outlines and ephemeral reckoning. It was too soon to share my suspicions with

anyone, even Liya or Gussie, and certainly not Messer Grande. I required further conversation with this ghost—a prolonged *tête-à-tête* in which it would either fully explain itself or vanish like a wisp.

Eventually, I closed my eyes and rubbed my forehead. The combination of my fanciful ruminations and the pungent fumes of binding oils and turpentine had set up a throbbing headache.

"Signor Amato?"

I looked up to see Angeletto approaching. His lace neckcloth was as tightly knotted as ever, and his high-boned cheeks had been enhanced with powder and a subtle application of rouge. His blond wig—sporting a triple *bouclé* on each side, a silk bag behind, and smelling sweetly of pomatum—was a marvel of the perruquier's art. And yet, amid all of this artifice, Angeletto's brown eyes held an unmistakably genuine expression—they beamed tender concern that rested on me as lightly as a moth's fleeting kiss.

I sincerely hoped that Angeletto had had nothing to do with Maestro Torani's death. There were other, far less pleasant people I'd rather see under the Leads.

"Are you quite well?" The singer continued in fluting tones, "Signor Rumbolt told me of your recent illness. Perhaps it was too much for me to ask to see you this morning."

"No, not at all." I rose from the low chair and made my bow. I knew why I had made the effort to come to Gussie's studio, but I was curious as to what Angeletto wanted of me. "I am at your service, Signore."

"It's one of the duke's arias. I've tried and tried, but I can't seem to get it right. Maestro Rocatti has been unable to direct me. I thought perhaps you would do me the honor of listening… and…" Angeletto dropped his gaze. His nerve seemed to falter, and his voice sank so low that the remainder of his request was inaudible.

It didn't matter. I understood. The singer sought advice, even though he was embarrassed about needing it. Based on my knowledge of *The False Duke*, I thought I could even predict

which aria was causing difficulties. "The second act conclusion?" I ventured.

"Exactly." Angeletto exhaled in relief and nodded enthusiastically.

"I'll be glad to listen to your rendition, but tell me this—is Signor Rocatti unable to help you because he is so busy or…on some other account?"

Angeletto gave me a curious look. After satisfying himself that Gussie and his apprentice were consumed in conversation at the other end of the spacious studio, he replied, "Maestro Rocatti has written a wonderful score. *The False Duke* proves his talent as a composer beyond a doubt, but our director is a master of the violin, not the voice. Actually, as a singing tutor, he is worse than useless. And then," the singer interrupted himself for a dramatic roll of the eyes, "Signor Rocatti seems to spend a good deal of time in Oriana's dressing room—purely to insure the success of the production, of course. The rest of us can only thank good fortune that Signor Balbi has been allowed to conduct many of the rehearsals."

"Balbi is also a violinist," I put in quickly.

"But Balbi has obviously managed to absorb the elements of vocal technique during his long tenure as head of the San Marco orchestra. He's offered many helpful suggestions, but I've still been unable to bring this one aria up to my standards. It just seems…wrong." He shrugged and added as an afterthought, "Signor Balbi tells me that he has also composed an opera."

"Yes. *Prometheus*." I was surprised at how remote the entire notion of Balbi's masterpiece seemed. Had it only been a few weeks since I'd begged Maestro Torani to consider changing the performance schedule? I continued, "Signor Balbi's opera was originally scheduled to open the fall season, but that was before I discovered *The False Duke*."

"*You* discovered our opera?" His gaze widened.

"Yes. Who else?" I was unable to keep a faint tone of rebuke from my tone. "Rocatti handed me the first few pages of the score during a concert we were both attending. Let me tell you,

I had to do a quite a bit of convincing to persuade Maestro Torani to accept it."

"Somehow, I thought it must have been the other way around....Oh, well. Signor Balbi speaks very highly of you, particularly of your ability to unravel a knotty musical problem. In fact it was his idea that I consult you." His tone grew tentative again. "I realize this could be awkward...since Signor Passoni has banned you from the theater."

Gussie and his apprentice boy wandered over. My brother-in-law clutched a fistful of brushes and a smelly cleaning rag. He shook his brushes at Angeletto. "The Savio has no power here, my friend. You are free to raise the roof with your song—if you can."

Angeletto caught my eye and smiled.

"Very well, then." I took my seat again. I settled back, crossing one knee over the other. "I'm ready. Let me hear it."

Angeletto practically flew back to the dais. From that minia-ture stage, he warmed his throat with a few scales and vocalises. After a delicate cough behind his hand, he stretched tall, threw a commanding gaze over his audience of three, and commenced. Singing as if his life depended on it, the talented castrato rushed through the first section that established the melody without seeming to pause for breath. During the embellishments, he battered the studio's stone walls with immense, swelling notes and overwrought *fioritura*. Even the strains of the relatively quiet close were annihilating in volume.

Gussie's young helper had watched the performance with saucer-shaped eyes and open mouth, as entranced with the singer as Titolino had always been with the exotic animals at the annual Carnival menagerie. The boy broke into wild applause the second that Angeletto closed his mouth, though he quickly dropped his hands when he realized his master and I weren't following suit.

My brother-in-law snorted out a chuckle. "Paolo has never been to the opera. He had no idea a man could make a sound like that." Gussie then dismissed his apprentice with an indul-gent ruffle of his wiry black hair, and the boy started down the

iron staircase that spiraled downward from a hole in the floor behind us.

"Paolo," Gussie called after him. "Fetch three—no, four—chocolates from the café. And take care that you don't spill any on your way back."

Ah, chocolate. Didn't I say that Gussie was the best friend a man could have?

I turned my attention back to Angeletto, whose rounded chest was still heaving in an effort to replace the air in his lungs. I crossed the floor to the dais, tinglingly aware of his intense scrutiny. It made me rather uncomfortable. I knew a performer's mentality inside and out—he was hoping that I could work a miracle when all I could really do was offer observations and suggestions.

"Well?" Angeletto wheezed, raising a hand in an unconsciously graceful gesture.

"I stand in awe of your technique," I replied. "But its very power is where you're going wrong. Though written in heroic style, the piece is actually meant to be light and tuneful. The composer"—I couldn't bring myself to say Rocatti, but neither was I ready to openly attribute the work to Vivaldi—"is having a joke on the audience, making a playful jab at staid conventions. The aria and accompanying action must be delicately handled if it's not to become preposterous."

He regarded me sidelong. "Do you really think so? Maestro Rocatti doesn't conduct it that way. He doesn't seem to find any humor in it at all. For that matter, neither does Signor Balbi."

What to say to that? I shuffled my feet, pursed my lips. "Perhaps the director has other things on his mind," I finally replied. "If you sing the aria as I'm going to ask you to, you may remind him of the charm of the piece."

Angeletto made a willing pupil. While Gussie drifted back across the studio to study his sketches, I instructed the singer to ascend the opening strains gently and to sound each note with equal attention as the melody unfolded. I listened to his efforts, pacing to and fro with my eyes on the paint-pocked stone

floor. Without the accompaniment of a harpsichord, the notes poured out of his throat in a solitary stream that allowed me to instantly spot the deficiencies. His original tutor must have schooled in him in nothing but embellishment, so determined was Angeletto to add trills and tremolos at every opportunity. Neapolitans! They wouldn't recognize moderation if it smacked them across the face and challenged them to a duel.

"My dear Signor Vanini—" I halted my pacing, raised a forefinger.

"Carlo," he urged.

"All right—then I am Tito." I smiled to take the sting from my next words: "For the moment, you must forget what your maestro in Naples taught you."

His handsome face registered sudden desolation. His frame sagged like a fallen soufflé. "You must not ask me to forget Maestro Belcredi. It's…impossible."

"Not the man." I sighed inwardly. I could well understand loyalty to one's first teacher, but we had work to do if the aria was to be a success. "Just his love of fioritura. If you value my expertise, tamp it down to almost nothing. Pretend that you're a young student again, only beginning to learn the piece. Sing it simply, cleanly."

After a bemused nod, Angeletto struggled to do as I requested. We worked through several repetitions, and with each one, he improved. I was amused to see Gussie keeping a rapt eye on the performance as he pretended to sort brushes into stoneware jars. I wondered if this morning's posing session had changed my brother-in-law's mind about the singer's sex.

I still found it extremely doubtful that Carlo Vanini could be a woman who was hoodwinking a great many people with the full awareness of her nearest and dearest. But I granted that it was within the realm of possibility, perhaps with an element of coercion involved. I wouldn't put much past Signora Vanini, as cunning a Neapolitan as I'd ever seen. Not all families were honest and loving. I'd encountered a few scoundrels who'd hand

their sisters over to Barbary corsairs if they could come out a zecchino ahead.

I also realized that I might never be certain which sex claimed Angeletto; I'd actually ceased to ponder the matter, except for how it might possibly be linked to the angel cards that had been so pointedly brought to my attention. Man or woman, Carlo Vanini—Angeletto—had been the target of vicious gossip. Was he also a target of someone who wished to make him a decoy for Torani's murderer? Someone who would love to see Messer Grande haul him away in chains? Or, almost unthinkable, was this gentle singer actually a killer?

Over a pot of chocolate ably fetched by Paolo, I tossed questions at Angeletto in a way I hoped would seem like idle chatter. We sat alone at one of Gussie's cleaner work tables—my helpful brother-in-law had found urgent business for himself and Paolo downstairs.

"How are you getting along with your fellow singers?" I began. "Before the Savio showed me the door, I cautioned the company about minding its manners, but jealousy does sometimes take hold."

Angeletto pursed his lips in an expression of delicate disgust. "You're speaking of Majorano."

I nodded, taking a sip of my frothy bittersweet brew. "Our proud primo uomo has become accustomed to the top role—and to the acclaim that comes with it. Standing in another performer's shadow is not in his repertoire. He might try to… stir up trouble in some fashion."

"Set your mind at ease, Tito. I've already been warned about Majorano's bag of tricks. He can spread his coins far and wide, buy as much applause as he wants, but I will win the audience's favor honestly." Angeletto drew himself up, suddenly appearing as regal as the Doge in his purple robes and pearl-studded cornu hat. "I charmed Naples and Milan the minute I hit my top note. Venice will be no different."

"Majorano has more in that bag than hiring a claque. I'd watch what you eat and drink at the theater, keep an eye on your

wardrobe. You don't want to find yourself suddenly taken ill or your tunic slipping down around your knees at a crucial juncture." I waved my hand in a vague circle. "That is…if Majorano has shown animosity of that magnitude."

Angeletto winked. "The poor fellow is practically sweating animosity, but Maria Luisa looks after all that. Perhaps you've wondered why she insists on keeping all of my sisters and twin cousins near."

"It is unusual to travel with such a large entourage." I thought back to the purses I'd emptied hiring coaches and drivers. The Vanini traveling expenses must rival an army's.

Across the table, my companion took a gulp of chocolate and wiped his mouth with the back of his hand. It was the first boorish gesture he'd displayed in my presence. He replied with a grin, "Besides seeing to my costumes and wigs, my sisters are… what you Venetians would call my bravos."

I chuckled into my cup. "Don't tell me those girls carry stilettos."

"No stilettos. But they all know how to keep their eyes open. If they felt I was in danger, their screams could be heard from one end of your piazza to the other."

"And what…danger…are they keeping their eyes open for, exactly?"

He gave a casual shrug, still grinning.

I pressed on. "Are they on the alert for someone intent on undermining your performance, or for someone who means to expose your secrets?"

Angeletto clamped his lips together. His expression suddenly registered a mix of confusion and alarm.

"Perhaps it's time to settle the prevailing rumors, my friend. You must have heard them. Maria Luisa told me they'd wounded you to the core." I sent him a level look. "Tell me, am I addressing Carlo or Carla?"

The singer's fist closed tightly around his pottery cup. A flush rose to his cheeks, eclipsing the pink of his rouge. "You surprise me, Tito," he finally said. "I didn't expect that question. You are

such a capable voice tutor, I'd almost forgotten your reputation for ferreting out information."

"Will you answer?" I reached across the table to lay my fingers on his arm. "You have my word that I won't reveal anything that doesn't bear directly on Maestro Torani's murder."

"How could that ridiculous tittle-tattle have anything to do with the murder?" He adjusted his position, a move that served to place his arm beyond my reach. "I'm the only one it wounds."

"Simply state the truth, and let me be the judge of its relevance." I briefly considered telling Angeletto that Girolamo Grillo, the chief purveyor of the rumors, had charmed his way into the Ca'Passoni on the fatal night, even attacked me in the very room where Torani was later killed. But why? The scheming charlatan had been cleared of suspicion. Andrea had assured me that Grillo had run straight to the bed of his favorite whore once he'd vaulted through that window. His time was accounted for. He had witnesses to prove it. Besides, he'd left the island and wouldn't be returning.

Angeletto had turned his face away to gaze at Gussie's empty easel. One slender hand covered his cheek.

"Well?" I asked gently.

He turned back, slowly, as if his movements were restrained by invisible cords. "I wish you would simply accept me as the singer Angeletto," he murmured, "and consider the matter of Carlo or Carla closed." He dropped his protective hand. His tone was rueful. There was more he wanted to share—I was certain—but something prevented him.

"You've just trusted me with your most precious possession, your voice. Why can't you trust me one step farther?"

"My dear Tito…" Angeletto replied with strained courtesy, rising. "The matters you wish me to speak about are not entirely my own, and I don't have leave to share them."

I stood, too. "Does Maria Luisa share them?"

He gave a shudder, then looked around the sunny studio as if searching for his cloak. "I must go. Forgive me…I appreciate your advice, but really—"

"No, no. Wait." I couldn't let my fish slip off the line that easily. "It is you who must forgive me. I'm prying inexcusably. It's just that I loved Maestro Torani just as you must have loved Maestro Belcredi...."

The singer shot me a startled look.

"Please, calm yourself." I extended my palm. My tone was pleading. "Do sit down. I won't ask about you or your family, just several questions that might help me find justice for the man who made my career. Wouldn't you want the same for Maestro Belcredi—if he had died by a killer's hand instead of the cholera?"

"I can tell you this much." Angeletto sank down and managed a weak smile. "Whatever Maria Luisa has told you, you can take it with a grain of salt. She's a troublesome creature, prone to exaggeration. But you must understand, her life has not unfolded as she wished. We've all had to learn to put up with her ill humor."

He finished on a deep breath that caused his torso to appear even more rounded beneath his fitted coat and festoons of lace. I honestly tried not to notice.

The inhalation became a yawn. Behind his hand, Angeletto said. "Excuse me. I've not been sleeping well...but about Maria Luisa, she's had many disappointments."

"An unhappy betrothment?" A stab in the dark.

"No, nothing of that sort."

I suddenly recalled Maria Luisa's skill at the Savio's harpsichord. "Perhaps your sister had a musical calling that was never allowed a full flowering."

"In deference to my talents, you mean?" He cocked a plucked eyebrow.

I nodded. I'd seen many a boy pushed ahead of his more talented sister. In music, as in most things, males drew the inside track. What was a castrato, after all, but an improved version of a female soprano? Perhaps a festering jealousy, hatred even, lay beneath Maria Luisa's careful management of her brother's career. Perhaps she longed for revenge. But surely she wouldn't want to see him accused of a murder he didn't commit—only

a monster could wish for that—and Maria Luisa did not strike me as so thoroughly evil. Anyway, it was a castrato who had delivered the last angel card, not a woman.

The singer continued, "Maria Luisa has more talent in one little finger than I possess in total, but circumstances prevented her from becoming a performer."

Despite my promise, I again nibbled at the bounds of dangerous inquiry. "I don't suppose you mean to explain more fully?"

He shook his head firmly, gazing into his cooling chocolate as if the dark liquid were the most interesting sight he'd ever encountered.

"I understand. It's a brother's duty to keep his sisters' secrets."

His long eyelashes flicked up. "You sound as if you've had experience with sisters."

"You met my older sister at the Savio's ill-fated reception. She is Signor Rumbolt's wife, Annetta. Perhaps she was presented as Anna Maria."

"I do recall her—a quiet beauty. She seemed quite keen to see *The False Duke*." Angeletto took a quick measure of my face, then asked in a curious tone. "Have you another sister?"

I considered evading the question—my sister Grisella's monstrous secrets must certainly overshadow any that Maria Luisa was hiding. Instead I merely replied, "We had a younger sister. She died several years ago."

"I'm sorry to hear it."

I nodded, aware that the light in the studio was changing. It must be nearing noon, for the sun had moved to blaze through a high window at the peak of the far wall. "Carlo, I have just one more question. Quite simple and above-board," I hastened to add.

"If you must," he replied with a hint of a sigh.

"Where were you between half past one and three o'clock yesterday afternoon?"

The singer pulled his chin back, clearly surprised. "I was at the theater—rehearsing the grand finale."

"With the entire cast?"

"That's right."

"Was Majorano there?"

"Oh, yes. Signor Balbi had quite a struggle with him. No matter where Balbi placed me, Majorano insisted on standing several paces closer to the footlights." Angeletto shook his head. "Majorano's ambitions are so tiresome. If I were in charge, I would have dismissed him until he consented to take direction without argument. But Signor Balbi—truly, that man possesses the patience of a saint."

I thought for a moment, chewing at the inside of my cheek. The picture Angeletto painted was wrong in one detail. "Signor Balbi was rehearsing the finale? Surely Signor Rocatti wasn't closeted with Oriana—she plays a large part in the finale."

"No, it wasn't Oriana that claimed our director's attention this time. Around noon, Rocatti was called away. He didn't return for several hours. Since *The Duke's* provo is scheduled for tomorrow, he turned the rehearsal over to Balbi rather than give the cast an extended break."

"Called away, you say. Who called Rocatti away?" I was suddenly conscious of the blood drumming in my ears.

The singer frowned. I could see that my questions intrigued him, but to his credit, he didn't hesitate. "It was Franco," he answered. "You know, Signora Passoni's companion. Franco had Aldo fetch Rocatti from the harpsichord. At first Rocatti seemed surprised to see Franco at the theater, but after he'd whispered a few words in his ear…" Angeletto paused to shrug. "Off they went."

I held Angeletto's gaze for a moment, then we both turned as banging noises came from the spiral staircase. Gussie's haystack of yellow hair popped up at floor level. My brother-in-law climbed several more steps and questioned me with his eyes. Had we completed our conversation? I nodded. It was time to leave. I had strained Gussie's good graces long enough and doubted that I would gain anything more of interest from the angelic castrato.

Besides, I had another stop to make before my newly-won strength gave out.

Chapter Twenty

It wasn't terribly difficult to find Peppino. The man and his boat were a fixture on the canals, and it seemed that everyone in the neighborhood of Maestro Torani's lodgings knew where the gondolier generally took his dinner. I was directed down a tortuous alley running north from the Calle Castangna, to a tavern where the kitchen's only dish appeared to be *pidocchi*, our national soup of lagoon mussels and whatever vegetables the cook had at hand.

By virtue of my attire and bearing, I stood out in this rough place, but such was Venice on the eve of Carnival that few of the diners so much as flicked an eyelid. With the streets filling up with costumed Moors and Red Indians, horned devils and capering pirates, one operatic eunuch was unlikely to cause a stir.

Only Peppino eyed me with an air of suspicion as I crossed the long, dimly lit room to his table. Torani's boatman had tied a once-white napkin around his neck and was tucking into a steaming bowl of soup. Its fragrance was much more appetizing than the odor of cheap wine and old sweat that permeated the smoky tavern. I waved down Peppino when he made motion to rise and remove the napkin.

"Sit, my friend. Let's not stand on ceremony," I called, then eased onto the bench across from him. A hanging lamp threw a yellow glow on his sunken, stubbled cheeks. Unlike some of his compatriots, he'd removed his cap; a faded red-and-white

kerchief contained his lank dark hair. Fortunately, Peppino was eating alone. Many of the tavern's other customers had clustered around a game of dice going on around a scaldino in the opposite corner. Good. Their exclamations would cover our conversation if we kept it low.

Peppino and I passed some casual talk concerning his current fortunes—as well as those of Maurino, Torani's valet—and then I announced the purpose of my visit. The gondolier replied with a scowl, but I hadn't forgotten Maurino's advice on how to loosen his tongue. Peppino's fierce expression turned to a smile when I ordered a bottle of the tavern keeper's best Montepulciano.

"Now," I repeated, "tell me what you know about Niccolo Rocatti."

"Would he be a well-set-up young man who teaches the orphan misses at the Pieta how to make music?"

I nodded. "The very same. Did he and Maestro Torani ever meet?"

"Several times my master had me row to a landing near the Pieta. This Rocatti would be waiting for us with his toes hanging over the water—he practically jumped in the boat."

"When did these meetings occur?"

He pushed his lower lip up. "It was hot. Whenever I stopped the boat, the mosquitoes ate me alive."

"Back in the summer, then."

Peppino nodded indifferently, his gaze glued to the keeper who was sauntering over with a tray.

"Look here, man," I said sharply. "How many times did you carry your master to this landing?"

Peppino opened his mouth, but kept silent as the keeper thudded an uncorked bottle and two flat-bottomed cups of thick glass on the oak table. I turned mine over, then poured a purple-red stream of Montepulciano into the other. Peppino would have the entire thing—if he cooperated.

The gondolier understood. He thought for a moment before replying, "Three times I remember for certain—could've been four."

"Where did you take Maestro Torani and Signor Rocatti?"

"Nowhere. And everywhere." He took a clumsy gulp of wine, then used the end of his napkin to wipe a purple dribble from his long chin. "Sometimes we went up and down the canals, but mostly my master ordered me out on the lagoon to follow the tides while he conducted his business."

"And what business was that?"

"Can't say." He covered his glass with a reddened fist, as if he feared I would snatch it away. His tone grew aggrieved. "How could I say? His business weren't none of mine. And besides, my master had me cover the boat—as if it were November weather—and he pulled the curtains tight."

Peppino, like any boatman of Venice, provided more than transportation to and fro. Throughout our island pleasure palace, gondoliers made the perfect go-betweens. Just as they knew all the canals' twists and turns, all the hidden stairs and locked doors, and every conniving ladies' maid, they were also excellent judges of character. An experienced gondolier could read a man's appetites and inclinations at twenty paces. Peppino had more to tell me—if the wine hadn't robbed his memory.

I leaned forward. "I want you to think back to these summer meetings—describe Rocatti's demeanor."

He lowered his glass with a puzzled gaze. "Eh?"

I simplified. "Was Rocatti lighthearted and agreeable? Argumentative? Pleading?"

Peppino shook his head. "None o' that. The man was tickled, like my master wanted to make him a nice present. But he was scared, too, like he knew that present would cost him dear in the end."

I felt my backbone wilting. A sigh tore itself from the depths of my lungs. It was just as I'd thought. My chance meeting with Rocatti at the Ghetto concert—the lengthy discussion of operas with Torani on the Rialto—my mission to convince the Savio that *The False Duke* should open the season. It had all been a grand deception—Maestro Torani's grand spectacle of deception—with me as its unwitting dupe.

Yes, maestro, I thought. You surely do have much to reproach yourself with.

One crucial detail floated to the surface of the bubbling, confused stew of my mind. "Peppino," I asked. "Did Signor Rocatti always wear his wig when you collected him at the landing?"

Soup forgotten, the boatman sucked down a noisy gulp of wine, then sat back and crossed his arms with glass still in hand. "There was that one time my master insisted on rowing to the Pieta while the sun still had its arse in the lagoon. Rocatti was waiting for us, but he looked like he'd just rolled out of his bed and into his breeches. His hair was loose and flying every which way."

"What color was that hair?" I asked on a tight breath.

"Red." Peppino jerked his long chin towards the corner. "Orangey-red like the coals in yon scaldino."

I managed a weary grin. That was also just as I'd thought. My ghost of an idea was taking on solid form.

◇◇◇

A breathless ten-minute walk took me to the Rialto where maskers and merchants churned in a merrily roiling crowd at both ends of the bridge. On the canal, a water-borne barrel organ was cranking out a tune I recognized from an opera I'd sung several years ago—a magnificent aria now reduced to drivel. I shouldered my way onto the stone span with shops centered along its spine. One lone constable was attempting to maintain orderly passage, but not succeeding very well. As I climbed the ramp, my heart seemed to have swollen to twice its normal size, but its frantic pounding had subsided by the time I'd gained admittance to a familiar office in the nearby guard house.

"But, Andrea, don't you see?" I pounded a fist on Messer Grande's oaken desk. "Niccolo Rocatti is Vivaldi's son."

The chief constable stood at an unshuttered window that overlooked a canal filled with brisk traffic. The sun of the morning had given way to lowering gray skies. The Sirocco wasn't finished with us yet. Though Andrea's gaze was directed elsewhere, I knew that he'd been listening closely. He held his hands behind his back, his fingers tapping anxiously against each

other, as I pelted him with my suspicions. Now he turned. "Are you saying that because Rocatti has red hair, he must be the son of The Red Priest?"

"That's only a small part of it," I responded impatiently.

"Venice is known for its redheads," Andrea continued dryly. He came away from the window and paced his office, hands still joined behind his back. "Besides our Titian-haired whores who can gather a crowd of foreigners by simply brushing their tresses on their balconies, there's ten ginger-topped urchins on every campo. But that is not what you want to hear, of course." He aimed a sharp glance at me. "You should be at home, you know. You don't look well."

"I'm fine." In fact, my strength was flagging and my head felt as if it might burst at any moment, but I couldn't run back to the Cannaregio with my tail tucked between my legs. I was on the verge of untangling the knotty skein of hidden motives and half-truths that surrounded Torani's murder. I continued wearily, "I've probably not been making much sense. Let me lay my theory out, point by point."

"At least sit." Andrea gestured to a wooden armchair and further encouraged me by taking his own seat behind his desk.

"Yes. All right." I sank down, thinking carefully. To make my case to this man of law, I must begin at the beginning, but whose beginning? Rocatti's? Signora Passoni's? I decided to start with what I had personally observed.

"On the day I visited the Ca'Passoni to secure the Savio's permission to mount *The False Duke*, Franco approached me in an empty corridor. His manner was oddly secretive, and he pressed a purse of coins on me. 'For the success of the new opera,' he said. He was merely acting as Signora Passoni's messenger, of course. But why was the signora so keen to support Rocatti's opera? She'd never before displayed any particular interest in the politics of the opera house. I confess this little mystery slipped my mind during the whirlwind journey to Milan."

Andrea lifted a forefinger. "A journey forced on you by Signorina Beatrice's nascent longing to hear Angeletto—such

are the whims of young girls with powerful fathers. They can overturn the best-laid plans, change the course of history, topple empires…"

"Yes, I suppose that is so." I twisted on the hard chair. I would do much better if Andrea could refrain from interrupting me with his philosophical digressions. "It wasn't until the reception for the two singers that I understood why Signora Passoni was so invested in *The False Duke's* success. At least I thought I understood—when I observed the obvious warmth between her and Rocatti. I pegged the violin master as her lover, an ambitious young man courting an older woman in a position to advance his career. And she…well, the signora is like many women of her class—ignored by her husband, with time hanging heavily on her hands. But I was wrong." I allowed myself an indulgent chuckle. "Signora Passoni and Rocatti are not lovers—they are mother and son. The tie that binds them is Maestro Antonio Vivaldi."

Andrea rewarded me with a congratulatory nod. "Good thinking, Tito. You may well be correct. Though the Savio would like to forget his wife's unfortunate origins—indeed, he's taken pains to suppress any talk of it—it is common knowledge that Giovanna Passoni was raised at the Pieta. She came of age during Vivaldi's early tenure there." He grinned. "You didn't know?"

I shook my head. Messer Grande's definition of common knowledge stretched much farther than mine. "What was Signora Passoni's maiden name?"

"Bragadin."

I rubbed my aching brow. He'd named a noble family of great antiquity, whose tree had produced so many branches that only the clerks at the office of the Golden Book could sort them out with any degree of accuracy. Venice had never elevated a Bragadin to the Doge's throne, but many men of that family had served as Senators, Savii, and Procurators. And as every schoolchild knows, our Republic's most celebrated hero of the prolonged Turkish wars was the ill-fated Marcantonio Bragadin. For these reasons, I supposed, the Savio had found Bragadin blood worthy of matrimony, even when it flowed through the veins of a bastard

daughter. Still, a marriage to a Pieta so-called orphan was not an exceptionally proud match, and if that orphan had already produced her own bastard child, it would be outright scandalous.

Andrea went on, "The signora's wastrel father, Julio Bragadin, tended his inherited seat on the Great Council but not much else. From age sixteen on, he had a string of mistresses and concentrated on a life of pleasure, not business. Julio met an early death, but not before depositing a goodly sum in the Pieta's coffers to be used as his daughter's dowry." Then, after a pause: "Her mother isn't known."

It struck me that I was laboring over already plowed ground. I asked, "Is it also common knowledge that Giovanna Passoni gave birth to a son before she married the Savio?"

"In short, no—that is mere speculation. At seventeen, she left the shelter of the Pieta for the Ca'Passoni. I've unearthed no witnesses to a pregnancy. No gossip, even." He rearranged the items on his desk with ferocity, as if the ink pots and blotters were personally responsible for this lack of evidence. "If she did—by some miracle—manage to carry off a secret childbirth at the Pieta, it can't be proven. No one knows a thing."

"Rocatti knows, I'll be bound." I rolled my eyes toward the window that had become a misty gray rectangle and heaved an exasperated sigh. The weather irritated me. My ailing body irritated me. Venice irritated me. "What have you discovered about Rocatti's early life? Where was he raised?"

"As a boy, he lived on a campo near the Pieta, with an elderly couple he called Zio and Zia."

Uncle and Aunt, my left foot. "Paid caretakers," I said bluntly. "Have you questioned them?"

He shrugged. "They died several years ago, just weeks apart."

"How very convenient."

"Tito." Andrea left his desk and came to lean over my chair with one hand on the back. With the other he rubbed his bluish jaw. He drew his eyebrows together in a tight furrow. "You obviously believe that this supposed relationship formed a basis for Torani's murder—"

"He knew! Torani knew that Vivaldi was her lover!" My vehement croak overrode his measured tones. "You know that the maestro could wield a vicious sense of humor. He was teasing Signora Passoni when he asked if she hadn't heard the whispers of Vivaldi in Oriana's songs."

Andrea straightened. "If I recall aright, Signora Passoni took Torani's comment as an insult."

"Precisely so!" I jumped up to face him eye-to-eye. "She left the salon, dropping her bag in her haste. I scooped it up and returned it to Franco." I laid a hand on Messer Grande's shoulder. "Andrea, that bag was as heavy as if it had been filled with lead shot."

His eyes widened in surprise. Finally I had told him something he didn't already know. He asked, "Was it heavy enough to break Torani's skull?"

"In the right person's hand."

"Not Giovanna Passoni's hand—I judge her head cool enough to carry out such a deed, but her slender arm encompasses no more muscle than a cabbage."

"I'm speaking of Franco's hand." I fell silent, allowing the name to hover in the small space between us. The castrato's elongated frame defied the ideal male physique, but I would wager that his strength was adequate to the task of coshing an old man's skull with a weighted bag. Mine certainly was.

I continued, "Angeletto told me that Franco and Rocatti left the theater together yesterday afternoon—at the perfect time to allow Franco to appear at my door and place the angel card under my door knocker."

Andrea didn't even blink. "You're right about that," he said. "My men found someone who spotted Franco at your door."

I sighed. I was again telling Andrea something he'd discovered on his own.

Perhaps this next would impress him, I thought, as I set about adding flesh to my ghost of an idea. "Let's say that Giovanna Passoni had Vivaldi's manuscript for *The False Duke* in her possession—precisely how doesn't matter now. She knows her son

is hardly the equal of his father where composition is concerned, nevertheless she is determined to propel him to a brilliant career rather than allow him to labor unrecognized. She strikes a bargain with Maestro Torani—he will present *The False Duke* as a brand-new opera by Niccolo Rocatti and—"

Andrea couldn't contain himself. "What does Torani gain from this arrangement?"

"The maestro needed money." I ticked points off on my fingers. "He needed an ingenious opera that would draw subscribers back to the Teatro San Marco. He needed to end his career on a high note, so that he could sail off to his mainland villa with Tedi and bask in the rosy glow of remembered triumphs. The only risk was that someone would recognize the composition as Vivaldi's and expose Rocatti for a thief and Maestro Torani as an idiotic dupe. Or worse, as a party to the deception. However," I paused, the next words sticking in my throat, "Torani skillfully manipulated that risk onto my shoulders."

"All right...." Andrea was warming to my theory, I could tell. A sharp knock sounded at the door and a constable cracked it open. "Get out!" Andrea yelled, and the door immediately clicked shut. Andrea turned back to me. "Then what do we suppose happened? How did Torani's one teasing comment suddenly turn the mild, retiring Signora Passoni into a murderous virago?"

"Don't all women have a touch of the virago where their children are concerned?"

After a brief nod, Andrea took up his pacing again, back and forth from desk to window. To judge from the condition of the carpet, it was a well-worn path. Were his present thoughts in agreement with mine?

I soldiered on. "Maestro Torani's quip showed Giovanna Passoni the precariousness of her son's position. If anyone guessed the truth of the opera's composition, not only would Rocatti's musical career be destroyed, her own reputation would be held up for scrutiny. Perhaps her son's bastard parentage would finally be revealed to one and all. Can you imagine the depth of the Savio's humiliation? So...let us suppose that after fuming

over Torani's comment for a bit, Signora Passoni sent Franco to conduct the old man to a *tête-à-tête* in the card room. She admonished Torani, really got the old man's back up. His wig was off, remember—it had been tossed on the sofa like he always did when he was aggravated. Perhaps he upbraided her fears as ridiculous. Perhaps he disparaged Rocatti's talents...or...I don't know..." I pressed fingertips to my throbbing forehead. "No one can say what angered the killer enough to attack him except for the one who committed the deed."

Andrea narrowed his eyes, still pacing. "I see a problem here, Tito. Torani had as strong a motivation to keep the true authorship of *The False Duke* a secret as Signora Passoni. Though he could always shift the worst of the blame to his dim-witted assistant," he softened his words with a grin, "the opera house would still suffer if Vivaldi's role was known. Why did he gibe at the signora?"

I sighed. "Maestro Torani often wagged his tongue without consulting his brain."

"Hmm....I see another problem. This card room sounds terribly busy—was there sufficient time for all these secret meetings, this flouncing in and out?"

"Plenty of time. By the time Torani came to the card room, Grillo had escaped, I'd cleared out to tend to my wound, and Beatrice had been in to remove any evidence of her amorous activities."

My companion halted in mid-stride and pulled his chin back. "You know this from the girl's lips?"

I shook my head. "The Savio would never let me near the girl. But she must have gone back to the room. Grillo had left his cloak behind, and at Torani's funeral that green cloak sat atop Beatrice's shoulders."

"Perhaps Maestro Torani came upon Beatrice in the card room."

"I doubt it. It took nearly a quarter hour for me to clean up at the basin in the water closet—plenty of time for Beatrice to take the cloak and for her mother to send Franco after Torani."

My head was swimming again. Steadying myself with a hand on the desktop, I managed to croak out, "Still, the girl is a nosy little busybody, she may have witnessed something. Could you question her?"

"A brilliant suggestion," Andrea said with a dash of sarcasm. "I simply march into the Ca'Passoni, request an audience with the Savio's daughter, and interrogate his little princess about a grisly murder." He shook his head. "Some people are untouchable, my friend, and most of them are aristocrats."

I experienced several things at once: a sense that our conversation had veered off course, a galling premonition that Maestro Torani's killer would never be found out, and...the very odd sensation of the floor tilting under my feet.

Andrea threw an arm around me, turned me about, and set my feet into motion.

"What...where are we going?" My words seemed to echo up from a deep well.

"I'm taking you home, Tito. You've done enough sleuthing for a sick man. You must leave this in my hands." He opened the door and propelled me through. "And I'll brook no argument."

◇◇◇

That night, after I'd snuffed out the candle, I tossed and turned beside a gently snoring Liya. Eventually she rolled toward me. In the darkness, she found my forehead with her palm.

"Are you feverish, Tito? Is that why you can't sleep?" Her voice was husky with concern.

"I'm all right. I just needed some rest." Indeed, I'd fallen asleep on the sofa the minute Andrea had delivered me to my door. A long nap had set me right again, but now my eyes remained stubbornly open while my brain rummaged through the details of the day like the rag-and-bone man picks through Carnival refuse.

"What is it, then? Are you worrying over Benito?"

Yes, there was that. The longer Benito was gone without word, the more uneasy I became. The lack of even a brief letter made me think my manservant had traveled far afield, perhaps to a

backward part of Italy where the mail was uncertain and brigands plentiful. I sat up in the blackness. Though the delinquent Benito was ever on my mind, it was something else that troubled me.

"Liya," I asked. "Is it possible for a girl to hide a belly swollen with child? During the entire nine months, right up until the baby is born?"

I felt my wife push up on one elbow. "Would it have been possible for Giovanna Passoni to hide a pregnancy from the nuns at the Pieta, you mean?"

"Yes, that's what I'm wondering." I'd recounted the fruits of my day's interviews over dinner.

"It could be managed, depending..." She sighed. "I knew a girl in the Ghetto who shocked her family with an infant that no one suspected. It was her story that convinced me I could keep Titolino a secret. You remember what a disaster that became."

I nodded, though she couldn't see me.

"My hips are narrow. Titolino couldn't settle into my pelvis, so my belly looked like a pumpkin before I was even five months along. But other women are different. Perhaps Giovanna is blessed with pelvic bones as wide and deep as a soup kettle—it's impossible to tell through layers of skirts and petticoats and panniers."

"I know so little of this....Could a birth be hidden, as well?"

"Again, it depends. She would have needed help, a trusted friend or perhaps a sympathetic young nun, and a few hours of privacy. The Pieta is a huge building...there must be lots of alcoves and nooks. So sad, if that's true...." She finished on a yawn and rolled over. In a moment she was snoring.

I continued to toss in my sheets, trying to imagine Giovanna Passoni as a girl. Would the quiet, mature, aristocratic wife have been as capricious and strong-willed as her daughter, Beatrice? Had she pursued her violin teacher with fluttering lashes and bold smiles? Or had Maestro Vivaldi seduced an innocent virgin? Had Vivaldi arranged for the infant who became Niccolo Rocatti to be cared for by the elderly pair that Andrea had mentioned? And later become his bastard son's musical mentor?

One minute I was certain that my theory made perfect sense. Then, after pondering only a few minutes more, I decided it was shot full of moonbeams. Before sleep came to me, I heard the city's bells toll midnight, then the first hour of the new day.

Chapter Twenty-one

Several days of storms followed. The wind drove showers of cold rain slantwise, whipping our quiet canal into a furious river. The cisterns beneath the surrounding pavements, designed to catch the rain and provide drinking water, were quickly overwhelmed. Their drain covers spurted like the fountains of Rome. Above our heads, the roof-tiles made a brave stand against the constant assault, but were finally beaten into submission. Liya and the maid were forced to raid the kitchen for pots and pans to catch the leaks. With bluster, pounding, and gurgling outside and a symphony of drips within, my home became a noisy, uncomfortable place. Liya's sullen refusal to discuss her lingering inability to decipher her scrying instruments only made things worse.

By Saturday, the day before the official opening of Carnival and the premier of *The False Duke*, I would have sacrificed the last few ducats in my strongbox for any distraction. Happily, paupering my family wasn't necessary. Gussie called in. Heedless to the depredations of wind and rain, my brother-in-law appeared cheerful and invigorated. Perhaps our current weather reminded him of his homeland that I'd found so frigid and rainy.

"No, I won't sit," Gussie said, standing in our foyer in a dripping oilskin cloak and beaver hat. His rosy cheeks were running with damp, and his sodden plait made a lank rat's tail down his back. "I just wanted to see how you're doing. Annetta has been fretting."

Liya rolled her eyes skyward. She leaned on a mop she'd been using to chase drips. "Tell her we're fine, as long as the roof doesn't open up and drown us."

"If it comes to that, you must stay with us," Gussie said solemnly, nodding. My solid-thinking brother-in-law often took Liya's sarcasm at face value. "Though Isabella will bother you to death about her kitten. She thinks of nothing else, and is marking off the days with a piece of chalk." He flexed his eyebrows. "You don't think Aldo has forgotten, do you?"

I shook my head. "He won't forget. It's all arranged. But tell us, what's the news around town?"

"Well...a violent storm has breached the sea wall at Malamocco. They say its docks are ruined beyond repair."

I wasn't surprised. That ancient port guarded a narrow inlet on the Lido, a long sandbar that separated our lagoon from the Adriatic, and took the brunt of the Sirocco winds. "What about the piazza?"

"Pretty wet." He shook a hail of raindrops from his sleek beaver hat, and my wife went to work with her mop. "Oh, Liya, beg pardon, I wasn't thinking....Anyway, at high tide the water is lapping at the porch of the Campanile. It's driven everyone indoors. The Ridotto is five punters deep at the faro tables, and you can't find a seat at a café at any price."

I clasped my hands under my chin. "Everyone at the Teatro San Marco better be praying that the piazza stays underwater until tomorrow night."

Liya thumped her mop on the tiles. "Well, I hope it doesn't. The Savio deserves to have the opera fail—after how he treated you. Nothing could make me set foot in that opera house again—nothing."

Gussie nodded severely. "Annetta and I feel the same. Tomorrow, our box will be dark, and it will stay that way as long as I have the key in my possession. I don't know but what I should go down to the box office and turn it in for a refund on my subscription." He screwed his tricorne onto his head. "Will they give my money back, do you think?"

"I couldn't say," I replied quietly. I shuffled my feet, cleared my throat. There was one thing I'd neglected to mention to either my wife or my brother-in-law.

"I appreciate your sentiments…but, from the beginning, I've been so involved with *The False Duke* that I would hate to miss it. And I confess I'm eager to see how Venice welcomes Angeletto." I spread my hands apologetically. "Messer Grande has invited me to watch the premier from his private box—the Savio be damned."

For once, both Liya and Gussie were speechless.

◇◇◇

It was my decision to attend the opera premier—mine and mine alone. I could have pleaded illness, thanked Andrea for his kind offer, and simply stayed home.

How I wish I had.

The weather was still beastly—cold, wet, and blustery—but it didn't stop the flow of spectators streaming into the theater, crowding into every nook and cranny. On this first day of Carnival, no matter what the weather, Venice and her visitors were as one in their determination to celebrate. Masks—black velvet and white satin on the women, leather on the men—were the order of the day, throughout the pit as well as in the boxes. Only the gondoliers who crowded the benches near the stage made no effort to conceal their identities. The boatmen cared nothing for the Carnival whirl. They had paid their soldi to hear the music and cheer their favorite singer. I wondered if any of them formed a claque in Majorano's pay.

Angeletto had declared that he and his family were ready for any jealous singer's trick, but did the Vanini family realize just how passionate a Venetian audience could be? If they loved you, the stage would be awash with flowers and sonnets folded and ribbon-tied into easily thrown declarations of love. But if they hated you…oh, my. Overripe fruit was nothing—at least that was soft. It was the hard candle stubs that could raise a bruise.

As I was recalling several performance-halting incidents, my attention was diverted by a hulking, broad-shouldered man

pressing in among the gondoliers and passing a word here and there.

I leaned over the box railing and squinted my eyes. Those shoulders looked particularly familiar. Turning, the man confirmed my suspicion. The puckered scar that ran from ear to chin was visible even three tiers below. Scarface, Lorenzo Caprioli's chief bravo, had come to watch *The False Duke*. And right behind him was his fellow chair-bearer, the one with the broken nose. I sank back, more concerned than ever. Had the pair been sent to spy on the production for the Teatro Grimani or simply to cause trouble? For Maestro Torani's sake—despite the director's frauds and deceits—I wanted *The False Duke* to be a success. It would end up being my mentor's legacy.

Accustomed as I was to backstage life, this elegant third-tier box served as an unfamiliar vantage point for me. It contained only Andrea and me and several empty, gilded chairs. My friend, who was busy studying the program he'd purchased in the lobby, had thrown his red robe of office over a severe black suit. I wore my best wine-red brocade coat, shirt trimmed with Burano lace, stockings of the whitest silk, and paste-buckle shoes. In Benito's absence, I'd been forced to summon a friseur to arrange and powder my hair. No mask. I wanted to be recognized—by those opera goers who still remembered my stage triumphs and especially by the Savio.

My desire was soon fulfilled. While Giuseppe Balbi and the rest of the orchestra tuned their instruments in a cacophony of sound that was barely audible over the general din, I kept my eye on a curtained box a quarter of the way around the tiered crescent. Presently, the drapes were thrown back, and the Savio's second-tier box sprang to life. Footmen lighted candles on torchieres and wall sconces and scurried to hold seats for the richly dressed party divesting themselves of cloaks and bautas. Their masks fooled no one. The Passoni box enjoyed the best view in the house except for the Doge's and had been in that aristocratic family's possession since the theater had been founded. Their neighbors bowed as the Savio, elegantly bewigged, eyes and

nose masked in white leather, stepped to the railing and sur-
veyed the house. Choosing his moment well, he drew himself
up and extended a welcoming arm that seemed to include the
entire auditorium. Beneath his mask, his lips stretched in a wide
grin. Someone raised a cheer that gathered strength as it rolled
through the pit.

Andrea and I shared a withering glance. A subtle smile played
around the Messer Grande's lips.

It was actually Franco who spotted me first. Under the
dusky glow from the great ceiling chandelier, I felt the intense
stare behind his black satin eye mask, then saw him lean down
to whisper to Signora Passoni. He aimed his long arm with its
pointing finger up one tier, across the smoky gulf, straight toward
me. The signora had been hiding her face with a jeweled mask
on a stick. She lowered it and tilted her head musingly. Beatrice
also lowered her own mask to follow her mother's gaze.

The Savio was still returning bows and accepting accolades,
but he bent to his daughter when she tugged at his sleeve. Bea-
trice spoke into his ear. His posture stiffened. His eyes snapped
to our box.

I came to my feet and made a low bow, accompanied by a
graceful flourish of my hand. Was it only my imagination that
a few more cheers rang out?

The Savio's head whipped toward the rear of his box. At his
rough gesture, a pair of bravos sprang out of its shadowy depths.
They shifted their weight from foot to foot, awaiting orders.
Signora Passoni pushed through them, using her wide panniers
to sweep the men aside. At the railing, her small figure challenged
her husband's noble height. Heedless of the gabbling audience's
stares, she argued with the Savio. Her upturned chin wagged
like a marionette's, and the blue feather atop her wig bounced
up and down. Was the signora taking my part? Reminding him
why he couldn't have me tossed into the canal?

The nobleman aimed one more black look toward me, then
waved his men away. A few people—loyal supporters from the
old days—applauded. Then the Savio showed me his back.

Gazing down at the curtained stage, he stood remote and still as a marble statue. Ah, I was to be pointedly ignored.

I grinned at the Savio's obvious frustration. He could have had his men stop me at the door or lay hands on me in the corridor, but he had missed his chance. Once Andrea had ushered me into his box as his guest, I was beyond his reach.

The boxes as the Teatro San Marco, indeed at every Venetian opera house, functioned as miniature salons, luxurious outposts of the subscribers' homes. Seats lined the railings for those who wished to follow the opera—or for those intent on training their glasses on the assembled company and gossiping with friends in adjacent boxes. In the scarlet-and-gold interiors, candlelight fell on reclining couches or on tables laid for intimate suppers, which would be delivered and served by liveried footmen who spent the evening either outside in the corridor or crammed into a small, square anteroom just inside the door. The corridor door opened only to the boxholder's key and was made ready and attended only by servants in his employ. Thus, the Savio had no more power to eject me from Andrea's box then he would from Andrea's home.

As long as I stayed within these scarlet-and-gilt walls, I was safe. And once the curtain had fallen on *The False Duke's* grand finale, I would gladly quit the theater, perhaps for the last time.

Events proceeded quickly. The Doge's party entered the imperial box, and Balbi struck a chord that signaled his musicians to launch into a triumphal march. The entire audience rose. For a brief moment, chatter ceased. Even our ruler appeared infected with the prevailing Carnival gaiety. Tonight the Doge's usually stern face crinkled with pleasure and pride. His jaws spread in a stiff smile as took his seat besides his brilliantly jeweled Dogaressa.

A thrill of anticipation passed through the crowd. Now the opera could begin.

Niccolo Rocatti plunged out of a side door and made his way to the harpsichord. Balbi and the other musicians acknowledged him with bows. Tepid bows, I thought. The director's white wig

and new coat of silver brocade suited him to perfection, but his glassy expression was a study in nerves.

Appearing deaf to the rash of applause from the audience, Rocatti took his seat at the harpsichord. Balbi raised his instrument to his chin. A look I couldn't decipher passed between them. Then Rocatti lifted his right hand, sounded a chord with his left, and they were off.

The orchestra played the overture with a heavy hand, but few noticed or cared. The entire theater was agog to catch a first glimpse of Angeletto, the now infamous castrato who had captured the ears and hearts of Naples and Milan. As the overture drew to a close, the curtain rose, slowly, inch by inch. Had Aldo been ordered to make the suspense last as long as possible?

Finally, there he was. Alone on the stage, surrounded by the marble arches and endless corridors of a duke's palace—all *trompe l'oeil* effects of Ziani's art—a grandly costumed Angeletto stood in profile with one hand resting on an outsized globe of the world. Wild cheering, applause, and rhythmic stomping arose from all sides. Already wise to the ways of the theater, the singer spent a long moment allowing the thirsty eyes to drink him in before he turned and processed to the footlights.

Andrea spoke near my ear: "Your prize looks a damn sight more like a Devil than an Angel to me."

I had to agree. Angeletto's wide-skirted coat was a bright orange-red, threaded with gold that seemed to run with flame in the massed glare of the footlights. And though his painted face and tall powdered wig were as polished as could be, the smoldering look he cast over the house was far from that of a heavenly creature.

During this display, Rocatti remained hunched over his keyboard, back curved in a tense bow, waiting for Angeletto to signal that he was ready to begin the recitative. This sing-song dialogue explains the details of the opera's story, while the soaring arias give the performers free rein to express their emotions regarding each new turn of events. Once the audience had

quieted a bit, Angeletto raised a finger, Rocatti struck his keys, and the singer's mouth opened.

My eyes took it in, but my ears heard less than two minutes of it. A fight broke out in the rear of the pit. First came contemptuous shouts:

"Take your *culo* back to Naples, Signorina."

"Put on a skirt, *Puttana*."

"Give us Majorano!"

Hoarse, violent cries responded. Gondoliers sprang off their benches, intent on silencing the interlopers. Then, from the first tier of the cheapest boxes, a large wine bottle flew through the air and crashed onto the pit floor with a loud explosion. Women screamed. People pushed and shoved. Panic began to take over.

Andrea and I had both jumped up. My hands were white as I grasped the railing. I yelled to my companion, "No one will be able to hear Angeletto's aria with that uproar going on!"

He shot me a look of gruff disbelief. "I'm more interested in seeing that no one is trampled. I've got to disperse that crowd."

"Of course," I responded bleakly as I watched the tail of his red robe disappear through the anteroom.

The theater quickly became a maelstrom of noise. The pit's screams and cries swirled up to the chandelier in the dome and echoed off the tiers of boxes whose denizens were adding their own shouts and whistles. Eggs, apple cores, candle stubs, and other debris hurled from the pit crashed against the front of the boxes like the drumming of a hail storm. I peered toward the Savio's box, only to see the footmen drawing the scarlet drapes. I snorted—a brave man, our Savio alla Cultura!

On the stage, incredibly, Angeletto was still voicing the recitative, even though Rocatti had stepped away from his instrument. The young violin master faced the melee squarely. His handsome features seemed to melt in grief, and his slumped posture shouted defeat. Giuseppe Balbi had also abandoned his music stand. One of the cello players was climbing over the railing, intent on joining the fray. Balbi was tugging on the tail of his black coat.

Finally, thankfully, the curtain rolled down—much faster than it had risen. Good. Aldo must surely realize that there was no point in going on with the opera until Messer Grande had summoned his sbirri and restored order.

I sat back down, chewing on a knuckle. How had *The False Duke's* premiere gone so terribly wrong, and so abruptly? Paying for applause was one thing, but fomenting an outright riot was a crime and a scandal. Was Majorano behind this? Surely not. As a singer, he well understood that any tricks he employed to bolster his renown could be turned against him during the next performance. My thoughts ranged a little farther; Lorenzo Caprioli was the agent behind this, I'd be bound. His *Venus and Adonis*, starring that fatuous dunce Emiliano, was also opening tonight. Many from the audience wearied by the antics at the San Marco would seek entertainment at the Teatro Grimani.

I stood again and scanned the sea of angry faces for Lorenzo Caprioli's henchman. There he was—in a first tier box! A red-haired harlot was planting a kiss on his scarred visage. Had one of them tossed the bottle that started the panic? It had seemed to come from their direction.

At least the sbirri had arrived and were fanning out amongst the crowd. The uniformed constables wielded fists and truncheons, barking commands and threatening arrest if they weren't instantly obeyed. Gradually, the noise lessened. The pit was coming to heel.

A tapping knock sounded at the door behind me. Was it Andrea, back already? Had he forgotten his box key in the excitement?

I stepped through the anteroom, flipped the latch, and cautiously opened the narrow door. A woman stood before me. At first I thought it must be Signora Passoni. A blue feather decorated her wig's white curls, and her face was hidden by a stick mask encrusted with multi-colored paste jewels. Then I realized that this woman was several inches taller than the petite Giovanna Passoni.

She lowered the mask to reveal gray eyes and a long, straight nose with a moleskin patch beside it.

"Tedi!" I whispered, at the same time reaching out to grab her wrist. The soprano wasn't going to slip away from me this time.

"I must speak with you, Tito."

"Then come in." I gave her arm a gentle tug.

"No! I can't be seen."

"If we stay right here, no one will see you."

She shook her head firmly. "Messer Grande will. He'll be returning any minute. I must talk to you alone."

I hesitated, loathe to leave my place of safety.

"Please, Tito." The mask sank still farther. She stepped closer. Now I saw that the black pupils of Tedi's eyes had dilated so that only a rim of lighter gray remained. Her painted lips flared blood red against her powdered cheeks. I'd always thought of Tedi Dall'Agata as a confident, handsome woman who hid her forty-odd years well and could always be relied on to do the calm, sensible thing. At this moment, she was far from calm and confident. Tedi was afraid.

"All right." I dropped her wrist, angled through the narrow door, and cast apprehensive looks right and left. Except for several footmen and an elderly party toddling toward the stairs complaining about the sad state of Venetian morals, the corridor was deserted. "Where?" I asked.

"Just follow where I lead, Tito, but stay well back. It will be safer."

Dio mio, what sort of trouble had Tedi gotten herself into?

I followed the soprano down the curving corridor behind the third-tier boxes, shaking my head at footmen who stepped forward with offers of assistance. More corridors and a set of stairs. At times, Tedi ran like a doe flaunting a delphinium-blue skirt instead of a white flag, and I was forced to pursue her like a huntsman starving for venison. I'd begun to think she had changed her mind about wanting to talk with me when she dove into a corridor that led to the second-floor gambling salon. Tedi slowed once she reached the tables. No matter what was going on

in the auditorium, there were always a few punters who spent the evening losing their money to the wheel or the cards. There was enough action going on at the faro table that we attracted little attention from guests or servants, but Tedi still kept her mask to her face. Before she disappeared through an arched doorway in an inconsequential corner, she lowered it for an instant and shot a look back toward me.

I nodded, barely perceptibly, to demonstrate that I knew where she was headed. Through that archway curtained with a tapestry were side stairs left over from a building that predated this one. The stairs climbed up to a warren of attics where unused costumes and props were stored and descended into stone storerooms too damp to be used. They also connected to several corridors that ended in blank walls or other dead ends. I hurried through the curtain and paused. Though this area was cold and largely unused, wall lamps had been lit on each landing. From above came the tapping of Tedi's spool-shaped court heels.

My long legs took the stairs two at time. Hampered by her wide skirts, Tedi slowed so that I was able to catch up to her. Both of us were breathing in gasps by the time I pushed open the green-shuttered attic door with most of the slats missing. Attached to a spring mechanism, it swung closed of its own accord. Within the dark, slope-ceilinged chamber, Tedi's skirts raised a cloud of dust that made a ghostly ladder in the dim light filtering through the slats.

I glanced around at the banks of linen-covered gowns and tarnished Grecian and Roman armor hanging from rafters. Beneath them were barrels of wooden swords and scepters and leather-bound trunks piled on top of each other, all cobwebbed and furred with grime. I breathed in the smell of mildew. It could have been months since anyone had come up here, I thought, pinching my nose against a sneeze.

I turned to face my panting quarry. "We should be safe now. What do you have to say?"

Tedi's pale face presented an eerie sight. Her paint had run, mingling with the powder from her wig. The black around her

eyes etched streaks down her cheeks, her lip rouge made red rivulets in the wrinkles around her mouth, and sweat had carried her patch from cheekbone to chin. With a horrific moan, she raised her arm and threw her stick mask with the force of a cannon shot. It bounced off a lozenge-shaped shield with a metallic clang that made me jump. A sob broke from her chest as she covered her face and staggered sideways. I grasped her elbow.

"No, no. Just let me rest." She gently extricated herself from my touch and sank down on a heap of ragged petticoats and boned corsets. She was a broken doll atop a sea of blue-satin skirts. "Oh, Tito…"

Chapter Twenty-two

Apparently, Tedi wanted to make her confession—with me as an unlikely priest. She craved heavenly absolution, or at least human forgiveness. Since she would have neither from Maestro Torani, I would have to do. Here was the stumbling block: Tedi preferred to remain hazy about the details of her offense.

"I've made such a mess of things," she began, then repeated several times.

"You'll have to do better than that." After seeing her climb into Lorenzo Caprioli's sedan chair on the day of Torani's funeral, I wasn't feeling very charitable toward the soprano.

Her eyes puckered. Tears made a further mess of her cheeks. She tried to hide them in the crook of her satin-sheathed elbow. "Rinaldo would be so ashamed of me," she finally said.

Summoning patience, I settled myself beside her on the heap of rags. I handed her my handkerchief and waited while she wiped her face. "It's hard to imagine that Torani would ever be ashamed of you, but he would have been surprised to see you in Lorenzo Caprioli's chair. I certainly was."

She bowed her head and answered softly, "I know."

"Why, Tedi? Were you turning your back on Torani and his memory? Had you come to hate him because of his unrepentant gambling and his mounting debts?"

Tedi looked up with fire in her eyes. I drew back. The woman looked angry enough to strike me. She said, "I loved Rinaldo. I loved him through everything, even if he did make me mad

enough to kill him sometimes. I didn't, of course. Don't think that for one minute." She wrung the linen square I'd handed her, then tilted her chin suspiciously. "How do you happen to know about Rinaldo's debts, Tito?"

"Maurino told me—the day you left to take the waters at some imaginary spa."

At least Tedi had the grace to blush.

I repeated all that the valet had explained concerning Torani's unrestrained and imprudent behavior, finishing on a sigh. "I only wish the old man had come to me for help. I understand the nature of the malady as well as anyone who hasn't experienced the lure of the tables himself."

"Your father," she stated simply.

"Yes."

She shook her head. "Rinaldo didn't want you to know that he shared your father's weakness. He wanted you to look up to him—to think he was well-nigh perfect." She studied me for a moment, then reached out to touch my hand. "He loved you so much, Tito."

I bowed my head. Oh, yes. My mentor loved me so much that he contrived to put me into a position where I could become the laughingstock of Venice's musical world.

Tedi let me sit in silence. She pulled her wig off and ran its blue feather through her fingers. Her own hair twisted into a tight, flat bun had more silver in it than I recalled. When she spoke again her voice was strained. "I want to tell you how I came to be in league with Lorenzo Caprioli."

"Go on."

"You know about the debts—and about how Maurino and I found Rinaldo in an alley, beaten and bleeding—then the attack on his gondola. That was the last straw for me—I sold my jewels, used every soldo I could raise to pay those debts. They were wiped out. The bravos from the casino didn't kill Rinaldo."

"Yes, yes. But, Tedi, why Caprioli? The maestro's sworn enemy? The man who's been trying to steal the Senate's backing for his own theater?"

Tedi scooted closer. She crushed my hand in hers. "I went to Caprioli precisely because he was Rinaldo's enemy—the only person I could think of who actually hated him."

"You believe Caprioli killed Torani?"

Tedi nodded her agreement so vigorously that a lock of silver shook loose from her bun. "I thought if I could gain Lorenzo's trust—become one of his inner circle—I might be able to find proof of what he had done. I offered myself to him as prima donna and…more."

Anger coursed through me. Without knowing how, I was suddenly on my knees, then my feet.

"Tito, it was the only way! I was certain he killed Rinaldo, and I was willing to do anything to prove it." She struggled up from the filthy nest. "You hate me, don't you?"

"No, Tedi." I shook my head sorrowfully. "Just tell me this— do you still think Caprioli committed the murder?"

She took a deep breath. "No. These past few days I've gathered all the threads that seemed to have promise, but they unraveled in my hands." She nibbled on a thumbnail. "Tito, I've put some other clues together—things Rinaldo said in unguarded moments, something Peppino said, too. I've come to a totally different conclusion. Rinaldo was harboring a secret—it's that secret that killed him."

I took her hands in mine. "I know what it is."

"Do you?" she tilted her head in a gesture of disbelief.

"Yes." The glow of true understanding settled around my heart. The ghost of an idea that had been haunting me for so long became rock solid. "Niccolo Rocatti didn't write *The False Duke*. Antonio Vivaldi did. Signora Passoni gave Torani the score to pass off as Rocatti's. He's the son of Vivaldi and Signora Passoni."

Tedi shook her head. She jerked her hands from my grasp.

"What?" I felt like the floor had disappeared beneath my feet. "Vivaldi isn't the opera's true composer?"

"Yes, yes, he is," she said. "Years ago, believing it was too radical for a public performance, Vivaldi gave the score to Giovanna Passoni as a lover's memento." She peered into my face. After

a brief pause, she said, "I think you must have found Rinaldo's hiding place."

I nodded. "The bust of Minerva. Why on earth did he stick the score in the statue?"

She gave a wistful smile. "Rinaldo spent a great deal of time considering Signora Passoni's scheme. At first, he objected to the deceit, but she refused to give him the entire manuscript unless he agreed to produce the opera her way. I suppose she felt she was killing two birds with one stone. Her lover's gift would finally see the light of day, and their son's career would receive a much needed boost. Once Rinaldo agreed, he set about carrying out the plan in the wisest way possible. He was casting about for a place to secrete the score and I suggested Minerva. 'Consign it to the Goddess of Wisdom,' I said, 'and perhaps she will smile on your project.'"

A bitter taste rose from my throat. "He thought it wise to make me the target of humiliation and censure if the opera failed."

"That's what you've been thinking?"

"What else am I to think?"

Her eyes flashed. "Oh, you foolish thing! Rinaldo knew *The False Duke* couldn't fail. Its time has come. Venice—all of Europe—is ripe for it. He had faith that you would develop it into a wonderful production, even with the difficulties that Beatrice's demand for Angeletto presented. Rinaldo wanted you to take over the opera house. He longed to see you reap the benefits of this great success, while we put the cares of Venice—and all of her gaming houses— behind us." She swallowed a sob, put a hand to her mouth. "All was finally turning out well…until someone killed him."

"Just a minute, Tedi. You're telling me that *The False Duke* had nothing to do with Torani's murder?"

"That's right. The secret that killed my love is…something entirely different."

"For God's sake, what is it?"

She stared at me, eyes glittering, chest heaving in little sobs. Just as her lips parted, a shot exploded in a burst of flame from the doorway.

"Tedi!" I cried as the soprano collapsed into my arms. Blood trickled from a ragged hole at the front of her neck. Frantic, I tried to staunch it with my fingers, but it quickly became a gory stream. She gurgled out one last gasp before her body went limp and her eyes rolled back in her head.

There was nothing more I could do. Tedi Dall'Agata was dead.

I lowered her gently to the floor and ran to the door. Heedless of the danger, I pulled it open so hard it crashed against the wall and lost a few more slats. The landing was deserted. All that remained was a puff of smoke and the acrid odor of gunpowder.

◇◇◇

"You must have been born under an unfortunate star, Tito. It seems your destiny is linked to murder. Do you know that most men go through their lives without once encountering an atrocity of this sort?" Andrea's solemn words filled the cabin of his luxurious gondola.

When I didn't answer, his gaze left my face. He parted the curtains with one gloved finger and stared outward. Even at this late hour, the watery avenue of uninterrupted grandeur that is the Grand Canal was alive with boat traffic and the songs of their boatmen. The yellow glow from palazzo windows and the orange blaze of landing torches made shimmering zigzags on the murky water.

Eventually, I voiced the remorse that had been plaguing me for hours—ever since I'd burst into the San Marco's corridors shouting of murder and putting an end to any hope of resuming that night's performance. "If I'd only made it through that door to the stairwell more quickly, you might have Tedi's killer under arrest. And Maestro Torani's, too."

Andrea dropped his hand; the curtain whispered shut. In the darkness, his face stood out as a pale oval. "Tito, I have nothing to convince me that the murders were committed by the same hand."

"Tedi was about to tell me what she believed caused Torani's death," I protested.

"Yes, my friend, the deaths are related, but secrets and motives abound. Just consider the complications. Torani and his mistress were entangled in a desperate struggle to accomplish several things—save the reckless old punter from his gambling habit, ensure that the Teatro San Marco would continue as Venice's flagship opera house, and retire to the mainland with some shreds of their reputation and dignity remaining."

I sat back and surveyed him with lifted brows. He was correct, as usual.

"Besides, Tito. The murderer took one precise shot and ran. He was well away in that maze of stairs and corridors before you even crashed through the door."

"You did search that area top to bottom."

"As I told you—yes. My men found only empty corridors and damp cellars filled with refuse and skittering with rats."

"They didn't find any forgotten gate or postern? Any means of escape that the killer could have used without going back through the gaming salon?"

"No, Tito. That crumbling pile attached to the opera house contains no doors, and the few windows are merely slits. Whoever shot Tedi came through the main portion of the theater building and left the same way." He added in a conversational tone, "Did you realize that your Teatro San Marco was built on the ruins of a monastery?"

Though he probably couldn't see it, I shot him a scornful glance. "It is no longer *my* Teatro San Marco."

"Perhaps not now." His grave tone turned to a chuckle. "You must wait, Tito, and cultivate patience. I predict that one day you will rule the opera house just as Maestro Torani did."

"How can you possibly believe that?" My voice grated harshly. "And how dare you laugh in the face of Tedi's death? Whatever Devil's bargain she made with Lorenzo Caprioli, she did it to find justice for the man she loved. Both their lives were ripped away just when they should have been resting on their well-earned laurels."

A pale hand rose to wipe his forehead. His sigh hovered between us. "The violence that men visit on each other has

become a constant in my life—such is the burden of a Messer Grande. If I didn't allow myself a laugh, I would soon sink into melancholia."

"Of course. Forgive me." I bowed my head. Fate had brought my family so much grief that I should have understood that without being told.

"Forget it. Tell me more about what Tedi was afraid of."

I leaned back against the cushioned leather seat. "Not what, but who. She'd come to another conclusion about Torani's killer. He—or she—must have been in the theater. Tedi was obviously afraid of being followed."

"Of course, she might have also feared Caprioli and his bravos. It appears she'd slipped his chain, and I imagine he would be determined to have her back. Tedi as prima donna would have been quite a prize for the Teatro Grimani."

"I did see two of Caprioli's men, before the riot."

"I saw them, too. When my sergeant was marching them away in irons. Tomorrow they'll come up before the avogardo under charges of creating a public disturbance."

I sat up very straight. "When were they taken into custody?"

"About the time Tedi was persuading you to follow her."

"That doesn't mean that Lorenzo Caprioli himself hadn't gained admittance to the Teatro San Marco—a majority of men in the audience were masked."

"I've already ruled out Caprioli. The opera premiering at the Teatro Grimani began at the same hour as *The False Duke*. Caprioli was swaggering all over the theater greeting subscribers and crowing about his singers. Hundreds of witnesses would swear to it."

"Another of his men, then. Who knows how many bravos he has in his pay?" I had a sudden thought. "Perhaps Girolamo Grillo has slipped back into Venice."

"I'll look into it. You may be sure that I'll hold Caprioli's feet to the fire concerning all you've related…but there are also other possibilities that I find interesting." Andrea again parted the curtain. We were passing the soaring arcades of the Turkish

traders' residence and warehouse. Unlike the Venetian palaces, the Fondaco was slumbering in total darkness. For the Turks, Carnival must be as forbidden as wine or pork.

"What other possibilities?" I asked. "Can you tell me?"

"Certainly. I would welcome your opinions." He left the curtain open. A cool breeze came off the rippling, lucent surface of the canal. "After the theater's curtain rolled down, Angeletto exited the stage through the left downstage wing. He appeared to be very upset. His mother and sisters say that he came straight to his dressing room and stayed there, licking his wounds, but a scene shifter who was up on the catwalk is certain that Angeletto disappeared in the direction of the pass door, not the stairs to the dressing rooms."

"Oh, no. Not Angeletto. I can't imagine that he could make his way through the theater without causing a great stir—in that gaudy costume, no less."

"It would take but a moment to don an eye mask and a spare cloak. That's why I so dread the months of Carnival—you can't trust appearances. Is that mischievous little nun truly a good sister, or perhaps she's a whore playing a part? Or a patrician boy with certain tastes?" He waved an impatient hand. "You have no idea how difficult my life becomes during Carnival."

I sighed. "How would Angeletto even know Tedi was in the house?"

His shoulders moved in a shrug. "Do you know where she was before she came to my box to find you?"

"No," I reluctantly admitted, "but I can't see Tedi being afraid of a mild, gentle soul like Angeletto."

"Tedi told you that Torani—and now Tedi herself—was harboring a secret that someone was intent on keeping under wraps. Isn't the singer's true gender still a mystery? Wouldn't his career be utterly ruined if he were exposed as a masquerading female?"

"I expect so."

"A secret worth killing for, eh? Perhaps Signora Dall'Agata was in possession of evidence that would raise a bit of extra cash."

"What evidence?"

"If I had that information, we wouldn't be having this conversation." He shrugged impatiently. "Just follow me here. Perhaps Tedi approached Angeletto to ask for money to keep her lips sealed."

"But how much damage could she do? Venice has been arguing over Angeletto's sex for weeks. That's what started the riot tonight—scornful shouts accusing him of wearing skirts."

"Our café and coffee house populace is idle, shiftless, prying, and ruthless. But at the end of the day, gossip is merely gossip. Some might argue that Angeletto has even benefited from all the talk."

"He didn't benefit tonight," I countered.

"That is true. Tonight, rumor inflated to ridicule. But one month ago, who even knew Angeletto's name? In that light, would you agree that all the speculation is a benefit?"

"Yes," I admitted grudgingly.

"Now," Andrea raised a finger. "What if Lorenzo Caprioli, under his standing as manager of the Teatro Grimani, made a formal complaint to the Savio with evidence to back his claim. What if our lovely angel was forced to prove his sex beyond doubt?"

"I suppose it would depend on the outcome of that examination," I answered wearily. "But really, I just can't imagine Angeletto standing on the other side of that door, aiming a pistol through the slats, and taking such an accurate shot. I think you should consider further."

"I have." My companion took a deep breath. "At the first sign of disturbance in the auditorium, the Savio closed up his box and ordered his family to stay inside. He was spotted in several different locations—the box office, the second and third floor corridors, backstage. He was hectoring anyone and everyone who might have some power to halt the interruption."

"Did he speak to you?"

Andrea nodded and added in a low, deliberate tone, "We had a brief…conversation."

I could just picture that conversation. "Was the Savio spotted in the gaming salon?"

"I received no useful information from any of the gamers. If I believe them, not one man or woman lifted their eyes from the tables until you came through yelling at the top of your lungs. No, what I consider interesting is that the occupants of the Passoni box did not stay put as ordered. I was fortunate enough to ask a few questions before the Savio bustled his party away. I discovered that both Franco and Beatrice left the box."

"Together?"

"They left at different times, and both were gone for twenty minutes at least. A footman stated that the signorina insisted on going to find her father—he accompanied her, but she quickly slipped away from him. Beatrice says that she sought the Savio backstage, but no one recalls seeing her there, not even the observant fellow on the catwalk.

"Now, Franco is a different matter." Andrea continued stonily, "You're not forgetting that Signora Passoni's *cavaliere* is almost certainly the one who delivered both angel cards."

"I wouldn't be likely to forget that."

"Just so." He gave a tilting nod. "Signora Passoni reports that she became over warm sitting in the shut-up, curtained box. She sent Franco for an ice."

"In the middle of a riot?" I asked incredulously.

"Exactly. Franco returned after twenty minutes, desolate that he was unable to obtain her treat."

"So, where was he?"

He shrugged. "Perhaps outside the attic storeroom, ensuring that Tedi Dall'Agata would never breathe her secret." He added quietly, "Ah, we've arrived at your landing, Tito."

Franco? I slapped both hands to my brow. Secrets, told and untold, reeled in my brain. The faces of people who kept secrets, people who had the opportunity to kill both Torani and Tedi, joined them in a nonsensical whirl. None of it made sense, and I was loath to leave Andrea's company until it did.

Yet, the door to the cabin swung open, and the moist night air cooled my cheeks. Andrea's gondolier extended his hand to help me disembark. Dimly, I heard Andrea bid me goodnight and advise that a brandy might be in order.

I pulled myself together with a jerk. "When will you question Franco and Signora Passoni? Tomorrow? I mean, later today?" It must have been nearly two o'clock.

"That remains to be seen." Andrea shook his head. "To further interrogate any member of the Passoni household, I must wait upon the Savio's pleasure. And I warn you, my friend, if Signora Passoni is involved in either murder, on her own or through her loyal cavaliere, she'll never be punished."

"You couldn't arrest her?"

"Think on what you're saying, man. This is a woman of patrician blood, no matter that she was born on the wrong side of the blanket. The Savio's family is no less illustrious, and he holds an office of power. No one will want to believe that his wife was involved in a murder."

"What about Franco?"

He reflected a moment. "Her cavaliere is a tool and nothing more. If Giovanna Passoni prevailed upon Franco to kill Tedi, and I'm unable to bring her to justice, then I would as soon arrest Franco as the pistol that fired the shot."

I heard the door to my house open. I didn't want Liya out in the cold damp, but..."What if Signora Passoni took a pistol from her muff and shot someone in the middle of the piazza in the full view of hundreds? Could you arrest her then?"

"The presence of witnesses would certainly make a difference, but her position would still hold sway." He stretched his legs as best he could within the confines of the cabin. "In that case, the lady would probably end up in the madhouse rather than on the gibbet. Actually, I'm not certain which would be the more unbearable fate."

"Venetian justice," I intoned ironically.

"Our justice moves slowly, Tito, but it does move. Sometimes it even moves in the right direction." His lips stretched in a bitter

twist of a smile. "I advise you to remain patient on this score, as well, and leave the solution of these murders to me."

"But…" I began in protest.

He tapped my knee. "That's more than advice—it's an order. Stay out of it. Meanwhile, trust that I'm not giving up. Who knows, I may even catch a stroke of luck." He dipped his chin. "Now, I really must bid you goodnight."

I climbed out of the gondola and lingered on the pavement watching the boatman navigate a sharp turn and oar back the way he had come. I didn't relish telling Liya about Tedi's murder. The women had not been particularly friendly, but Liya had formed a deep appreciation of Tedi's talents on the stage and of her loyalty to Maestro Torani. My wife would be disappointed; she would worry.

Padding footsteps sounded behind me. I sighed. "Liya…" I began, turning.

My next words stuck in my throat. It was not my wife, but my grinning manservant who stood in the wedge of light spilling from the door.

Chapter Twenty-three

"Naples smells to high Heaven," Benito reported, sitting forward and warming his hands above the glowing scaldino. "It's not just the rotting garbage—it's the stink of sulphur that hits you in the face every time you open a window or venture into the street."

I nodded. "The mountain must have been belching while you were there."

"Just a wisp of black smoke against the blue sky, but somehow it was enough to foul the air."

I lounged on the sitting room sofa, every bone crying out for rest. Benito sat in the opposite chair, seemingly as fresh as a spring morning. By the wavering candlelight, I noted subtle changes in my manservant as he drew a small notebook from his pocket and flipped through its pages. Benito's cheeks were tanned and wind roughened. And thinner. The little castrato had lost several pounds of his barely sufficient flesh. Oddly, his acute leanness did not suggest an increased fragility. Benito appeared as strong and pliable as a whip's braided lash.

We had chewed over my sad news, and I was anxious to hear what had sent my manservant haring off to southern Italy. Since Benito had landed in Naples, his news must concern Angeletto, but that was all I had managed to deduce. "Are you going to keep me in suspense forever?" I asked, none too kindly.

He raised an eyebrow. "I have one simple word for you—twins."

"What?"

"Twins," he articulated even more precisely. "Angeletto and Maria Luisa are twins. I found the record of their baptism at the cathedral. Listen, I copied it down word for word." He held his notebook close to a candle and read, "I, Giorgio Francesco Bersoglia, archpriest of the Cathedral Church of San Gennaro, have baptized a male and a female, born 22nd of July last at the 3rd hour, to the married couple, Bertraido Vanini of this diocese and Antonia Nardo. The children are given the names of Carlo Gian and Maria Luisa."

My manservant waited for my response with a winning smile.

"Twins. Huh. A boy and a girl. So I was right—Carlo is Carlo after all." I yawned, not bothering to cover my gaping mouth, and moved to the edge of the sofa, more than ready to seek my bed.

"Wait, Master, there's more. Much more." Benito held up a pacifying palm. "The good priest also made a note of their god-parents' names. I managed to track one of them down. Onofrio Ascolo, the godfather, is a baker in the heart of the city. I think you'll find his story interesting."

"I'd better. Otherwise, I may fall asleep right here." I sat back, stretching forth my legs and crossing one ankle over the other.

"It is no secret that Carlo Vanini was discovered by Maestro Belcredi in a parish church choir." Benito cast another glance at his notebook. "That would have been when the twins had reached their tenth year, after the father's death left the family basically penniless."

I nodded slowly. "That's as Angeletto told us—in Milan the first time we met. Belcredi took the entire Vanini family under his wing."

"Yes, but Angeletto passed over several important details." Benito cocked his head like an inquisitive canary. "Would you like to guess what they are?"

"Just go on," I urged with another yawn.

"Belcredi actually took both twins under his tutelage. The girl displayed a particularly fine voice. Despite her squalid

upbringing, she possessed natural intelligence and grace, and she took to the maestro's musical instruction like a duck to water. The boy also had talent...." Benito interrupted himself with a wry smile. "At least enough to put an end to his nascent manhood. Once he'd been relieved of his balls, he attacked his lessons with great determination. I suppose he realized that he must succeed as a singer or live the rest of his years as a figure of disdain and pity.

"And so, for some time, all was well. The girl progressed rapidly, not only in her art, but in her fervent attachment to Maestro Belcredi. She turned into a lovely young woman, and the attraction was apparently mutual—or perhaps Belcredi was simply more interested in caging a songbird who could feather a comfortable nest for his old age. At any rate, by the time she was fifteen, Belcredi had taken her as his wife."

I shook my head, picturing Maria Luisa's scraped back hair and steel spectacles. Lovely? Hardly. Had her early widowhood transformed her into the unattractive woman I was familiar with?

Benito continued, "Then a series of disastrous events occurred. The twins were giving concerts in noble homes, and though the papal ban prevented the girl from singing on the stage of the opera house, the boy had debuted in secondary roles—always playing female characters, as young castrati in Naples and Rome tend to do. His pure, agile soprano and his coquettish acting brought him quite a bit of attention and welcome monetary rewards. Maestro Belcredi's investment in the twins was finally coming to fruition." Benito paused for a sighing breath. "But on the very eve of a pivotal opera premiere, the boy came down with a raging inflammation of the throat. He couldn't sing a note. What was Belcredi going to do?" My manservant spread his arms. "What would you do, if you were in his place?"

I leaned forward, all fatigue fled. I was suddenly as alert as if I'd just returned from the coffee house. "Are you telling me that Belcredi sent Maria Luisa to appear in Angeletto's place?"

"Something like that."

"How could they get away with such an audacious switch?"

"Remember, the role in question was a female part. Both twins were sopranos, and, as twins, their voices undoubtedly shared a similar range and timbre. The godfather told me that Carlo and Maria Luisa often learned each other's music, each functioning as the other's most severe critic. When you consider all that, it really was not such an impossible switch. Onofrio Ascolo was standing in the pit that night. Even knowing the brother and sister since infancy, he did not see the true woman beneath the heavily costumed creature on the stage. He thought he was applauding his godson and didn't know any different until a few months later—when old Signora Vanini came to him begging a handout, after Maestro Belcredi had died in the cholera epidemic."

I rubbed my jaw, consumed by memories from my early career, then I said, "The exhilaration of singing on the stage has no equal. Maria Luisa must have truly relished her moment of triumph."

Benito winked. "Her triumph lasted much longer than a moment. Her brother's lovely soprano never returned. Much like your own injury, the illness left the castrato with a coarse, thick voice that would never again be raised in song."

It took a full minute for the implications of Benito's words to sink through my thick skull. I'd been wrong! Angeletto wasn't Carlo—Maria Luisa was Carlo.

I threw my head back. In the shifting shadows on the ceiling, I saw all the hints I'd missed. The down on Maria Luisa's upper lip, her long arms, her skill on the harpsichord, and so much more. Maria Luisa wasn't an ugly woman—she was a castrated male. An angry, bitter young man who'd been forced to surrender his name and career to his twin sister after he'd already sacrificed so much.

"Oh, Benito, what a bird-brained fool I've been." My gaze locked his in a solemn stare. "And I would still be one if you hadn't discovered the truth. I forgive your desertion, but you should have told me what you intended, you know. The longer you were gone, the more we worried."

His expression turned suitably apologetic, but before he could reply, another thought leapt to my lips. "Gussie—how I've

wronged him. I urged him to use his artist's eyes, and when he told me what they saw, I refused to credit him. I accused Gussie of seeing only what he wanted to see, while I was the one who was totally blinded by my hopes for *The False Duke*."

"Don't reproach yourself too much, Master. Angeletto and his brother have perfected their roles through constant practice—their performances had even me stumped for a while—just a little while." He leaned sideways to cup his hand around a guttering candle, then blew it out. He repeated the process with several others. As the sitting room dimmed, I saw that the grey light of dawn was creeping through the shutters. We'd talked the night through.

Benito asked, "Now that you know *The False Duke* is truly false in every regard, what are you going to do about it?"

"Nothing," I snapped.

"You lie. You won't allow the opera house to continue with this travesty."

I pushed to my feet with a sigh. "The Teatro San Marco is no longer my concern, Benito. While you've been away, I've been reminded of that a hundred times."

He also rose. "What is your concern, then?"

The little castrato had hit the nail squarely on the head. Now that I could neither perform nor move into Maestro Torani's shoes, what was I going to do? It was altogether possible that I would never see the inside of the Teatro San Marco again. How was I going to provide for my family? How was I going to live my life? Messer Grande had even ordered me away from investigating the murders.

For a moment, Benito and I faced each other in silence. With an aching heart, I whispered. "I…I don't know."

◇◇◇

In the following days, a sense of futile urgency pervaded all my activities. After taking a dismal inventory of the coins in the household's strongbox, I made a list of all the students I had once taught and eventually given up so that I could be of more service to Maestro Torani. If I could regain only half of my loyal

students, their fees would at least put coal in the stove and food on the table. Liya brought up the possibility of doing some sewing as she'd once done for the opera house, perhaps crafting gowns to be sold from Pincas' shop. I rejected that suggestion out of hand. I must be the one to support my family. Besides teaching, I must find another position.

But who would hire me? My name was still tainted with the suspicion of murder and would probably remain so for some time. Actually, I wasn't certain I would take work at one of the second or third-rate theaters if it was offered. After being so closely aligned with the best—the Teatro San Marco—it didn't seem right. I even toyed with the idea of leaving Venice, but no. The very thought made my heart ache. My family would have to be in danger of starving for me to quit my native land.

I did take time out to pay a call at Messer Grande's office on the Rialto. Though I thought Angeletto's secret held no relevance for the solution of Torani and Tedi's murders, my natural inclination for completeness pushed me to inform Andrea of Benito's discovery.

But Messer Grande was out, the sergeant told me. Out, with no estimated time of return.

Well, I'd tried. There was always tomorrow. Or the next day.

As it was as beautiful an autumn afternoon as ever occurs in Venice, I headed toward the piazza to mingle with the Carnival crowd. I'd barely stepped from under the clock's underpass when I spotted Giovanna Passoni and her willful daughter inspecting a barrow of feathered masks and other fripperies. A pair of liveried footmen stood in attendance several yards away.

Without stopping to consider Andrea's ban on investigation, or even how I might put questions to the lady in the midst of carnival revelry, I called out, "Signora Passoni." She looked over her shoulder, and when she saw who had hailed her, her face flushed bright pink. Beside her, Beatrice shuddered and clutched her blue cloak to her chin. Blue, not green! The girl's face registered a confusion of dislike and alarm. "What do you want, Tito Amato?" Beatrice cried. "Go away!"

The Passoni footmen sprang to action. One hustled the women toward the shelter of the Basilica. The other planted his six-foot frame in front of me. His livid scowl dared me to try and get around him. "Make tracks," he ordered. I had no choice but to comply.

During those days, I also tried to coax Liya into conversation concerning her distress over her cards. She remained close-lipped on the subject; from long experience, I knew that she would only talk when she was ready. On my own, I came to no useful conclusions as to why her mystical faculties had deserted her so suddenly. What did I know of goddesses? Diana had surely never spoken to me, or for that matter had the Blessed Virgin, though I prayed to her nightly. In one wild moment, my thoughts ranged toward the ridiculous, and I imagined these two womanly deities—the ancient goddess of the woodland and the Mother of Our Lord—meeting each other on a garden path in some green and glowing Paradise. Like great ladies promenading on the Riva degli Schiavoni, they would raise the veils of their zendali and acknowledge each other with regal nods. Who would speak first?

One night, after we'd gone to bed, I made the mistake of repeating this to Liya, who merely gaped and said, "Oh, Tito, you don't understand at all." My wife then flipped over and set her face to the wall, taking most of the bedclothes with her.

I rested on an elbow for a moment, staring at her tangle of jet hair, but she didn't turn back. Presently she began to snore in little moaning gasps. Fully awake, I slid from under the blankets and donned my dressing gown.

After wearing out the floor of our chamber with my pacing, I opened the balcony doors and stepped out into the chilly air. Carefully, silently, I shut the doors behind me. Then I did something I hadn't even attempted for several years.

I sang. Not an aria I'd learned in the conservatorio or performed on the stage, but the pure and magnificent music I heard in my heart. Though my delivery was halting and my throat's timbre coarse and heavy sounding—unworthy of being heard by any human creature—my lungs were still capable of putting

some power behind the earnest melody. I was absurdly delighted when the breeze took up the strains and seemed to lift them upwards toward the star-strewn sky. Perhaps the Blessed Mother would hear my poor song, understand the grief that gave it life, and bless me with her smile.

I stood for a moment, gripping the railing, with my face upturned to the stars. To my amazement, I was treated to my melody coming back to me. It was repeated by a single, sweet tenor voice accompanied by a mandolin. Once, then twice, it sounded from the direction of the Canal Regio before floating away forever. The Virgin's gift? Perhaps. During Carnival there was always a great number of vagrant musicians abroad at all hours of the day and night—but they seldom wandered as far as the Cannaregio.

The next day, toward evening, a boy from the theater delivered a message that shook me out of my doldrums. The Teatro San Marco was dark that night, for the first time since Tedi's murder. This I knew because Gussie had broken his resolve. Curious, he and Annetta had attended a performance of *The False Duke* and mingled with acquaintances backstage. He reported that most of the company had been aghast when the Savio refused to close even one night in respect for the murder of its longtime prima donna, right on the premises, no less. But Gussie also had to admit that the Savio alla Cultura had made a shrewd business decision. The latest scandal had entirely replaced the furor over Angeletto, and Gussie judged that both *The False Duke* and its star performer were well received.

It was the star who had sent the message. In the short note, Angeletto begged for my help with another difficult passage.

I crumpled the page on a rush of anger. Hot blood suddenly coursed through my veins. Yes, I had a few things to say to Angeletto—none of them calculated to perfect that lady's singing. I tossed the balled-up paper into the waste bucket the maid had left in the hall. Making a quick grab for my cloak, I set off without a word to anyone. What I had to say wouldn't take long. I would be back in time for supper.

Chapter Twenty-four

Venice existed in a cold twilight mist. Her humped roof tiles glistened with damp, and the strains of a brass band on the piazza were muted and distant. As I approached the theater where I'd spent so much of my adult life, I shivered within my cloak. I'd come to ask the real Maria Luisa Vanini why she thought she should be allowed to enjoy operatic wealth and fame without making the ultimate sacrifice that had been forced on me and every other castrato who had ever poured out our hearts in song.

Finding the stage door locked, I thumped on it with the side of my fist. Presently I heard uneven, clumping footsteps approaching from inside. Those couldn't be Angeletto's light steps. Before that thought fully formed, a prickling sense of danger shot up my spine. I backed away and was poised to leave when I heard a familiar voice through the stout door planks.

"Just a moment…having trouble with the bolt."

Giuseppe Balbi! Perhaps the violinist had agreed to also assist Angeletto by providing accompaniment for the tutoring session the singer had requested. I relaxed as the door swung inward and Balbi's slight form appeared. His expression was unusually severe, and I was surprised to see him in performance attire: an immaculate black coat and breeches, white shirt, and neatly folded neckcloth. His own silver-streaked hair was tied back and lightly powdered.

"How good of you to come, Tito. If you would just step onto the stage…" Balbi's pale hand sketched an expansive arc. "The opera is about to begin."

"Opera?" I asked as I passed Balbi and crossed the dusty boards. I thought Angeletto merely wanted some coaching. My eyebrows pinched together. Did the singer intend to perform an aria fully costumed, implementing his full stage business?

I stepped onto the glowing stage. Every footlight and wing light had been set aflame, and the scenery for Act Three of *The False Duke* was in place. The backdrop portrayed a rocky coast-line. At its base, a triple series of wide rollers was covered with blue-green fabric that stood in for ocean billows. They would appear quite realistic when in motion, but now the silk lay limp and dusty. The Savio's triumph, the tall-masted ship that split in two as it foundered on the rocks, dominated the center stage.

"What's going on here? Where's Angeletto?" I asked Balbi as I turned my back on the scenery and gazed out toward the empty auditorium. One fuzzy point of light beamed out of the blackness; three tapers branched from a candelabrum beside the harpsichord in the orchestra enclosure. Their wicks must have been lit within the past hour. The tapers hadn't burned long enough to perceptibly reduce their length.

"Where is Angeletto?" I asked again. My voice sounded hollow, as if I were calling into the mouth of a cave.

Receiving no answer, I glanced around. Balbi had disappeared. I sighed and stepped closer to the footlights. All was quiet. Not even a mouse's footfall disturbed the all-encompassing silence, yet my ears relived the waves of cheers and applause that had greeted me in times past. I closed my eyes and tilted my head back. In that instant, I'd just sounded the last note of a spectacular aria, and Maestro Torani was waiting in the wings to gather me into his arms. I could almost feel the weight of a royal cape on my shoulders, an elaborate wig and helmet on my head, a sword in its baldric pulling my shoulder down.

For what happened next, I have nothing to blame except my own woolgathering and misplaced trust.

From behind, clattering steps and a blur of motion snapped me back to reality. Something very hard struck the back of my head.

The last thing I heard was my own hoarse cry of pain as I crumpled to the floor. Stars danced in front of my eyes, then nothing.

◇◇◇

Music prodded me to consciousness—terrible, terrifying music—a harpsichord being attacked with the frenzy of a demon player. Gradually, I realized that I was on the ship's deck, ten feet or more above the stage floor. Coarse ropes held me fast against…something. I strained against my bonds but was unable to do more than turn my head from side to side.

Meanwhile, the music jangled on, faster and faster. With a sickening jolt, I recognized the overture to *Prometheus*. Its composer, Balbi, must be the demon at the keyboard.

After shaking off a wave of dizziness, I realized that both of my arms had been stretched painfully back over the ship's steering wheel and lashed to the wooden spokes. I was upright, but forced up onto my toes with my ankles tied together, with no way to free myself. The mast with its flaccid sail riggings stretched above me into the darkness above the stage.

Marshaling the entire force of my lungs, I bellowed for help. Perhaps someone would hear. That slender hope evaporated as manic laughter rang out over the music.

I could expect no rescue. Balbi had clearly tricked me to the theater with the purported note from Angeletto, and I'd tossed that note away where no one at home would find it. As for Angeletto, she was probably resting in her family's quarters at the Ca'Passoni, totally unaware of being used as bait.

It was just me and Balbi, then, and I had to figure out what to do fast. The harpsichord had fallen silent and the musician was climbing the stairs to the stage. From the corner of my eye, I saw him scurry across the stage and pass behind the ship, then I heard him climbing up the steep ramp to the deck.

I would not have recognized the man who came to stand before me. The round head that usually bobbed so genially was shaking with anger. The once gentle eyes glittered with liquid hatred, and deep-cut lines etched his brow. Balbi seemed to have gone mad.

Or been possessed by something not quite human.

Though his melody had hinted at the source of his torment, I decided to appeal to our shared past. I panted out, "Balbi. Giuseppe. Why are you doing this? I'm your friend, Tito. We've made music together for many years."

He'd been holding something behind his back. Without a word, he whipped his arm around and shook a long-bladed stiletto just inches from my face. Then he retreated a step. Still silent, he ripped my linen shirt wide open, exposing my chest, and with focused intensity, used his blade to etch a vicious path along the base of my right rib cage.

I couldn't help from crying out. Blood streamed down my flank, tears of pain down my cheeks.

His voice erupted like Vesuvius. "Be silent, coward! You are not my friend—you're a vile, sneaking reptile. All along it was you who scuttled my opera. You—you—you! I thought Maestro Torani had thrust *Prometheus* aside for *The False Duke*. But now I know the truth. You treated my masterpiece—the labor of years, the treasure of my heart—like a load of refuse."

"No, no," I cried on a gasp. "I only meant for Maestro Torani to postpone *Prometheus* until later in the season. I admire your composition. It's just that for Carnival we needed something revolutionary to fill the theater. The San Marco was in danger of losing Senate support."

"I know all about that." His mud-colored eyes never left mine. His tongue flicked around damp lips. "My *Prometheus* was the perfect opera to save the theater—but you ruined everything—you replaced it with Rocatti's drivel." The blade pricked my skin once more.

"No, Rocatti didn't write *The False Duke*. It was composed by Antonio Vivaldi…when he was a young man." At least I

managed to surprise my tormentor into dropping his blade. I heard it hit the deck boards.

"You're lying."

"It's no lie—I've seen the original manuscript with Vivaldi's signature."

"Then why does Niccolo Rocatti take credit for it?"

I groaned. "It's a long story with many twists and turns. Untie me and I'll explain." Noting a flicker of indecision in his expression, I ventured a feeble smile. "There's no shame in being temporarily supplanted by Venice's revered maestro. Who could hope to top Vivaldi, after all?"

Balbi stooped to retrieve the stiletto. Had the mention of Vivaldi saved my bacon? It was a bare possibility. And short-lived.

As he straightened, Balbi made a sudden lunge and lodged the blade's point under my breast bone. Tensing my abdomen, I shrank back as much as I was able. "I don't care who wrote the foul thing," he growled. "Maestro Vivaldi had his time in the sun. My turn had arrived. *Prometheus* would have pushed me to the pinnacle of success—if not for you."

I cried out as the knife point pierced my skin. Then, in desperation: "Dio mio, do you mean to murder me as well as Maestro Torani?"

Balbi drew back. Blood—my blood—stained his blade. Yet the violinist sent me a wounded look and challenged me accusingly, "You believe I killed the maestro?"

"Why not?" I shouted hoarsely. "If you once believed Torani cancelled your precious opera? For all I know you overheard his insulting comments at the reception—you'd come back to the salon from the kitchen by the time he praised *The False Duke* as a musical feast and disparaged *Prometheus* as gruel. An hour later, he was dead."

Balbi's eyes narrowed to slits. He asked in a broken whisper, "Maestro Torani called my opera…gruel?"

I nodded hesitatingly, now certain that he hadn't heard Torani spouting off. Not even a trained actor could have faked that look of heartrending disillusionment and dismay.

"I didn't kill the maestro." Balbi rubbed his brow like a man with a mounting fever. "Every day while I led the orchestra in rehearsing *The False Duke*, I held my tongue. Though every aria was like a dagger in my heart, I screwed my patience to the sticking point, determined to do my duty. I've murdered no one—until now."

"Now…" My voice trembled. I was growing weak, fuzzy-headed.

"Now. Yes." He lowered his hand and drew himself up. He addressed me smoothly, as if we were discussing nothing more serious than the proper phrasing of a musical passage. "I'm tired of playing other men's inferior compositions—tired of waiting for *Prometheus* to be recognized for what it is—finished with being taken for granted. Good old Balbi! Yes, I've heard you call me thus. Well, good old Balbi is going to cut out your liver. Just as the impertinent Prometheus had his liver pecked out by a giant eagle, my little darling"—he waved the blade triumphantly— "will return again and again to peck at your side. While you bleed to death, you may listen to my glorious opera and think on what a fool you were to thwart my life's work."

"Balbi, you must listen—Prometheus stole fire from the gods on Mt. Olympus, but I've done nothing—nothing except try to take care of the Teatro San Marco as best I could. For the love of God, man, I don't deserve this."

His face hardened. He gazed at me with the cold eyes of a madman. "You deserve nothing less."

After delivering another painful jab to my side, Balbi scrambled off the deck, trotted across the stage, and made his way back down to the harpsichord where he clawed at the instrument like a rabid animal. Somewhere in that clash of notes was an aria from *Prometheus*.

I hung my head. Beads of sweat ran down my face, joining my tears. My heart hammered against my ribs. Shivering from the pain spreading throughout my midsection, I wondered how I could have missed the simmering anger and resentment that had transformed this mild man into a savage. I also wondered

how long it would be before Balbi worked himself up to deliver the mortal cut. He had deceived me utterly, and I had no way of predicting how long my torture would last. I was helpless.

Or was I? Out of empty air, near my ear, Liya's calm voice seemed to speak: "Hold on, my love. There is a way out of any predicament, if you have the courage to find it."

Liya! And Titolino! If I couldn't manage to save myself, I would never see my family again.

I forced myself to put the pain aside and take measured, if not deep, breaths. *Take stock*, I told myself. *As long as Balbi is at the keyboard, you're safe.*

All right. I was secured to a ship's wheel at a very uncomfortable angle. I'd tried to wiggle free, tried to pick at the knots, but Balbi had bound me too tightly. The question of precisely how the slight violinist had accomplished that—indeed, how he had managed to drag me up the steep ramp at the rear of this set piece—flashed through my mind. It was quickly replaced by the memory of Aldo demonstrating how the deck split in half during the great shipwreck. I was actually draped over the wheel that controlled the mechanism. If I could set it into action the next time Balbi came on deck, the little man would be dashed to the…

My blood froze. The music had stopped.

Panicked, I stretched and clawed until my right hand closed around a stout spoke. My left hand couldn't make the connection, but I was able to press my left shoulder blade onto a protruding knob.

But what was the correct sequence? One notch right and two left? Or was it the reverse? I was exhausted, burning with pain, unable to decide.

The ramp's crossties creaked. Balbi was coming, and I had to act one way or the other. Placing my fate in the hands of the Blessed Mother, I pushed and pulled, cranking the stubborn wheel to the right until I felt it catch.

A swell of triumph swept through me.

As Balbi passed through the gate in the ship's railing, I shifted my weight, pushing to the left. The mechanism refused to budge. The violinist drew closer, staring at the stiletto in his hand, muttering under his breath. With an agonizing effort, I coaxed a trace of movement from the wheel.

Still Balbi advanced, one deliberate step after the other, intent on his insane purpose—until he stopped and stood stock still, staring upwards. We'd both heard his name sounding in a disembodied, rumbling basso—*Balbi*.

My head jerked around. Someone else was in the theater—up on the catwalk above the stage. Of course, I should have realized it at once. The small-statured Balbi could not have accomplished moving my deadweight onto the deck.

I peered into the shadows overhead but saw only dangling ropes, hanging scenery, and crisscrossing platforms. "Who's there?" I cried. "Show yourself."

The response was a pistol shot that whizzed across the deck.

I watched in horror as Giuseppe Balbi stiffened, his face set in the classical mask of tragedy. Blood trickled from a round hole in his forehead. He teetered, then collapsed near the ship's mast with a crash. I felt the boards quiver through my toes.

Chapter Twenty-five

A menacing silence filled the seconds following the shot. I craned my neck, frantically searching for Balbi's killer. Nothing! Then, a blur of movement caught my eye from the opposite direction, from the auditorium I'd thought was empty. A slim female form in a pink gown appeared at the railing of a second-tier box. She began to applaud—a thin sound in the yawning cavern of the Teatro San Marco.

"That was wonderful," she called. "You took care of Balbi—now it's Tito Amato's turn." Somehow, I wasn't surprised to see Beatrice Passoni standing in her family's box, though it did shock me that her voice was so exhilarated, so unbelievably merry, as if she were watching Punch-and-Judy antics instead of an actual murder. She went on, "Shoot Tito, too, Papa."

Papa. The Savio.

He was coming. I could hear him. My stomach twisted in nauseating panic.

"Carrissima, you forget..." the Savio's senatorial voice boomed out from stage left. He had descended the ladder from the catwalk. "These deaths must be made to look as if one man murdered the other."

I wasted no time in pondering how the Savio meant to kill me and why. I tensed in anticipation of making the final push that would awake the sleeping giant under the ship, the machinery that would lift the deck and split it in two. If Signor Passoni was incapacitated in the resulting fall, I would have only his

daughter to contend with. It would take Beatrice a few minutes to make her way from the box to the stage. Perhaps by then, I could think of something else.

Striving to control my terror, I leaned into the wheel with all my strength. Thank the Holy Madonna, it yielded and advanced one notch to the left just as the Savio reached the deck. Hoping to convince my new assailant that he had nothing to fear from me, I then slumped as if my strength were totally spent.

From under half-closed eyelids, I watched as he went straight to Balbi's prone form. Sweeping his long cloak aside, the Savio knelt and removed the stiletto from the violinist's flaccid hand. My heart was beating as if it would tear through my chest. I strove to calm it as the Savio came to loom up before me, stretching every inch of his noble height.

"Poor Tito." He shook his head pityingly, an aristocrat of the first order giving alms to a scabrous beggar. "What an ignominious end for a renowned singer—killed in a tragic wrangle with a vengeful composer. Your rejection of *Prometheus* drove Balbi mad, you see. He lured you to the theater and attacked you in a semblance of his operatic hero's cruel death. Such is the fury of a patient man—it grows unseen like the roots of a tree, digging at a man's soul, strangling his better nature, until it bursts forth in uncontrollable rage."

The Savio smiled, baring every tooth. May I never again see such an unnerving sight!

Dimly I heard him continue, "It may cheer you to know that the world will believe you fought back. You courageously overcame and shot Balbi before your own loss of blood felled you."

Despite my intent to appear defeated, I glowered. I couldn't help it. "Are Torani and Tedi on your list of victims as well?"

His smile faded. "Regrettably, yes…but I believe Balbi's final mad act will convince Messer Grande that he killed Torani for the same reason that he killed you."

"And Tedi?"

"Well, let's say that she guessed Balbi killed her lover, and thus he felt compelled to silence her. That makes logical sense,

doesn't it?" Passoni gazed at the stiletto point and touched it with a fingertip as if to test its sharpness. He continued meditatively, "Or perhaps Tedi incurred Balbi's wrath by arguing against the production of his *chef-d'œuvre*. Where a lunatic is concerned, there's no lack of possible motivations."

"You manipulated Balbi, drove him around the bend." With a start, I realized I'd already forgiven the little violinist. His mind had been poisoned by a greater evil.

"It was pathetically easy to turn Balbi to my will—after I'd convinced him that Torani left the choice of opera entirely in your hands, and that you chose *The False Duke* over *Prometheus*. I told Balbi that when you came to me to request permission, you called him a hack, the worst sort of amateur composer—"

"That's enough. I see," I spat out. Sweat ran down my brow, stinging my eyes. I knew I must conserve my strength for the wheel's final turn, but I had to know the truth. I raised my chin and asked, "But why did you kill Maestro Torani in the first place?"

Beatrice shouted from the auditorium, "Watch him, Papa. Tito is a crafty one—he might have a trick up his sleeve."

The Savio turned his handsome profile toward his daughter. "Don't worry, my pet. Tito is completely in my power."

"Then what are you waiting for? Do it!" Though the girl was merely a blur of pink across the blazing footlights and the dark space beyond, I could envision her moody pout.

The Savio turned back and made a shallow bow, one precisely befitting my station. He was a consummate patrician, all right. He knew Venice and her customs through and through. No wonder he had risen so far. Now he was saying, "You really don't understand—after all the time you've spent poking your long nose where it has no right to be."

I shook my head.

"It came down to this. Rinaldo Torani was a thoroughly feckless punter. As was his failing, he played one card too many." He lifted an eyebrow. "I was surprised to see the old man toddle into the palazzo on the night of Angeletto's reception, but since

he had made the effort to attend, I asked him to meet me in the card room. I had bad news, and it seemed churlish to deliver it before the assembled company."

"Bad news?"

"Yes. Lorenzo Caprioli had also turned up unexpectedly... anxious to gauge his prospects regarding the Senate's support for his theater, I presume. Can't stand the fellow; he's an ass who considers himself an Arabian steed. But Caprioli did make me a most attractive proposition. If I were able to persuade the Senate to change its official backing from the Teatro San Marco to the Teatro Grimani, I could call the shots on any scenic illusion I desired." He spread his hands, looked around with a satisfied smile. "This shipwreck would be nothing—a mere trifle. I could order Caprioli's machinist to create a hot air balloon ascent from the stage, a raging naval battle, even the sulphur pits and burning lakes of Hell itself. No spectacle would be too great. How could I refuse?"

"You told Maestro Torani you were planning to support the Teatro Grimani over the San Marco," I whispered, imagining the ire and frustration my old mentor must have felt. I could just see him arguing with the Savio, snatching off his wig and throwing it across the card room.

"Yes, and Torani made the mistake of trying to coerce me into changing my mind. He thought he held a trump card." Half-closing his lids, the Savio glanced toward the box where Beatrice kept watch. "Somehow the old maestro had found out about certain...attentions that Girolamo Grillo was paying my daughter. Torani had an eyewitness who could describe one of their trysts. You couldn't name the man he spoke of, perchance?"

Peppino or one of his fellow gondoliers was my best guess, but I'd die before I'd mention the boatman's name to the Savio.

"No," he mused, "I don't suppose you could." The Savio rubbed his hands together and raised his voice in something close to disbelief. "Torani actually threatened me—if I didn't continue to support the Teatro San Marco with the Senate, he would turn his anonymous meddler loose in the coffee houses."

The Savio's voice became gravelly. "You know what that would mean for Beatrice. The good families would turn their backs on her. Her brilliant prospects would be ruined."

"I wouldn't blame you if you'd killed Grillo, but..." I shook my head in sorrow. "Was murdering Maestro Torani—the man who'd devoted his entire life to Venice's pleasure—was that the only way to protect your daughter's honor?"

"It was the surest way," he answered shortly. "Everyone who has the potential to harm my Beatrice must be removed. Believe me, if Grillo ever again sets foot on Venetian soil, he'll be dead within twenty-four hours."

"Tedi?"

"Tedi aroused my suspicion when she didn't leave Venice as she promised. Who knows what secrets Torani had shared with her? I gave her enough gold to travel anywhere she fancied, but, like you, she felt compelled to play bloodhound. Even then, if she'd kept to her love nest with Caprioli, I would have stayed my hand, but when I chanced to see her flit through the theater corridor, closely followed by you..." His jaw clenched. "Tedi signed her death warrant the moment she decided to confide in you."

"Why didn't you kill me at the same time?" I was beginning to realize that the Savio had no idea I'd witnessed Grillo and Beatrice's lovemaking in the card room. The little minx hadn't told him, and she was anxious to have me dead so that I couldn't.

He shrugged. "I had discharged my only pistol and didn't relish hand-to-hand combat. Besides, Tedi had not yet vouchsafed her precious secret." He continued matter-of-factly, frowning. "I actually considered letting you live—until you trailed my wife and daughter across the piazza the other day. You frightened Beatrice. She's convinced me that you'll never stop harassing us in your efforts to get to the bottom of Torani's death."

Beatrice! The cursed name echoed inside my head. I took a hard gulp. Torani, Tedi, and the hapless Balbi—all had been sacrificed on the altar of the Savio's bloodthirsty, undisciplined Beatrice. The tyrant Beatrice, I had once called her in jest. If I had only realized.

The girl's insistent voice tore through the space between us. "Papa, what are you waiting for? You promised to get rid of Tito."

"She's right," the Savio whispered. "It's time. May God receive your soul, Signore." With a heavy sigh, he lowered the stiletto to the level of my liver, screwed his eyes shut, and braced himself for a mortal thrust.

I shifted my weight to the left, pulled the spoke up with my right hand, and pushed down with my left shoulder.

The wheel turned. A faint creaking came through the deck boards. The Savio hesitated. Then his eyes popped open, and he cocked his head like a dog that hears his master's whistle in the distance. Metal grated on metal, followed by clanking chains. The entire ship shuddered.

"No!" The Savio realized that I had set his beloved shipwreck into motion. Fear blazed on his aristocratic countenance.

Beatrice saw what was happening, too. She cried, "Get off the boat, Papa!"

"You idiot!" The Savio lunged toward me with the stiletto. Groaning in agony, I quickly swiveled my hips and drew my knees up into my chest. The blade buried itself in the wooden column supporting the wheel.

The Savio didn't attempt to remove the stiletto. He whirled quickly. On shaky legs, he crossed the rising deck, heading for the stalwart mast that could provide a handhold once the ship split in two.

He didn't make it. The quivering jerk that halted the deck's upward progress knocked him off his feet directly over Giuseppe Balbi's corpse. In the Savio's fierce efforts to rise, his cloak became entangled with the dead violinist's limbs. I heard his strangled curses as the machinery ground on and a dark void opened between the two halves of the deck. Somehow he managed to extricate himself from Balbi's lifeless embrace just as the flat deck began to cant inexorably toward a steep angle.

I watched as the murderous aristocrat began to roll. With each notch of the gears, he picked up speed. In vain, he clutched at the air, beat his heels against the smooth boards.

As he slid under the polished wood of the deck railing, the Savio made one last frantic grab. His crabbed fingers missed the railing by a hair. His white-stockinged legs shot out into thin air, and he went over the edge, followed closely by his victim's body.

From stage level came a splintering, shattering thud. Then another.

I was left hanging from the sharply tilting wheel. In the space of moments, that instrument of captivity had become my salvation. My last fear was Beatrice. The girl must have witnessed it all, but I'd heard no wailing screams. Where was she?

I held my breath, listening intently. There were murmurs in the wings. What? Of a sudden, the murmurs became louder, turning into happy, chattering voices that I knew well. Aldo's clipped tones and Gussie's British-laced Italian, then a girlish treble calling, "Isis. Isis."

That had to be little Isabella!

Merciful Heaven, Gussie had fetched Aldo, and they'd come to the theater for the promised kitten. I had totally forgotten, but the eager five-year-old hadn't.

Then a different voice rang out. Its commanding note stifled the gaiety of the others. Was that Andrea? What would Messer Grande be doing at the theater?

I filled my lungs to shout a warning. I didn't know if the Savio was dead or merely stunned, and then there was Beatrice. I'd be amazed if she'd made her way out of the theater. No, that pampered tyrant would be on the move and out for my blood. And somewhere there was a pistol. And a stiletto.

Though my midsection burned with pain, I managed to shout, "Watch out for the girl!"

Steps sounded at the back of the ship—someone was climbing the ramp. I shut my eyes. Totally vulnerable, sagging on the wheel, at the utter end of my strength, I just couldn't bear to look.

"Tito!"

My eyelids flew open. A red-robed Andrea half-skidded, half-stumbled across the canted deck and braced himself with both hands on either side of my head.

That welcome sight gave me enough energy to ask, "How… how did you find me?"

He grinned. "I finally recalled the Savio's full name. The late Savio! You may be relieved to learn that His Excellency Arcangelo Michele Passoni has broken his neck, and that his grieving daughter is being guarded by Aldo."

Chapter Twenty-six

Every bone and muscle ached, but my heart brimmed with joy. One day had passed and I lay in our chamber at home. A fresh breeze blew through the open balcony door, sunlight made shifting patterns on the stuccoed walls, and the people I loved best surrounded my bed.

"He's awake," Liya announced as she bent to stroke my cheek and kiss my forehead. I gave an involuntary sigh as her petal-soft hair and the familiar scent of orange blossoms wrapped me in a loving cocoon.

On the other side of the bed, Annetta slumped on a stool with Gussie's arm encircling her shoulders. My sister had been weeping—she clutched a damp square of linen in her hand—but now a brilliant smile broke over her face. She reached out to pat the blankets. "Tito, thank God, we've been so worried. You lost a lot of blood."

Ouch! Yes! I struggled to poke a finger beneath the bulky bandage over my liver. Besides the throbbing pain, the damnable thing itched.

"Leave it alone, my love." Liya trapped my probing hand between her smooth palms and gently rested it on her bodice. "You must keep still or you'll start bleeding again."

At the foot of the bed, Benito waited with a steaming basin and a white towel draped over his arm. "Shall I bath your forehead again, Master?" His voice seemed reedy and hollow. Distant. I blinked my eyes and his form wavered.

"Master?" Ah, it stilled.

"Not now," I managed to croak out.

Then I noticed the taller figure at the foot of the bed. Messer Grande—Andrea—with his red robe slung carelessly over one shoulder. "The Savio!" I cried, raising my head a fraction. "He killed Maestro Torani…and Tedi…and…" I trailed off on a wave of dizziness. My head sank to the pillow. Liya's hands tightened around mine.

"I know, Tito," Andrea replied in a soothing tone. "I know everything. Don't trouble yourself."

"But he was…the Archangel Michael." I was determined to speak my piece. "Franco didn't send the tarot cards to call my attention to Angeletto. He—and Signora Passoni—were prodding me to investigate the Savio." I groaned, not just in pain. "I knew the nobleman's Christian name; his wife had used it in my presence several times. I just never thought of the man in such informal terms. To me, he was always the Savio or Signor Passoni. If I'd only understood the cards' message, Tedi might still be alive."

The chief constable arranged his features in an inscrutable mask. He spoke with unusual emphasis. "My friend, don't reproach yourself. It took me quite a while to put it together, too. Once I did, Giovanna Passoni admitted that she feared the Savio had killed Torani. Through the cards delivered by Franco, she was trying to send you a hint without openly accusing her husband."

"She could have made her hint a little more obvious," I complained. *Or I could have been a little smarter.* I shook my head, then wished I hadn't. "What about Beatrice?" I asked with a sigh.

Gussie cleared his throat. "We peeled her off the body of her dead father. She was babbling unreservedly—one minute threatening to kill you, the next deploring her father's mania to keep the family from disgrace."

Andrea took up the story. "The Savio was not only determined to protect his daughter's good name, but also to avoid scrutiny that might bring his wife's illegitimate liaison with Vivaldi to light. He wanted Torani's wagging tongue silenced for good."

I shook my head. "If the Savio was aware of the opera's true authorship, why did he allow me to mount *The False Duke* in the first place?"

Andrea shrugged. "I believe he discovered the truth *after* he'd given permission. Exactly how is something neither Beatrice nor her mother has been able to tell me."

"Where is the girl, now?" I asked.

"In the care of her mother," Andrea replied. "But Signora Passoni is making plans to dispatch her daughter to a convent— Santa Maria della Croce."

He'd named a cloistered institution on one of the more secluded lagoon islands. I'd seen it only once, from afar, rising from the glassy lagoon like a brick-work fortress. While I tried to imagine the nuns taming Beatrice Passoni's undisciplined passions—a monumental task, to be sure—I felt my eyelids growing heavy. Beatrice would have no escape, no freedom as her mother had enjoyed at the Pieta. It would be a life sentence. Presently, I felt Liya's warm lips touch my forehead and her hands tucking the bedclothes up around my neck. Barely aware, I sank once more into healing sleep.

◇◇◇

A week passed before I finally had my confrontation with Angeletto. I met the singer and Maria Luisa—I could think of this twin by no other name—on the stage where I had nearly met my end. The cursed ship had been dismantled, and a limp, unpainted canvas hung from the flies.

"You're not firing me?" Angeletto, dressed in the street clothing of a modish young blade, regarded me with astonishment.

I shook my head. I was now the Teatro San Marco's permanent artistic director. The Senate had taken its vote on the matter of Venice's state theater. When this august body had considered Lorenzo Caprioli's hand in the opening night riot, as well as his dirty deal with the late Savio, support for the Teatro San Marco had been renewed by a comfortable majority. My appointment was nearly unanimous.

My first task had been to cancel *The False Duke* and send Niccolo Rocatti on his way. Not happily, I admit. I had turned the problem of the purloined opera over in my mind for some time. Out of concern for the San Marco's reputation and after extracting Rocatti's solemn promise that any further claim to *The False Duke* would never pass his lips, I finally decided to consign Vivaldi's score back to where its true composer had left it—in deep, anonymous obscurity.

Armed with his Pieta masters' letters of recommendation, Rocatti quickly found work teaching violin at a small conservatorio in Geneva. He asked Oriana Foscari to accompany him as his wife. To the surprise of no one except poor Niccolo, the greedy songbird refused him. I trusted the humbled man to keep his promise to me—rather, I trusted his mother to see that he kept it. After her husband had come so close to cutting out my liver, Giovanna Passoni felt she owed me a favor.

My second task was censuring Angeletto and Maria Luisa over Benito's revelation. I called the pair to the theater, empty of everyone else besides Liya and Aldo, and laid the facts out in detail. Once I'd finished, there was a long, uncomfortable silence. Then Angeletto's shoulders began to shake, and great, racking sobs took possession of the soprano's frame.

Tears of relief.

It seemed that both twins were thoroughly sick of their dual masquerade. Six years of deception. Six years of gnawing worry at being found out. They actually seemed relieved that they could meet the world as themselves. The astonishment came when I offered to hire Angeletto to sing as a woman. Why not? We needed a new prima donna, and Venice's curiosity over the switch was bound to plump up ticket sales. "Do you accept?" I asked the woman in male dress.

"Well, I don't know....Do you really think I could pull it off?" Angeletto wiped her eyes with her fingers, then bit her lips. "I suppose I would have to take a new stage name."

I shrugged, smiling. "That's up to you." For the past few days, I'd felt unusually alive, as if a fresh breeze blew over the

waters and stones of Venice, a breeze from a future land where men could sing as natural men and women would be welcome on any stage.

"I'll do it!" Angeletto said.

Her twin's hand shot out to grasp her elbow. "Not so fast!" He stared at me over steel spectacles. "Will the terms remain the same?"

I'd anticipated this question. I shook my head. "I simply cannot pay a female soprano the same wages as a castrato," I said. "But I can offer the same pay that Oriana Foscari receives—plus ten percent."

The twins eyed each other. "Mama will be furious," Maria Luisa muttered.

"I don't care," Angeletto burst out. "I want to sing."

Maria Luisa's mouth set in a firm line. Unspoken messages passed between them.

Again I asked, "Do you wish to perform at the San Marco? Yes or no?"

They both turned to me. In unison they replied, "We accept."

Once the twins had departed, Liya and Aldo drifted onstage, Liya from the backstage studios and Aldo from his cubbyhole in the wings. My wife's arms were full of silks and satins and lengths of spangles. Propelled by that new, fresh breeze, I had hired Liya to take charge of the San Marco's wigs and head-dresses. Without her powers of divination, she needed new scope for her restless talents. Truly, I saw no way in which her employment could diminish my role, either in our household or at the theater.

We were both stepping onto new paths. Together we would prevail.

"Did Angeletto agree to stay?" Liya asked, her pretty head cocked to one side.

I hesitated before answering. My gaze had strayed to the shadowy auditorium: the tiers of boxes that would soon over-flow with a full complement of patrons, the pit that would teem with hooting gondoliers, the Doge's official box that would no

longer be empty and dark, mocking the performers straining their tonsils to please. I turned triumphantly to my wife.

"The Teatro San Marco has a new prima donna," I announced. "All I have to do is find an opera worthy of her voice—something completely different—something dazzling."

Did I hear Aldo take a sharp breath from where he hovered downstage?

"I don't like the sound of that!" My wife drew her chin back, not completely in jest. "Isn't that how this all started in the first place?"

"Don't worry, my love. This time I will be more careful. I will unearth the perfect piece by a reputable composer. We will have a great triumph."

Laughing, Liya headed back to her workroom, but I paced the boards, plotting and planning. I jumped when I felt a tap on my shoulder.

The forgotten stage manager had crept up on his felt-soled boots.

"Aldo," I said, clapping my hands on his shoulders. "This is the start of a new era for the San Marco. We'll make beautiful music here."

He gave me a wide smile. "Yes, *Maestro* Amato, I believe we will."

To receive a free catalog of Poisoned Pen Press titles, please contact us in one of the following ways:

Phone: 1-800-421-3976
Facsimile: 1-480-949-1707
Email: info@poisonedpenpress.com
Website: www.poisonedpenpress.com

Poisoned Pen Press
6962 E. First Ave. Ste 103
Scottsdale, AZ 85251